GOYA

In all the world you won't find a human being who is human toward other men.
—Mateo Aleman, *Guzman de Alfarache*

I think with horror of the refinements that will be introduced into tomorrow's concentration camps, of their even more extraordinary nature, where man will be deprived even of the gift of suffering.
—Jean Cayrol

GOYA

The Origins of the Modern Temper in Art

Fred Licht

ICON EDITIONS

Harper & Row, Publishers, New York
Cambridge, Philadelphia, San Francisco, Washington
London, Mexico City, São Paulo, Singapore, Sydney

1817

FIRST ICON EDITION PUBLISHED 1983

Library of Congress Cataloging in Publication Data

Licht, Fred, 1928-
 Goya, the origins of the modern temper in art.
 (Icon editions)
 Includes index.
 1. Goya, Francisco, 1746-1828. I. Title.
ND813.G7L564 1983 759.6 82-48152
ISBN 0-06-430123-0 (pbk.)

89 90 91 92 HAL 11 10 9 8 7 6 5 4 3

Contents

List of Illustrations

6

Preface

This book is not a monograph but a series of investigations of those aspects of Goya's art that make him specially pertinent to the development of modern art in general and to our times in particular. For those readers who wish to consult a trustworthy and exhaustive monograph, I recommend *The Life and Complete Work of Francisco Goya*, by Pierre Gassier and Juliet Wilson (New York, 1971). The four-volume catalogue by José Gudiol, besides being unwieldy for most readers, also errs in being far too generous in accepting spurious and peripheral works as autograph paintings. Its photographs also leave a great deal to be desired.

To see Goya's *oeuvre* in the general context of the new revolutionary spirit of the epoch, it is essential that readers familiarize themselves with *Transformations in Late 18th Century Art*, by Robert Rosenblum (Princeton, N.J., 1967). To do justice to the theme of art during the revolutionary epoch, I would have had to cite Rosenblum's text on almost every page of the present volume.

The scope of this book also forbade a more thorough and scholarly exploration of portraiture during the late 18th and early 19th centuries, and since portraiture is one of Goya's fundamental genres, this is a serious lack. Unfortunately, no book exists on the specific theme of portraiture during the relevant period. Readers who are interested in learning more about this fascinating topic should consult the masterful article by Edgar Wind, "Humanitätsidee und heroisiertes Porträt in der englischen Kultur des 18. Jahrhunderts" in *Vorträge der Bibliothek Warburg*, 1930/1931.

Cordial thanks are due to Joan Vass, who first conceived of this slightly unorthodox treatment of Goya's art. She, my wife, and Lou Barron all encouraged me during the long and not always happy vicissitudes that marked the writing of this book.

Goya's
Life in Brief

The known facts of Goya's life have served to obscure rather than to clarify his character and the tenor of his life. We are fairly well informed about the major events of his career, and yet this knowledge remains strangely superficial when we try to draw conclusions regarding the nature of his personality. Perhaps it is this puzzling detachment that has provoked so many authors to give an emphatically dramatic note to Goya's biography. It is also this disparity between Goya the artist and Goya the man that gives his biography a startlingly modern note. Just as Picasso could paint *Guernica* and come to terms with the German occupation of France, just as Manet could paint *The Execution of Emperor Maximilian* and hope for public recognition and remuneration, so Goya lived simultaneously with and against the dominant trends of his time. To determine the nexus between the life and work of a modern artist is a risky business indeed.

Born in 1746 in the remote Asturian town of Fuendetodos into a very modest family, Goya must nevertheless have enjoyed a better-than-average upbringing and schooling. In *The Last Communion of St. Joseph of Calasanz*, painted at the end of his life, he gave grateful testimony to his monastic teachers of the Scolopian Fathers, and this in the teeth of his pronouncedly anticlerical attitudes.

His first two voyages to Madrid in 1763 and 1766 were without any traceable importance. Nor are we much better informed about the impact that his Italian sojourn in 1770-71 had, even though it must have been of great importance to him. Certainly the frescoes just being completed in the Spanish church of Santa Trinità on Via Condotti in Rome must have impressed him. Their influence is still visible in the large mural canvases of Aula Dei which Goya painted in 1774 as well as in his early tapestry cartoons. It is also highly probable that he first absorbed the principles of pre-revolutionary neoclassicism while in Italy. Even though his entry for

the competition at the Academy of Parma is lost, the prizes during the years before and after 1770 were consistently given to classicizing artists. Goya, who won second prize, must have known how to conform to the prevailing taste of this prestigious Italian academy.

Returning to Saragossa in 1771 he obtained a commission for the great church of Santa Maria del Pilar which he executed in the traditional late Baroque manner. This first important commission on home territory must have brought him into close contact with Francisco Bayeu, a painter whose fame went beyond Saragossa and whose influence at the court of Madrid was considerable. Goya's marriage in 1773 to one of Bayeu's daughters, Maria Josefa, may have been dictated by prudent self-interest rather than by genuine inclination. Here, in any case, we touch one of the mysteries of Goya's life: his relationship to his family. Only a very few portraits of his wife and his children have come down to us, and they are all impassive, forbidding any revelation of Goya's affections. One can only hazard the guess that Goya, like most husbands and fathers of the latter half of the 18th century, was not overly concerned with the satisfactions of the hearth.

Goya's ascent was fairly rapid after he obtained his first Madrilene commission for a set of tapestry cartoons in 1775. By 1780 he had made enough headway to be elected to the Academy of San Fernando, and by 1786 he was named court painter. In the year of Charles IV's coronation, 1789, he was promoted to the position of *pintor de camara* to the king and was henceforth in a position to pick and choose his commissions.

The great caesura in Goya's life came after his grave illness of 1792-93. There can be no doubt that the shock of coming so close to death and the permanent deafness caused by his mysterious ailment proved to be a turning point in Goya's life. A new depth and a new seriousness mark all his work after 1793. Even the most cheerful of Goya's works after his illness, the frescoes of San Antonio de la Florida, are touched by a brooding and fateful note that bursts to full intensity in the *Caprichos*, which were published in 1799. A certain parallelism between the tragedy of Goya's personal life and the immense upheavals in world history should be noted, but it wasn't until 1808 that the fateful but distant events of the French Revolution broke over Spain with unheard-of ferocity. Once again, there are no documents, no secure testimony to Goya's allegiances during this period of conflict and tragedy. Whatever interpretation we put on Goya's great images of war and human misery we make at our own risk. We are at liberty to read these pictures as comments on the universal condition of mankind at the mercy of blind cruelty and pitiless, egotistic stupidity, but we have no trustworthy facts that permit us to deduce his

private feelings toward the specific political events or toward the public figures who were such prominent protagonists in the Spanish drama of those years.

In 1812, at the height of French repression in Spain, Goya's wife died; but aside from the inventory of the family's property taken on that occasion, we have no record of the impression her death made on the artist.

The year 1814 marks the creation of Goya's most emblematic work: *The Execution of Madrileños on the Third of May* [50]. This painting, which seems to sum up the revolutionary spirit that marked Goya's day and is still the primary force of our own day, was painted to celebrate the return of the Spanish Bourbons after the fall of Napoleon. Ferdinand VII, if he noticed the painting at all as he passed under the triumphal arch where it hung, certainly understood it to symbolize the courageous loyalty of the Spanish populace to the Bourbon dynasty. Ironically, there is no reason to suppose that such an interpretation was mistaken, nor have we any right to think that our understanding of the painting coincides with Goya's original purpose. After all, the events that led to the massacre were caused by loyalty to the Bourbon crown prince, and Goya need not have intended any sarcasm at all by celebrating this display of popular love for the dynasty. It is only the wisdom of hindsight that tells us that Ferdinand in his turn was as cruel a despot as the hated French invaders had been.

More than ever isolated by incipient old age, by his infirmity, and by the atrocious repressions of the restored Bourbon regime, Goya painted his greatest works. The paintings and graphics of 1815-20 could have been understood by only the most intimate among Goya's friends. For us today they are the most enigmatic harbingers of modern art. We know nothing at all of the commissions that called into being such masterpieces as the two large paintings in Lille [100, 101] or of the largest and most ambitious of all of Goya's canvases, *The Session of the Royal Company of the Philippines* now in the Musée Goya at Castres [102]. The same holds true of a small series of powerful paintings with proletarian subjects of which *The Forge* in the Frick Collection is the most famous [130]. As for Goya's most personal creations, the so-called Black Paintings, it is thoroughly possible that the artist himself may not have understood the psychic ferment that impelled him to paint what still remain the most appalling visions of human torment.

Again the known biographical facts fail to afford the insight for which one hopes. In 1823 Goya made a generous donation to his son, but probably the move was prompted by prudence. Goya already may have been planning to flee the oppressive and politically dangerous atmosphere

of Spain and may have wanted to protect his property from seizure by the Crown. In 1824 he finally made the break and traveled to France under pretext of taking the cure at Plombières. His self-imposed exile was interrupted only by a quick visit to Madrid in 1826. We have evidence that he was in Paris in 1824, the year of the Salon at which Ingres, Delacroix, and Constable first manifested the grand design of a modern epoch of art. But whether Goya visited the Salon, and what his reactions might have been if he did, are questions that are as unanswerable as they are intriguing.

Only in the last years, spent at Bordeaux, are we granted a flicker of spontaneous and revelatory feeling expressed by Goya outside the realm of his art. In a moving letter to his only surviving child, he speaks of his longing for this son. In 1828 his life ended, and slowly the world entered into his heritage of images, some tender, some terrifying, each one convincing as an oath, in which Goya first fixed the courage and the despair of our modern age.

1

The Background

rt, since its very beginning in prehistoric caves, has been what our modern political parlance would define as "conservative." It has served to preserve the status quo. It has been a signal to future generations. It attempts to prolong the present to the detriment of the future. In ancient Egypt it served to banish death and the passage of time at the same time that it extolled the dynasty. In Greece it raised monuments that made visible lasting ideas and glorified victories and gods. In Rome it first turned ancestors into gods and then, during the Empire, gave lasting expression to a dominant political principle of Roman authority. This system was gradually transferred to Christianity and again served God, who in turn lent power to the emperor and his enterprises. The relationship between religion, dynasty, and art changes constantly in its proportionate emphasis according to the political moment. Sometimes it is religion that dominates, sometimes it is the dynasty. But always, art is called upon to memorialize, to eternalize certain principles, certain personalities, and certain events that are deemed to be of lasting importance and that tend to stand in the way of further developments. If we call Giotto or Titian revolutionary, we use the word only in the esthetic, not in its political or spiritual, meaning. Giotto and Titian and other artists who introduce new notions into art do so in the name of those forces that, ever since the beginning of Western civilization, have supported and needed art.

In exchange, the belief in higher powers gave art a grandeur and a secure significance that it could not have attained in any other way. Since art was the interpreter of communal religious ideals, it could count on speaking clearly to all reaches of society, and it could also count on going beyond the material essence, and thus it distinguished itself from the limited world of artifacts. For the image, whether it was of stone, of metal,

14

or painted on terracotta tablets, automatically became a symbol of an ordered unive͏ je in which the power of divinity was manifest at all times. Art, in short, showed mankind that life was a meaningful, divinely ordained gift which was part of a vast scheme of things that could be understood and, within limits, controlled by faith and by ritual.

From the time of the unification of Upper and Lower Egypt (about 3000 B.C.)—which also marks the beginning of a truly Western point of view in art—though dynasties and religious ideals kept changing, the major premise of each succeeding culture remained the same. There were, of course, certain moments in this immense stretch of time that did not conform to this pattern. Of these, the closest to us in time and best known by us today is the short period that saw the flowering of Dutch art in the 17th century. But even here, where secular rather than dynastic or religious ideals were predominant, there still remained an abstract, otherworldly, and universal principle on which art fed: patriotism and love of those homely Protestant virtues on which the unity of the community was based. Pride in the land, devotion to the domestic scene, an emphasis on virtue that was universally believed in even though it promised no concrete rewards in the hereafter were the keynote. But in any case, such short periods are freaks of art history and not the rule. Religion and dynasty were the dominant forces that gave art substance over the centuries.

This state of political and cultural balance broke down toward the end of the 18th century. Questioned by the major figures of the Enlightenment, the system was destroyed by the French, American, and industrial revolutions. Art, an activity that had always been reactionary, was suddenly immersed in a revolutionary epoch. The Church and the dynasty, which needed the artist as much as the artist needed them, were no longer there to sponsor art, and the artist was cut off from financial support and from spiritual response. Up to this time all important works of art had been produced on request—in other words, the artist knew before he set hand to his work that there was a real need for what he was about to produce. Now, with the coming of revolution, the artist produced his work in the void and hoped that his painting or sculpture (now reduced to the level of merchandise) would find an appreciative or at least a generous buyer. He was no longer a man whose handiwork was needed by society. What he produced was a luxury item, which society, according to its whims and financial resources, would either accept or reject. His only chance of gaining financial as well as spiritual security under these changed conditions was to become a "dictator of the arts." If he wanted to be successful, he had to guess at the changes and shifts of public taste (a public, it must be kept in mind, that no longer had the high level of esthetic training that

15

the Church or the crown once had) and respond to this inarticulate public taste with an art that would satisfy the public demand. Both Jacques-Louis David and Francisco Goya, the first great artists to be faced by the revolutionary conditions of modern man, were able, each with great forcefulness, to impose their talents by sensitively (and perhaps intuitively) feeling the pulse of time. David responded with positive enthusiasm to the demands of a revolutionary public, but, when that fickle public changed its sentiments, found his very life in danger, and his major work, *The Oath of the Tennis Court*, was left incomplete. Goya's attitude was much more elusive. He found success and he found sponsors. He became as unquestionably the commanding figure in Spanish art of the epoch as David was in French art. But his art was never as widely understood and never imposed itself as an example to be followed. David responded to public taste—but he also fashioned it. That was not true of Goya. During his own lifetime, some of his most important work, the *Caprichos*, *The Disasters of War*, the *Disparates*, were either entirely unpublished or were available in extremely limited editions. The same was true of his major works in painting: Pictures that are now household words, such as *The Third of May* and the whole cycle of the Black Paintings, were entirely unknown in Goya's lifetime. Certainly every artist hopes for fame among future generations. But Goya, more than any other artist, made us his true heirs by creating an enormous body of images that he never presented to his own time but kept in reserve for us. It is possible to revere David and to see in him an artist of greater gifts than Goya; but Goya speaks much more clearly in the accents of the modern epoch, whereas David's paintings need exegesis and historical reconstruction.

Equally as fateful as the dissociation between artist and public is the dissociation between the artist and a universally understandable spiritual ideal which gives content and meaning to the artist's work. In earlier centuries, the lowest still life had had automatic significance and was automatically justified as an admissible subject for the artist by portraying objects that came straight from the hands of a benevolent Creator. A simple still life of fruit immediately signaled an obvious meaning to all who looked at it: a meaning translatable into the words abundance, fertility, the goodness of the earth. And beyond this obvious meaning, there usually were other meanings that were quite clear to the artist's contemporaries: Physical nourishment was the concrete symbol of spiritual nourishment, just as physical love was a concrete counterpart of spiritual love, of the love of the created for its Creator. For the more learned segments of the public—that is, for those who had a direct relationship with the artist—the lowly still life had still further level of meanings:

Grapes stood for the wine of the Eucharist, oranges for the sin of luxuria, eggs for purity. No particle of the universe but had ulterior meaning that bound it to the vast drama of salvation.

The universal structure of religious meaning broke down toward the end of the 18th century. The Madonna was removed from the high altar of Notre Dame, and Reason was put in her place. Man-imposed values were substituted for the dogma of revealed religion. The new system of Reason, however, had two defects: It did not guarantee permanence, and it furnished no universally acceptable measure. "By Grace of God" is a far cry from "By Grace of Reason." The former is incontrovertible; the latter changes as circumstances change. As David found to his detriment, it is dangerous to raise monuments because today's hero is tomorrow's traitor. The members of the Assembly who swore the Oath in the Tennis Court—the group portrayed by David—had all been declared criminals against the commonwealth by Robespierre. Authority, rather than coming from on high through the agency of men, now emanated from men only and was therefore always open to revision. Events and objects meant themselves and themselves only, without an ulterior, sacred significance. Moral standards were not based on divine commandments but on civic or social exigencies. At best, a majority decided on what was good and what was wicked. In cultural matters, this majority, however, was hardly ever competent. It was also consistently stingy.

At first this lack of ordained order was replaced by the then reigning spiritual as well as political ideology: Neoclassicism. Roman republicanism became the paragon in styles of dress, form of government, public demonstrations, drama, and art. David, with all the forcefulness of his immense talent, managed to find an equivalence between the civic virtue of a republican and revolutionary government and a dramatically pure style based on the precepts of ancient Roman art. That is to say, he imposed a system of values brought from outside, from a period in history that was considered by him and by his contemporaries an exemplar of social justice and liberty.

Other artists—Flaxman, for instance, or Ingres—derived a new system of esthetic values by detaching their art from the urgent problems of the day. They found a style that detached itself from exterior reality and set up a highly refined, artificial standard. Generation after generation would, from then on, labor to define the meaning of reality. Each generation would also find its own justification for the creation of art. Romanticists, realists, naturalists, all reinterpreted from their peculiar angle of vision the meaning of the world and the meaning of the artist in relation to that world. What once was an automatic predicate of every event and every

object—a meaning beyond its sheer physical presence—now had to be elaborated by highly personal philosophies. The "isms" were born. Contradiction and originality became the touchstones of art. True, Giotto and Michelangelo were different—but they were not contradictory. Raphael and Michelangelo were enemies at the Papal court—but they were not mutually exclusive. They agreed on the fundamentals of religion, of the meaning of life, and of the meaning of art. The same cannot be said of Delacroix and Ingres, Manet and Cabanel, Van Gogh and Meissonier.

Within this violent upheaval, within what Nietzsche called the transmutation of all values, Goya's life and Goya's work held a unique place. Owing partly to his own character, owing perhaps also to his deeply rooted Spanish bias, he was the only artist to absorb the very principle of revolution and anarchy into his art. Where David substituted a new authority (Roman *austeritas* and *virtus*) for an old authority (revealed religion), Goya was willing and able to express revolution in revolutionary terms. Living in a time that he perceived to be basically anarchic, he invented a language that conveyed the very principle of anarchy. Our baffled attitude toward a universe that grows more alien the more scientific data we accrue about its nature was already presaged in the images he created. Each succeeding generation of the 19th and 20th centuries, even though it may have been uninformed about Goya's work, stood in what we regard as a directly understandable relationship to the great Spanish master.

One must insist on Goya as a Spanish master because it is through his work that principles that were always apparent in Spanish art (and militated toward the divergence between Spanish art and the art of the rest of Europe) became European principles. Those readers who have experienced the sober refusal to be consoled and the loneliness of anguished mankind surrounded by an alien universe that speak from the pages of *Don Quixote* will be quick to grasp the same note in much of Goya's work. It ought to be kept in mind that Cervantes's masterpiece, which was familiar to Europe in the 17th and 18th centuries as an amusing tale of man's foibles, was completely misunderstood in its Spanish meaning. Only now, after centuries of neglect, is the story of Spanish art and of Spanish literature being written in fragmentary monographs dealing with Spanish artists. A comprehensive interpretation of the meaning of the Spanish tradition in art lies in the far future, although some attempts have already been made.*

*Notably Oskar Hagen's unjustly ignored book *Patterns and Principles of Spanish Art* (Madison, Wisc., 1943).

Goya's origins are obscure. An accretion of romanticized legend has grown up about his early years which Goya himself never contradicted—not, one suspects, because these legends were founded on fact, but because the legends suited Goya's desire for publicity.

We can be sure only that his early years were financially difficult and that his training in art was haphazard and provincial. His education, however, was somewhat better. For a period he attended the school of the Scolopian Fathers. So memorable was the teaching of these friars and so grateful was Goya for their teaching that he painted his greatest religious painting for them as late as 1819.

In 1763, when he was seventeen years old, he seems to have felt sufficiently well trained in painting to enter a competition held at the Academy of San Fernando in Madrid. He entered similar competitions again in 1766 with the same lack of success. Not until 1770, while he was on an Italian journey, did he finally win some small measure of public recognition. He received six votes and a special mention from the jury of the Academy of Fine Arts in Parma.

Goya's Italian sojourn gives us much material for speculation. We know that, in his application to the competition in Parma, Goya called himself "Romano," so that he must have spent time in Rome, and we have the painting that won first prize in Parma, which in turn gives us some idea of the tastes that governed the jury of 1770, so that we can come to at least some tentative idea of Goya's style at that time.

Borroni's prize-winning entry is characterized by strong light-dark contrasts and a great deal of heroic posturing derived, for the most part, from Roman statuary. The execution has a definite virtuoso cast to it: broad strokes vigorously applied. The classicism of this picture is not to be confused with the neoclassicism of a Mengs or a Vien but is simply a recrudescence of late 17th-century Roman classicism. From some small paintings by Goya which have recently turned up, it becomes fairly obvious that he tried to pattern his own style on the principles that are embodied by the Borroni picture.

More interesting than what Goya painted in Italy is the question of what he may have seen during his trip. It is safe to assume that he was acquainted with Naples. Any Spanish painter coming to Italy would certainly visit that city not only because of the newly discovered antiquities but also because it was politically as well as culturally very closely allied to Spain. Here, more than anywhere else in Italy, Goya could hope to find understanding and help. We can count on the fact that it was in Naples that he became acquainted with the work of such painters as Corrado Giacquinto (whose work he might also have seen in lesser variety at

19

Madrid). Certainly the work that Goya did in Saragossa after returning to Spain is strongly reminiscent of the Neapolitan school of decoration.

In Rome, as has been pointed out by Roberto Longhi, he could easily have been influenced by the drastic realism—drastic for those days, at least—of González Velázquez's paintings in the Church of the Trinity on Via Condotti.* But Rome and Naples, in all probability, were not the only cities Goya visited. Having won honorable mention in Parma, it would have been only sensible to follow up such success with a personal visit in the hope of finding patronage at an academy that had conferred such an honor on him. And once having crossed the Apennines, he certainly would have gone on to Venice, the traditional Mecca for painters. Tiepolo, the brightest star of the Venetian galaxy, was already familiar to Goya from his Madrid days. But perhaps the sly and realistic depictions of social life in Venice painted by Pietro Longhi in Venice also may have been of interest to him. Longhi's way of reducing human activity to the wooden, amusingly awkward attitudes of marionettes certainly found its continuation in the tapestry cartoons that Goya was to paint later on for the royal looms of Madrid. Two other enterprises by Longhi may also have impressed Goya. One was the ceiling decoration in the Palazzo Sagredo which, unlike all other 18th-century ceilings, is characterized by a downward rather than an upward dynamism—a scheme that Goya was later to push to its extreme conclusion in the frescoes of San Antonio de la Florida. The other was the unjustly ignored fresco cycle of the Casa Santa in back of the main altar of San Pantalon. Here, for the first time in 18th-century art, deliberate fragmentation of a composition was attempted. Longhi's efforts in this direction must be understood as part of the 18th-century love for ruins. Still, it may have struck a new, fruitful note in Goya's mind.

Traveling westward, back to Spain, Goya would have had to travel through Lombardy, where an independent though provincial art stood in full blossom. Especially the uncompromisingly realistic art of Giacomo Ceruti must have struck a young Spanish talent as germane with principles that knew of a long development in Spain. Less rigorously realistic and more addicted to the picturesque, but still capable of fascinating a young painter, were the two most important talents that Genoa had brought forth in the 17th and 18th centuries: Bernardo Strozzi and Alessandro Magnasco. From the former, Goya may very well have derived the bold, often strident color combinations of his early tapestry cartoons; from the latter, the interest in virtuoso, abbreviated notation and a love for the

*Roberto Longhi, "Il Goya romano e la cultura di Via Condotti," *Paragone* 5, No. 53 (1954), p. 36.

grotesque and mysterious. There is still hope that the archives of these northern cities hold clues of the whereabouts of Goya during this critical tour through Italy.

In itself, the work that Goya executed once he returned to his native Saragossa is relatively uninteresting. But it does reveal a good deal about Goya's character. He must have known that much of his future reputation would rest on his accomplishments at this first trial. In a canny way that was to characterize all his later commercial dealings, he played a safe rather than audacious game. His style in the frescoes of the Pilar cathedral in Saragossa reveals nothing of a new talent. It is a simple reelaboration of Neapolitan late Baroque church decorations.

With equally canny calculation, Goya married the sister of Francisco Bayeu, a very influential painter who was probably responsible for getting the Pilar commission for his young son-in-law. There is nothing in the life or work of Goya up to this point that distinguishes him from any number of contemporary young artists whose names are utterly and justifiably forgotten today.

2

Tapestry Cartoons

With the exception of a small number of portraits, all of Goya's great works were executed after 1790. Had his career come to an end before that date, we might still enjoy Goya as a spirited illustrator of the Spanish scene toward the close of the 18th century whose skill and vivacity were beyond the reach of his Spanish contemporaries. But we would certainly not have cause to honor him together with Jacques-Louis David as the discoverer of the modern temper in painting.

Nevertheless, Goya's career before 1790 is interesting for what it tells us about the artist's character. We can observe him step by step, building his reputation, making the proper connections, and disciplining himself with great shrewdness in order to consolidate his position. For it is one of the fundamental contradictions of Goya's entire career that the social and political revolutionary in him was counterpoised by the astute business-man, just as the impetuous, iconoclastic painter was often tempered by a native instinct for self-imposed discipline and careful preparation. If the facts of Goya's career are compared to the myths that have been woven about his person, there often results a vague suspicion that he may very well have fostered these legends for the sake of publicity. Certainly there is nothing of the adventurer about his known life. To the end, he remained the canny peasant who invested his money wisely, always covered his political moves by holding a plausible alibi in reserve, and lived the kind of life that would assure him lasting respect among the financially solvent public together with the kind of income that goes with a steadily growing reputation. The tricks, turns, and compromises of Goya's public life are far from being monuments to his integrity, but they brought him the success that was necessary for his full development. Living in dangerous

times torn by revolution and ruthless counterrevolution, Goya managed to keep his place of absolute preeminence despite envious rivals and political factions eager to bring about his downfall.

After he returned to Spain, he took on commissions that were probably of little interest to him but that were calculated to further his career. A still unrecognized talent has to be able to face the realities of his position, and Goya had the strength of character to act with prudence and in accordance with the dictates of circumstance. The ceiling decorations he executed for the church of El Pilar in Saragossa and the set of wall paintings for the Carthusian monastery of Aula Dei near that city represented a kind of visiting card that established his credentials. He carefully avoided sounding a personal note (presuming he had such a note to sound at that stage of his development) and let himself be guided by a safe prescription for success. He leaned heavily on the virtuosity of those Italian painters who were most honored in Spain; that is to say, he tended to imitate Luca Giordano and Corrado Giacquinto rather than Giovanni Battista Tiepolo, whose impressive, inimitable flair had failed to find an adequate response from the Spanish public. These works were conventional and offered little that was new. Here and there one finds a figure (especially in the sketches) that demonstrates a hardier realism, a finer sense of direct observation than that displayed by the other artists working alongside Goya. But it may only be the wisdom of hindsight that makes one single out such figures as the beheaded St. Dionysus as a harbinger of the mutilated bodies we shall encounter nearly half a century later in *The Disasters of War.* What one is willing to ascribe to bold realism in Goya's early painting might very well have been nothing but clumsiness. Certainly no critic has ever accorded Goya's colleagues in Saragossa equal benefit of the doubt. Yet their work, objectively seen, is no better and no worse than young Goya's.

The first commission of true importance that was parceled out to Goya in 1775 was rather incongruously due to the intervention of Anton Raphael Mengs (1728-79), an Austrian painter whose work and ideals were the most complete contradiction of everything that Goya was to express later on. The series of tapestry cartoons that Goya delivered to the looms of the Royal Tapestry Works of Santa Barbara take us out of the backward, provincial atmosphere of Saragossa, and though he tried repeatedly to shake off the burden of this commission, which he considered unsuitable to his talents, we can today turn to these cartoons as the first important works by a master who was beginning to find his own way and who had sufficient courage to declare that his way was no longer the way of the majority.

As the art of the Middle Ages centered around the cathedral, so the art of the 18th century centered around the salon. It was, therefore, an art that was meant to be a supremely tasteful backdrop and accompaniment for the prime function of the salon: conversation and polite, intelligent social intercourse. We today experience the art of the 18th century out of its context and are dazzled by its virtuosity and brilliance. We study it for its own sake and prize it for its exquisite effects. But our 18th-century forebears who sponsored art would find our modern attitude rather perplexing, especially in regard to their decorative arts. To them, the true virtue of their cabinetmakers, silversmiths, porcelain makers, and tapestry weavers resided not in their brilliant improvisation but in their perfect tact and restraint. Not one of the great French masters of the 18th century meant to call attention to himself. The painter, hand in hand with the *ébeniste*, the architect, and the designer of wall paneling, created an elaborate stage setting against which the artifice-bound life of the 18th-century salon was played out as if it were indeed a play—a play with the added piquancy of totally unforeseeable denouements. And it was the play that mattered. The setting was merely meant to enhance it.

Within the limits of such decorative considerations, Goya's tapestry cartoons are an anomaly. They represent not the last stage of a dying art but the deliberate perversion of the dominant attitude toward art and toward society. They are the first presentiment in art that a centuries-old tradition is in dissolution.

When we speak of 18th-century tapestries before Goya, it is almost a matter of indifference whether we mean the cartoons or the finished, woven tapestries. Boucher, Fragonard, and Audran express themselves as completely in woven tapestries which they never touched, as they do in their autograph cartoons. These artists accepted without doubt or question the essentially ornamental function of art, and not one of the great 18th-century artists would understand the pejorative meaning of the phrase "a decorative painter" so often used by critics today. Boucher (as did Raphael before him) accepted the fact that his cartoon was merely a stage in the achievement of a goal. If we today pay higher prices for an autograph cartoon than for the finished tapestry, we merely prove our pedantic, museum-minded approach toward art. Boucher and his contemporaries had too direct a relationship with art to be bothered by considerations of that kind.

With Goya's tapestry cartoons, however, the situation reverses itself quite dramatically: His cartoons are viable, perhaps even great, works of art. The finished tapestries are miserable failures. He was the first artist to

24

face the modern problem of art versus ornament, and his conclusions were also typically modern: He rejected the ornamental.

Goya thought in terms that were antagonistic to tapestry weaving and to the purpose to which tapestries were put. He was incapable of envisioning a work of art as being anything but a highly personal expression that cannot tolerate the kind of interchange between craftsman and artist on which fine tapestry weaving depends. With Goya our faculties are so completely engaged with what the painter is telling us and the manner in which he conveys his themes that there is little margin left for the casual enjoyment of fine textile weaving. Goya's tapestries do not merely represent a revolution that changes the course of decorative art. His tapestry cartoons represent a deathblow to the art of tapestry weaving from which it never recovered. Despite labored attempts to revive the ancient craft (Gromaire, Lurçat, Calder), tapestry today is nothing but a whimsy. It has lost its former position as a major means of visual expression.

To the late Baroque, tapestry was a highly developed instrument in the orchestration of architectural interiors. The technical skill of the major looms was such that, far from falsifying the painter's intention as expressed in his cartoons, the tapestry heightened his effects by translating them into precious material. There was no essential differentiation between painting and tapestry, because both variants of the pictorial arts were ultimately to be fitted into an architectural setting, framed by wall paneling, stucco cornices, and parquetry floors and set off by equally fastidious pieces of furniture. It was the harmony of the entire scheme that made of 18th-century interiors such a sensitive and high expression of Western civilization. Every object in such an interior was basically a sociable, polite element. It did not draw attention to itself even though it was always so perfectly fashioned as to bear the most attentive scrutiny. Its true nature was revealed not by examining it in isolation but by understanding it in its compositional context. In its turn, architecture never insisted on its rigid structural nature but became pliant. Ceilings were no longer set off from walls but blended imperceptibly with them. Along the walls, architecture opened up to make room for painted or woven decorations. Of special importance in this constant interplay between the arts was the construction of the frame, and the frame became in itself a work of art during the 18th century. To fulfill its function the frame had to work in two directions simultaneously: It had to separate, and it had to bind. It had to indicate the line along which painting and architecture met; it had to give to each of these two arts its full

individuality while simultaneously bringing painting and architecture to a single accord. Generally speaking, the 18th century resolved the problem by bringing the painterly element of architecture to the fore. Polychrome paneling was symptomatic. Paneling *was* architecture. But it was architecture freed from structural necessity. It did not need to respect the right angle; it could twist and curve and assume any shape. It could be carved and colored till it lost all its density. It could be interspersed with large mirrors and other decorations. Paneling met the demands of tapestry and painting halfway.

In their turn, tapestry and painting were enabled to make equal concessions to architecture. Paintings were now composed in such a masterfully authoritative way that they could fit themselves into the most difficult, irregular surfaces, and the sinuous, garlanded compositions *in* the pictures merged gradually into the elaborate, flowing frames in order to become reconciled to the architecture. Frames began to function like hinges, fixed points that allowed the two members they held together a maximum liberty of coordinated movement. Tapestry was by far the most consequential and widely preferred pictorial decoration in the 18th century because, in tapestry, the frame was an integral part of the picture, each tapestry having its own woven border. This border gave the artist an opportunity to "fade" from the picture to architecture with an ease that oil painting rarely afforded. Painting (and to the 18th century all painting was perspectival and possessed depth) gave one of the illusion of distance, of a hole being cut into the wall. At the edges of the painting there was bound to be a collision between illusion and palpable reality: The painting gave the illusion of reality; the carved frame around it *was* reality. In tapestry, the distinction between illusion and reality could be mitigated to the point of disappearing altogether. The figural composition at the center of the tapestry could be elaborated with all the depth-producing devices of perspective and modeling. The border surrounding this composition could pick up modeling in its garlands and tendrils and yet return to the surface of the fabric, since these garlands framing the figural compositions had no definite location in depth but existed on the surface. Usually, an inside border of a vegetal nature gave way at the outer edges of the tapestry to a more rigidly architectural border which completed the return toward the surface and blended easily and without shock with the thin, ornamental carvings of the wall paneling that held and enframed the tapestry. The transition from paneled wall to tapestry border to picture was an extremely subtle one because the tapestry border really existed in almost the same dimension as the actual wall on which the tapestry was hung but translated the physically graspable flatness of the wall into an

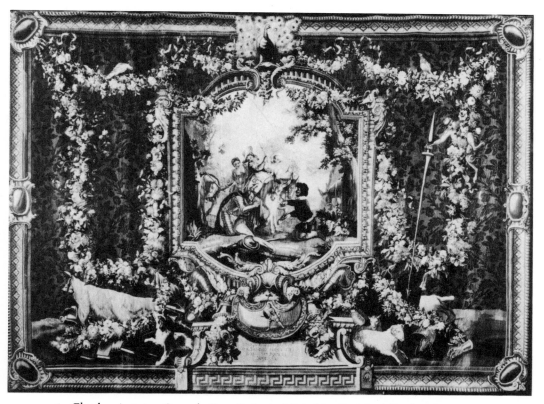

1. Charles-Antoine Coypel, *Don Quixote Misled by Sancho Mistakes Peasant Girl for His Dulcinea.* Cartoon for tapestry made by Gobelins. Philadelphia Museum of Art.

illusory dimension from which the jump into the pictorial world at the center of the tapestry was no longer abrupt but a logical and gently persuasive sequence. A perfect symbiotic system had been established by the arts.

As for the pictures contained in the tapestries, they were of a fairly neutral nature, illustrating Ovidian mythologies, *res gestae* of ancient or more recent history, and idyllic or pastoral poetry. There was much wit, supreme tastefulness, and great tact in all these compositions, but there was little moral or intellectual challenge. There was a distinct and deliberate lack of personal convictions, personal interpretations, or personal experience. Even when such intrinsically tragic stories as *Don Quixote* [1] were represented, they were interpreted as invitations to amusement. The artist did not insist on displaying his own vision of nature, or his own speculations and worries about the meaning of existence. In subject matter and in form, 18th-century tapestries never arrested the eye. That would

27

have been a breach of taste vis-à-vis the other arts. Entering a salon or an antechamber, the eye was free to glide from pleasure to pleasure. No single object tried to outshout the others in the polite conversation of the arts.

In all of these aspects, Goya's tapestries represented a distinct, conscious antithesis. Whether we choose our examples from the first or from any of the later sets of tapestry cartoons, we are brought back over and over again to the realization that Goya did not extend a venerable tradition by making it his own. On the contrary, by making the tradition his own, he destroyed it.

Whenever Goya and tradition encountered each other antagonistically, it was always tradition that was routed. Goya—and in this he was again prophetic of future generations of artists—was either incapable of harmonizing the new with the old or unwilling to do so. Whenever he was forced to do so, the result was a lamentable work which can scarcely be accorded the name of art. Giotto, Titian, Giorgione, Rembrandt, Rubens, Michelangelo were able to bring to art new values, directions, and experiences without in the least attacking or belittling old traditions. They

2. Goya, *The Parasol* (*El quitasol*). Prado, Madrid.

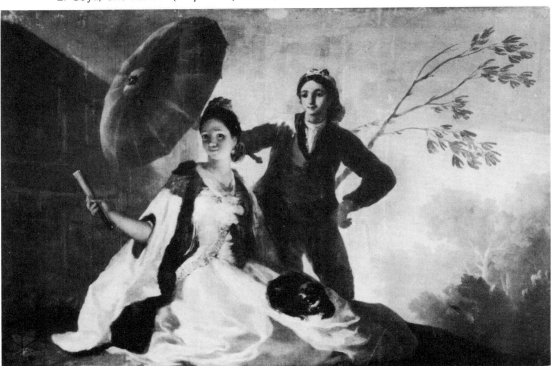

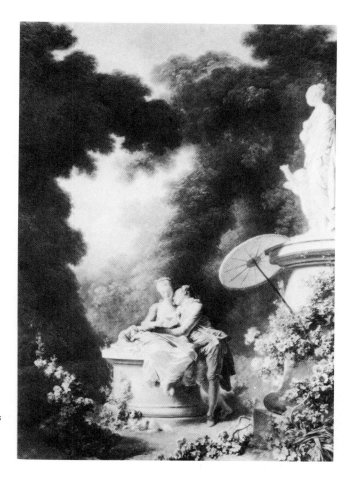

3. Jean-Honoré Fragonard, *Love Letters* (*Les Billets Doux*). The Frick Collection, New York.

could find an equilibrium between the two. Goya, when faced with similar situations, found neither reconciliation nor harmonic balance between two contending forces; he produced instead a rather sheepish compromise that was unworthy of his talent.

Of all Goya's cartoons, *The Parasol* (*El quitasol*) [2] seems the most representative of conventional tapestry design. In subject all requirements are met: the rustic rendezvous of a pretty girl and her cavalier who patiently holds his lady love's parasol to shield her from the sun. This triad of forms—girl, boy, and parasol—set into a landscape appears in any number of 18th-century paintings. Its most poetic incarnation is due to Fragonard, whose *Love Letters* (*Les Billets Doux*) [3] represents the same basic theme, except that the shading parasol is held by an obliging tree and the couple, instead of smiling at some amusing incident, are reading over the love letters of their courtship days.

29

The Fragonard is not a tapestry cartoon. But how easily it could be translated into a textile hanging! A delicate distance is established between us and the totally self-absorbed figures. The park, the lighting, the attitudes and emotions of the couple all belong to a mellow world that is far from the realities among which we move and live. Even though the theme is one of mundane gallantry, it nevertheless assumes the significance of an allegory; it translates irrelevant episodes into an idiom of eternally recurring and universally significant experience. Fragonard's lovers partake of timelessness. They are the distillate of all the lovers who ever lived. The realities they incorporate are recognizable as realities, but they never descend to specifics. The narrow descriptions of costume or facial features are not nearly so important as the harmonic shapes and lines that give resonance to the emotions of the figures. The manner in which the trees are coupled and each element of floral ornament is absorbed into the overall composition, the way the parasol sprouts out of a tree with the grace of all things that grow naturally under benevolent conditions—all this conspires to make the world in which Fragonard's figures exist a magic place where all is measure and accord. We are shown a world in which our quotidian, cynical standards are suspended. Even the grimmest Calvinist is not going to worry about the degree of carnality involved in the solicitous tenderness of boy and girl. Everything in the Fragonard exists far from us, in an enchanted world much like the enchanted world of the theater in which the proscenium arch sets definite limits between the realities of the audience and the realities of the actors on stage. Fragonard's figures require a similar proscenium arch—a frame that sets them off from us—and in the framework of the wall paneling into which they are set, they receive the necessary distancing from the world of mortal realities. If one were to use the painting as a tapestry, one could put a wide ornamental border around the parkland scene without in the least damaging the integrity or the meaning of the painting.

Goya's *The Parasol* creates quite a different impression. The impudence and audacity of the picture is not just something that pertains to the witty girl and her lover. It derives from Goya's irreverent, unconventional attitude. These figures will not stay beyond a border or a frame. They are not absorbed in a world that is essentially different from ours; they are aware of being stared at and stare back in a brusque encounter with the real world. We are not discreetly allowed to witness the scene. Instead, the situation is thrust upon us so that, far from being distant witnesses, we become direct participants. Even the coquettish smile of Goya's girl has an impertinence that can make us slightly uncomfortable. For all we know, we may be the cause of her mischievous laughter.

Formally, too, *The Parasol* is of an entirely different nature from comparable 18th-century idylls. Here are the beginnings of a steadily increasing will to do away with traditional figural composition. Goya has disturbed the relationship between figures and setting—a relationship that in the Fragonard was still logically coherent and harmonic. The very ground on which the figures in Goya's painting stand and kneel is so ambiguous that we don't have a solid footing. We cannot discover the peculiar accidents of terrain that separate the girl from her cavalier. Is she sitting on the thin edge of a very sharp mountain ridge? And what of the cavalier? His size is seriously diminished, as if he were standing in the distance, yet since he holds the girl's parasol over her head, he must be very close to her indeed. And is the cavalier standing on a sharply descending incline behind her? Certainly that is the only conclusion one can come to—but if the hill on which the pair sits falls abruptly behind them, then the wall to their right makes no sense at all, since it cannot possibly find any support at its foundations. Either the cavalier or the wall has to stand on sheer air. And what is one to make of the wall? It is not an architectural background, it belongs to no visible structure, and its perspective is so forced that by its rapid flight it contradicts the surface character of the tapestry. One cannot imagine any garlanded border fitting around this composition.

Perhaps the most revealing element lies in the placement of the parasol that gives the picture its name. Whereas Fragonard manages to weave this still life detail into his composition as if it were a blossom sprouting from the tree, Goya thrusts it into his composition at a slightly awkward angle that underlines the stiff, angular gesture of the girl. The compositional elements are no longer as fluently continuous as they were in Fragonard. There is a slightly forced impression. The traces of the artist's intervention are left standing much more visibly than in the Fragonard. *Love Letters* inspires in us the notion that the entire image appeared as an organic whole to Fragonard's imagination, whereas *The Parasol* leaves us with the idea of an artist pulling together disparate fragments into a composition that will "stick."

Goya's art was already individual at this early stage of his development, and his use of color merits our attention. Superficially, his palette and brushwork were still very close to the conventions established by Giacquinto and the other great decorative masters of the Italian 18th century. He retained their impasto and their generosity of pigment applied in large strokes. The intensity of Goya's colors and their opaque, saturated effect were entirely his own—an effect deriving from a very personal avoidance of atmospheric perspective and atmospheric description. Just as his figures

were moved very close to the viewer instead of being presented at a poetic distance, so they possessed an immediacy and a rawness that distinguished them from the centuries-old tradition of mellowed color seen through veils of atmosphere. Giovanni Bellini and Giorgione, who first discovered this procedure, were in many ways the most important founders of subsequent schools of painting, but especially of the 18th-century sensibility to color. From the Venetian 16th century on, the air surrounding color was used as a medium that diffused, enriched, and ennobled local colors. With Goya this veil of scintillating, warm air disappeared, and color began to stand out with a sharp nakedness typical of modern attitudes toward color and pigment. Perhaps it was in the realm of color that Goya and his greatest contemporary colleague, Jacques-Louis David, drew most closely together. David in his strongest works also dispensed with the flattering atmospheric use of color. He, too, set down sharply separated colors without any concession to the venerable Venetian tradition. But David, unlike Goya, applied his colors in smooth surfaces, foregoing any display of virtuoso brushwork as a logical concomitant of his sacrifice of atmospheric softness. Goya, on the other hand, compromised. He dispensed with Baroque atmospheric effects but still indulged his taste for bravura sketchiness. The result was a not altogether satisfying hybrid between anti-Baroque austerity in the hard-on-hard color areas and opulent brush calligraphy.

If *The Parasol*, despite its strongly accentuated traditional elements, deviated so markedly from 18th-century standards, what is one to say of a choice of subject matter that ran counter to all convention and that even today strikes us as daringly revolutionary? Keeping in mind that these cartoons were meant for the production of tapestries destined to decorate a suite of rooms in a pleasure palace, what is one to make of such scenes of black misery as *The Injured Mason* [8] or *The Snowstorm* [12], or the dreary vacuity of *Blind Man's Buff* [4]?

The dislocations and subversions of tradition observable in *The Parasol* are carried even further in *Blind Man's Buff* (*La galina ciega*) [4]. The *fête champêtre* theme invented in Venice and carried beyond the Alps by Rubens is now transmuted into a parody of its former self. A theme of innocent but highly civilized amusement is here altered from its normal meaning and put on the path that will ultimately lead to Manet's *Déjeuner sur l'herbe*. In earlier versions of the theme, there was an essential innocence despite the sophisticated artificiality. The grace of Watteau's *fêtes galantes* still echoed the fundamentally religious note that is at the heart of all great pastorals: Nature is the benign shelter for man and inspires his purest emotions. True, some of the finest Rococo pastorals already implied a nostalgia for a state of former innocence. But that

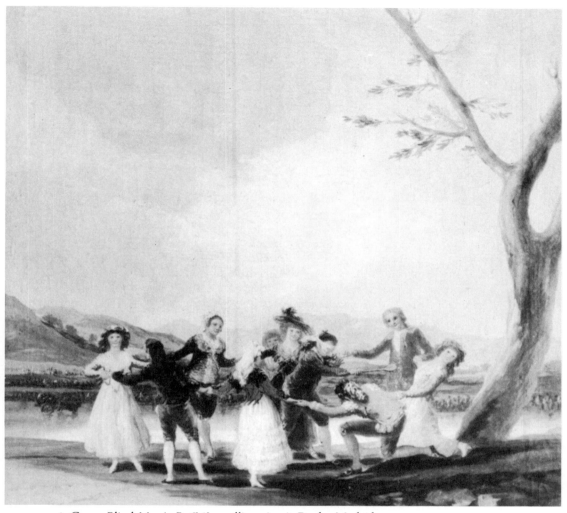

4. Goya, *Blind Man's Buff* (*La gallina ciega*). Prado, Madrid.

aspiration was in itself something noble. If the figures acted like shepherds
and shepherdesses without *being* shepherds and shepherdesses, their belief
in the values of pastoral life no more needed to be called in question than
that of actors who pretended to be the heroes and heroines of ancient
Greece. The play to which they devoted themselves and the values
represented by the play remained intact even if the actors themselves
could not find it in them to rise to the same heights in their private lives.
It was in this spirit that Marie Antoinette played the dairy maid and that
Fragonard's sociable figures disported themselves in magnificent park

33

landscapes. In a beautiful and benevolent natural setting, they behaved as one should behave; they danced, drank, and disported themselves with great freedom and enjoyed nature's gifts with a wholeheartedness that was totally enviable and quite unknown to later centuries. There was a natural grace about the grouping of figures that seemed an extension of their floral setting. Pleasure seemed to be the God-given attribute of mankind. Delight and virtue went easily hand in hand.

Goya's ladies and gentlemen, on the contrary, assume the posture of marionettes. Their gestures are stiff and angular, their faces smirk with an unnatural grimace, and any loveliness and grace residing in the picture belong entirely to the costumes. The playful theme is no longer childlike, but has become childish. There is a general air of boredom and false laughter that gives to the figures an odd, masked quality. One begins to wonder why these people behave so foolishly when they are not even honestly enjoying themselves. Frivolity, once justified by frank pleasure, has lost even this last justification and has become meaningless. This disturbing effect, arising partially out of the discrepancy between intention and actuality, is made more striking still by the discrepancy between figures and background. For these jerky figures with their staccato movements no longer play *in* the landscape but in front of it. The continuity between figure and environment has been shattered. A summarily painted, uninteresting, flat backdrop has been lowered behind the figures almost in the manner of a flimsy stage flat. Neither trees nor ground nor bushes seem to have any substance, and what is true of the backdrop is also true of the figures. The 18th century was generally very sparing with plastic modeling and preferred the light touch when it came to describing the volume of bodies. But even the most abbreviated of Guardi's figures have a more convincing substance than the flat cut-out figures Goya painted for this tapestry. This humorous speculation on the difference between doll-like people and peoplelike manikins is brought to its most explicit expression in *The Straw Manikin* (*El pelele*) [5], in which a stuffed and limp manikin tossed in a blanket has more convincing substance, and a more expressive gesture (expressive, that is, of being a manikin tossed in the air) than the women who are playing with it. In short, Goya has observed contemporary amusements, compared them to past representations of these amusements, and now passes judgment on them by means of parody. The boredom, the vapidity of playfulness that has degenerated into empty whimsicality begin to find expression in the tapestry cartoons.

A tapestry cartoon painted in Naples [6] at the time of Goya's Italian sojourn furnishes us with an interesting comparison, especially since the theme of the Neapolitan cartoon is taken from Spanish literature. It

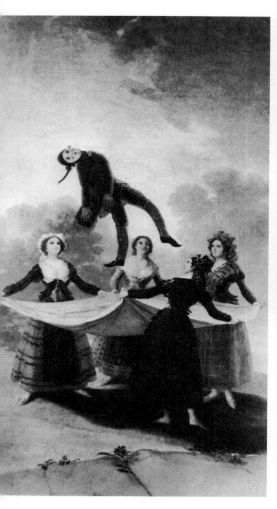

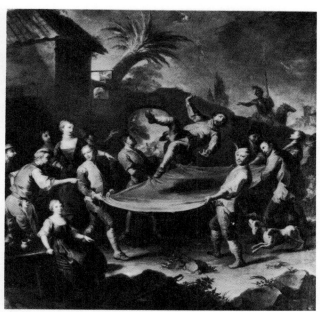

6. Giovanni Battista Rossi, *Sancho Panza Tossed in a Blanket* (*Episodio di Don Chisciotte*). Royal Palace, Naples.

5. Goya, *The Straw Manikin* (*El pelele*). Prado, Madrid.

represents Sancho Panza being tossed in a blanket, a theme that corresponds in every detail with *The Straw Manikin*. But the energy of the Italian cartoon and its forthright and illustrative use of the material have no parallel in Goya. The spontaneity, interest, and excitement have gone out of Goya's representation of the game. Goya's ladies seem awkwardly self-conscious as they play with their giant puppet. For all the grace of their costumes, their gestures are wooden and constrained. Vacuity begins to intrude upon the 18th-century paradise.

More acerb than the rather humorous parodies of *Blind Man's Buff* and *The Straw Manikin* is *The Wedding (La boda)* [7], which comes quite close to the irate castigations of cruel social customs that were to charac-

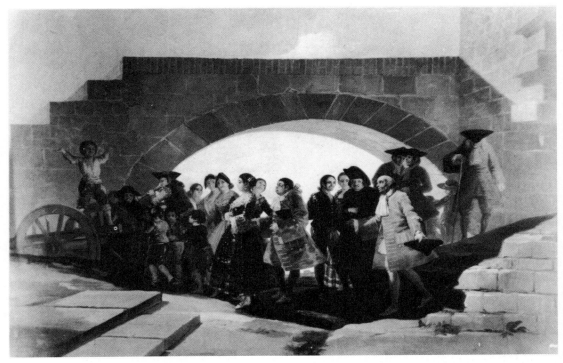

7. Goya, *The Wedding* (*La boda*). Prado, Madrid.

terize Goya's *Caprichos* almost a decade later. A hideously ugly, pompous man leads a pretty young girl to the altar. Presumably he is either rich or well connected, and the bride is being forced into a tragic marriage. Street urchins jeer at the ill-matched pair, and fatuous relatives bring up the rear. Hardly a subject fit for the casual decoration of a palatial salon.

The Wedding might still be explained as suitably decorative in theme on grounds of its picturesque, folkloristic content. But later tapestries lost even this connection with the history and the natural function of tapestries as items of decoration. It was in these more ambitious works that Goya resolutely left behind the strictures and taste of his own period in order to find a mode of expression more completely attuned to his personal demands.

For *The Injured Mason* (*El albañil herido*) [8] we have a preparatory sketch, which clearly shows us the growing maturity and rebelliousness of the artist.* In the sketch, entitled *The Drunken Mason* (*El albañil*

* Folke Nordström, *Goya, Saturn and Melancholy* (Figura Nova Series 3) (Stockholm, 1962), p. 55.

36

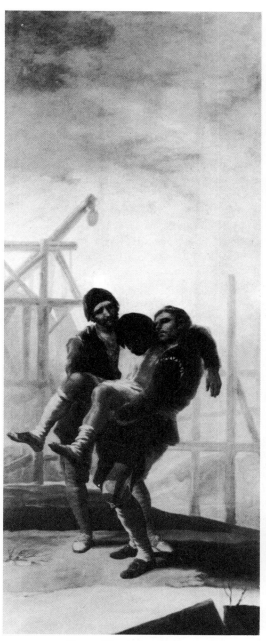

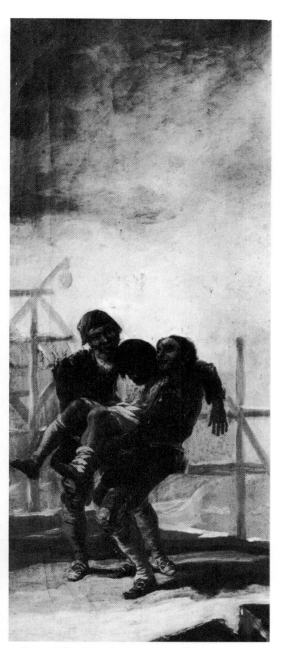

8. Goya, *The Injured Mason* (*El albañil herido*). Prado, Madrid.

9. Goya, *The Drunken Mason* (*El albañil borracho*). Prado, Madrid.

borracho) [9], Goya began with a proletarian theme but conceived of it in the acceptable fashion as an amusingly picturesque subject. Workers, being what they are, frequently get drunk and then have to be taken home by their jovial companions. The sketch, for all its gray tonality (and grays are obviously the sworn enemies of tapestry), provides at least in subject matter a suitable cartoon for tapestry work. The finished panel, however, transforms the theme even though it keeps the composition of the sketch intact. It is possible that after finishing the sketch and beginning to work on the final cartoon, Goya suddenly realized it was out of tune with the serious purposes that he was beginning to set for himself both as an artist and as a man. And by the simple expedient of changing facial expressions, he discovered the tragic implications of the genre scene. Even in the amusing sketch, *The Drunken Mason*, Goya must have been subconsciously aware of the pathos of the mason's life because the color of the sketch and the meager, harsh background are hardly consonant with the boisterous subject of a funny drunkard and his companions. But in the sketch, consciously or not, Goya has suppressed his true impulses and intuitions, covering them up with conventional attitudes. Only in the final version did he disdain to continue the travesty, and stepped forth as an artist at variance with dominant traditions and acceptable standards of taste. With stringent discipline, Goya confronted a novel theme and became the founder of an entirely new school of artistic thought which would find its future protagonists in such figures as Courbet, Daumier, and the social realists of our own century. He discovered that art need not concentrate on the heroic, that it can present the pathos of anonymous men and women whose lives are exemplary only insofar as they are shared by an immense mass of deprived and suffering humanity. Toward the end of his life, after many years of disillusionment and desperation, Goya returned to this theme and created a new—and unfortunately isolated—idiom that bestowed the sanctity and dignity of expression formerly reserved for antique heroes on the figures of workers and journeymen.

It is interesting to compare Goya's painting with two paintings of a similar subject, Hubert Robert's *The Accident* [10] and Tiepolo's *Falling Mason Rescued by an Angel (Il muratore cadente salvato dal angelo)* [11]. In Robert's picture the tragic accident befalling the mason is almost unnoticeable. The tiny figure toppling from the central monument seems to be as far removed from us in space as the monument is in time. Even after we have discovered the infinitesimal figure falling through the air, we are not overly concerned with his pathetic fate. He is obviously incidental. He is a grace note, an ephemeral event of irrelevant proportions which has no significance by itself but only serves to give added point to

the weighty, venerable monument that remains unmoved no matter what may happen to the tiny human creatures who agitate themselves in its vicinity. The theme is grand and abstract in its poetic effects, and unlike *The Injured Mason*, without particularization. In *The Injured Mason*, on the other hand, Goya is unconcerned with lessons to be learned from venerable monuments or with nostalgic generalizations about the nature of man's fate when compared to the grandeur of past civilizations. Goya gives us the biography of a specific event. Robert's subject is simply an accident—any accident. Goya's *Injured Mason* is a singular case which is not to be confused with any other. This is the first example in Goya's work of a reportorial element that will become an ever more important component of his style.

Tiepolo, in his *Falling Mason Rescued by an Angel*, is more serious about the question of the ultimate meaning of what we call accidents. He

10. Hubert Robert, *The Accident* (*L'Accident*). Musée Cognaq-Jay, Paris. Photographie Bulloz, Paris.

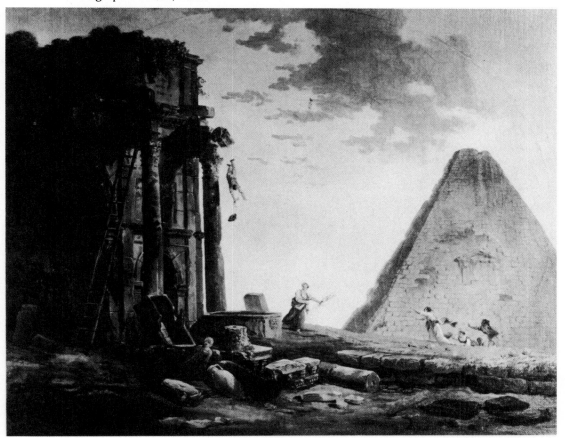

seizes on the figure of the falling mason with an eye toward the dynamic monumentality of the human figure. The inherited tradition of Italian figure painting from Masaccio to Michelangelo and Tintoretto is a very lively and conscious presence in all of Tiepolo's paintings, and even a humble mason hurtling to his death retains all the decorum and high pathos of the most transcendent of Michelangelo's heroes. In fact, though we are told of his lowly profession, we are also told that angels consider him worthy of miraculous intercession. The miracle is given added intensity because it occurs in honor of the humble.

The last shall be first. Here again, the decisive sobriety and tragic nature of Goya's vision make themselves felt in contrast. Goya's mason is not one to attract the solicitude of angels. His humility is not a badge of honor, and Christ's Sermon on the Mount was not addressed to him. For such laborers as Goya presents to us, "The last shall be first" is simply not applicable. If we wish to find a gospel consonant with Goya's total lack of transcendental sentiment as he views the victim of a working accident, we must look forward to Marx and not backward to Christ. That an angel should appear in Tiepolo's vision and be perfectly plausible visually as well as ethically needs no demonstration. But what kind of angel would be congruent with the secularized, dreary, ungainly figure of the injured mason in Goya's presentation? Tiepolo retained the unquestioned faith that allowed him to see the human element (pity) in angels and the angelic element (theological grace) in men. When the two meet, as they do quite often in Tiepolo's paintings, there is no rupture. In Goya, the meeting between the supranatural and the natural worlds either never occurs or occurs with such mawkishness that we are immediately alerted

11. Giovanni Battista Tiepolo, *Falling Mason Rescued by an Angel* (*Il muratore cadente salvato dal angelo*). Scuola del Carmin, Venice. Photograph: Osvaldo Böhm, Venice.

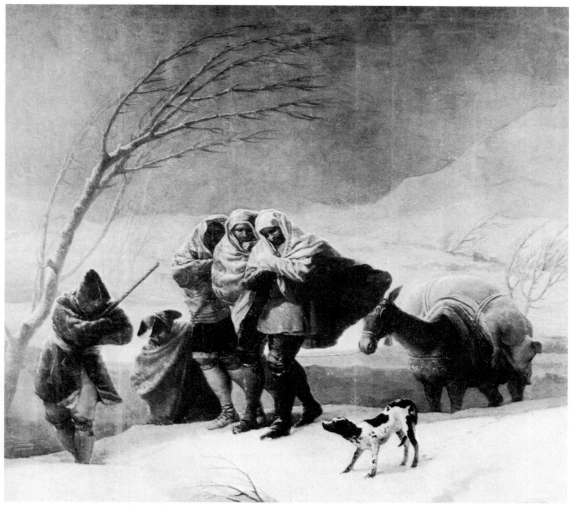

12. Goya, *The Snowstorm* (*La nevada*). Prado, Madrid.

to Goya's self-ironies. We shall see instances of this when we come to the official allegories of his later career.

The Snowstorm (*La nevada*) [12] offers an example of still other tendencies found in the tapestry cartoons that became fortified and dominant in Goya's later work. The subject itself was certainly not new, just as the subjects of the tapestries already discussed were not new. Allegories of the seasons were among the most standard subjects for suites of tapestry. In painting, Poussin, Rubens, Brueghel all represented the effects or the activities of the four seasons with the widest latitude of

interpretation. Certainly Brueghel's *Hunters in the Snow* [13] and Boucher's *Winter* [14] are poles apart. Yet it would be wrong to describe Brueghel's painting as the more realistic. The delights of a sleigh ride in the company of a gallant friend are as much a part of Boucher's reality as peasants, urchins, and hunters are a part of Brueghel's world. And though their conceptions of winter are drastically different, they do have one vital point in common: They represent the world as being resonant to and receptive of human sentiment. With widely differing degrees of intensity and depth of feeling, Brueghel and Boucher fully express the compatibility between man and his God-given environment. Winter may be harsh, but it is not alien. Even when nature is bleakest, it reveals itself as intrinsically admirable and lovely. The crisp atmosphere of the Brueghel landscape, its restrained and very poetic sentiment of homecoming expressed in the hunters, the lonely exaltation of the soaring blackbird, the companionship afforded by blazing fires, and all the humors of the children playing on the ice are the most endearing and immediately comprehensible symbols of Brueghel's presentation. And there are more subtle intimations of the continuity that exists among all participants in Creation. The row of trees, for instance, which gives a touch of companionship to the straggling hunters, the wonderfully balanced cross-directions of the spaces that penetrate into the depth of the picture, the beautiful relationship between tiny detail and overall structure—all these elements conjure up a world where everything has its place, its meaning, and its measure of inalienable beauty.

Boucher's *Winter* is neither so heroic nor so profound as Brueghel's. Still, Boucher, too, sees and feels in terms of the harmony he assumes behind all appearances. The wonderful rhyming scheme between the outline of the sleigh's runners, the curvatures of the lower frame, and the forward-bending of the man's back which results in the charming little woman in the center being embedded in a soft hammock of interwoven curves, is in itself proof of Boucher's vision of winter as a season made for pleasure. Even the lowering skies of the background are not really menacing but are a kind of compliment and complement to the warm rose tints of the lady's face and bosom.

Goya's *Snowstorm* is a detached meteorological phenomenon that is hostile or, worse still, indifferent to mankind. There are no comforting, gentle rhythms that bind man and nature, there is no consoling assurance about the beauty of the cold season. Instead of returning to their welcoming homes and friends, Goya's peasants march off we know not where. There is no presentiment of the comforts of homecoming. Gray, undifferentiated, and barren, the snow landscape stretches disconsolately

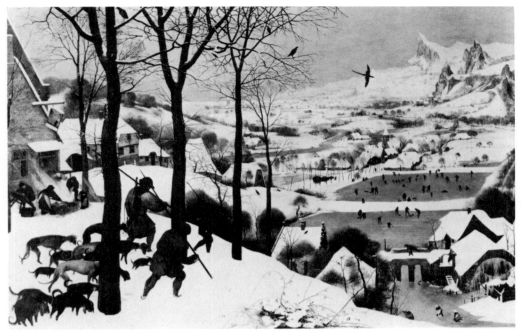

13. Pieter Brueghel, *Hunters in the Snow*. Kunsthistorisches Museum, Vienna.

14. François Boucher, *Winter (L'Hiver)*. The Frick Collection, New York.

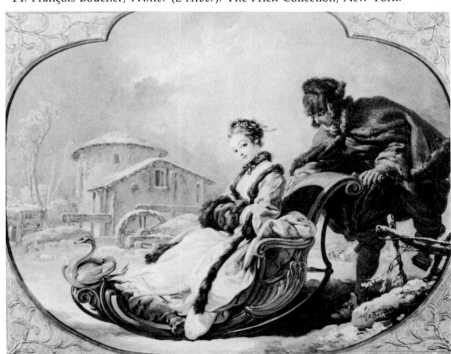

behind the figures, and even compositionally seems to be out of tune with the figures. In fact, it is seen in a disparate perspective, rising and falling in rhythms that are out of step with the advancing men. The figures present another novelty of effect. Huddled together under a blanket, they form an erratic, disturbing silhouette in which their human, individualized forms are ruthlessly suppressed.

Through the centuries, the rendering of drapery has undergone innumerable stylistic transformations yet has always retained its function of expressing the form of the figure. In the monumental sails of drapery that envelop God the Father in Michelangelo's Sistine ceiling or in the transparent silks of Tiepolo's choreographic angels, the drapery expresses the motion, the speed, the scale, and the form of the body underneath. The blanket that Goya spreads over his peasants, however, makes a sharp, arresting pattern that is totally at variance with the hidden figures. The effect of the group is not that of several figures swathed in drapery but rather that of a multilegged crustacean. The bodily presence of figures, their dignified freedom of movement in space, their individual motion expressive of a harmonious body rhythm have been suppressed by the realistically observed blanket frozen stiff.

Just as surprising as the disconsolate emptiness of the scene is the palette used by Goya for this cartoon. The blues, greens, and vivid yellows of traditional 18th-century tapestries have faded, leaving only an ashen gray in their wake. As for pink, the favorite color of the century, it still exists in Goya's painting. But it is only a mockery of its former self as it colors the repulsive detail of the slaughtered carcass of a pig slung over the saddle of one of the mules.

It would be unjustifiable, however, to state that all of Goya's tapestries are equally revolutionary. Such cartoons as *The Flower Vendors (Las floreras)*, the *Vintagers*, and the many smaller panels representing boys at play are far more traditional in attitude. Especially *The Flower Vendors* [15] manages to recapture an innocence and a genuine sprightliness that make it one of the finest products of the times. Its delicacy of color, its crisp, highly personal brushwork indicate dramatically what enormous sacrifices Goya made in *The Injured Mason* and *The Snowstorm*. What man would not prefer to execute works such as *The Flower Vendors*? What musician would not prefer to sing hymns rather than dirges? But for Goya, the future lay with such paintings as *The Snowstorm* and *The Injured Mason*. All of his subsequent attempts at recapturing the youth and loveliness of *The Flower Vendors* were stillborn failures because they stemmed from a part of his personality that atrophied after he became aware of a higher destiny to fulfill. Few artists have ever been so

intransigently severe with themselves. Few artists have sacrificed so much in order to do justice to their inner response to outer reality. From the 1790s on, Goya systematically cut off any possible retreat into the charm and sweetness of the 18th century and determined to rise to the exigencies of a new and changed world. Like his contemporary Talleyrand, he remembered the *douceur de vivre* that preceded the storming of the Bastille. And like Talleyrand, he knew that never again would this *douceur* return.

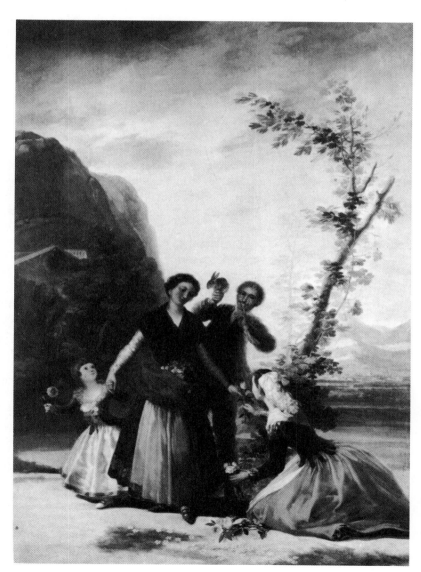

15. Goya, *The Flower Vendors* (*Las floreras*). Prado, Madrid.

3

Religious Paintings

Like the tapestry cartoons, Goya's religious works were all painted on commission, and it is very likely that if such commissions had not been forthcoming, Goya would never have produced any sacred works. And just as Goya's cartoons marked the end of a venerable tradition, so his liturgical paintings demonstrated the ambiguous and well-nigh impossible survival of what had been the dominant genre of art ever since the fall of the Roman Empire. Of all the many paintings with religious subject matter that were painted during the 19th and 20th centuries, not one can lay claim to being an *opus sacra*. Even the finest—Delacroix's *Lamentation* or Puvis de Chavannes's *Legend of St. Genevieve*—moving though they be as works of art or as personal expressions of faith, never had the force to function in the manner of altarpieces—to function, that is, as cynosures of communal worship. The most routine, the most insipid of Rococo altarpieces retained the power to be incorporated unobtrusively and organically into the religious life of the community. Even in those works in which the piety expressed was conventional and without any personal conviction, the traditions of worship and belief were still strong enough to lend them a sound religious dignity that made them viable and integral focal points of liturgy or religious meditation. In Goya's time, this tradition was disrupted, and the most respected branch of Western painting came to a decisive end.

If we speak of Goya as an independent master and not as a gifted purveyor of foreign styles, which is what he still was when he painted the frescoes at Saragossa, the earliest of Goya's important religious works is the monumental *Christ on the Cross* [16], which he painted in 1780 in order to be received into the Academy of San Fernando, the most prestigious association of artists and connoisseurs in Spain.

Technically, *Christ on the Cross* is one of the most finished and

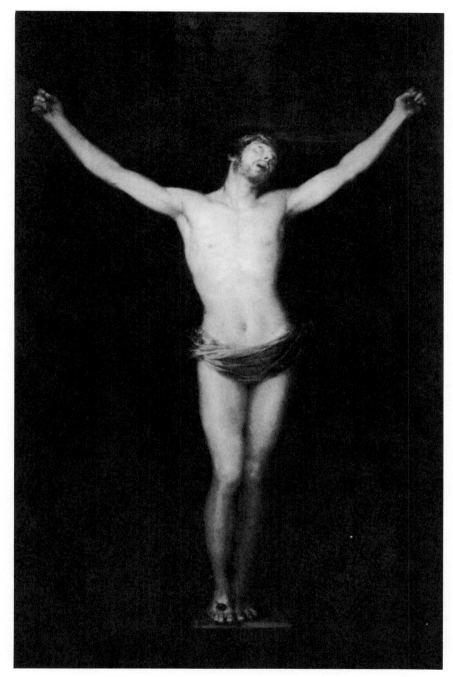

16. Goya, *Christ on the Cross* (*Cristo crucificado*). Prado, Madrid.

fastidious works we have by Goya's hand. The execution is smooth and flawless, the drawing precise; and Goya's command over anatomy never again rose to such unexpectedly high academic standards. If these were the painting's only qualities one would be justified in passing over it in silence, as most of Goya's biographers and critics have done.

But actually, Goya's *Christ on the Cross* is a fascinating clue toward understanding his methods and attitudes when dealing with officialdom during the early years of his gradually increasing fame. More than any other of his paintings, it shows how shrewd and calculating he could be when laying the foundations of his career. With cunning insight, Goya analyzed the prevalent situation and produced a work that combined all the desired ingredients in the proper dosages.

First there is the obeisance made in the direction of Spanish tradition incorporated in the greatest of all Spanish interpretations of the crucified Christ, Velázquez's *Christ of San Placido*. In both cases, Christ is seen against a uniformly dark background, unaccompanied, and very close to the viewer; the point of view selected makes the knees of Christ appear at our eye level; painful details such as the nails, the wound in Christ's side, and the humble, rough planks of the cross are scrupulously rendered.

But then, having imitated Velázquez with the greatest sobriety, Goya suddenly appears to lose the whole point of Velázquez's solemn realism and veers off into a style that is totally at odds with the earlier master's intentions: He suddenly has recourse to the pathos and theatrical elegance of Guido Reni. The shimmering moisture of Christ's eyes, the oratorical glance upward, the sinuous muscularity of thorax and arms, all of these are taken straight from the armory of the Bolognese master who was still ardently admired in the 18th century and whose work continued to command the allegiance of the religious establishment in the 19th century. Finally, Goya's picture is a perfect mirror of the indecisiveness and the willingness to compromise that marked all the output and all the demands and ideals of Spanish officialdom in the arts. They wanted to make the best of all worlds, and Goya shows them how. That his painting is definitely inferior to both the Velázquez and the Reni prototypes, because it compromises the honest though difficult ideals of both masters, didn't seem to occur to any of Goya's peers. We can be fairly sure, though, that it did occur to Goya, who took up the theme of Christ at other stages of his life but never again in the opportunistic vein of his *Christ on the Cross*. Over and over again, Goya played a sardonic joke with hallowed themes or hallowed conventions. Once having made his point, though, he never repeated the joke but went on to draw serious and sometimes even grim conclusions from what started out as an ironic prank.

It is extremely difficult to draw conclusions about Goya's personal attitude toward religion from the study of his religious works. To say that he was anticlerical is certainly justified. To say that he was antireligious is just as certainly false. We have no evidence of Goya's ever having failed to fulfill his normal religious duties even during the years of his exile, when it would have been perfectly safe for him to disavow his allegiance to the Catholic Church. From the satirical, anticlerical, and anti-Inquisition plates of the *Caprichos* we can only deduce that Goya, like so many of his contemporaries in Spain, Italy, and France, was passionately interested in reforming the Church, not in destroying it. Politically as well as religiously, Goya remained a son of the Enlightenment and never converted to an overtly Jacobin outlook. Humane reform, rational compromise were probably closer to his heart than any radical change in the major institutions of society. Francis Klingender's excellent book *Goya in the Democratic Tradition** is an eloquent and hair-raising index of the outrageously backward and downright insane conditions that were common in Spain during Goya's time, and certainly even the most reactionary 20th-century reader cannot help but be moved to thoughts of revolution by Klingender's sober and fair exposition of the Spanish social, economic, and political scene. But if it is true that the grass is always greener on the other side of the fence, it is also true that vice, injustice, and abuse always look blacker beyond the barrier of history. Just because we, living as we do in a tradition that at least publicly proclaims itself to adhere to libertarian principles, find the Spain of the 18th century odious does not mean that the Spaniards of that time found their condition unbearable. For better or for worse, the human spirit does manage to adjust to all sorts of conditions, and it is one thing to look back on barbarous ages and another to be accustomed to barbarity from the cradle. We need only look about us today and then imagine what people born a century and a half after our death will think about us. Learning about extermination camps, atomic bombs, racial conflicts, staggering social injustice, and the perpetual menace of inevitable war brought about by the stupidity, avarice, and blindness of our leaders, our successors here on earth will certainly believe that the generations since 1914 lived in daily fear and trembling and that the more forward-looking intellects and sensibilities were actively revolutionary. Now it may be that most artists, poets, musicians, professors, and other thinkers sympathize with utopian ideals and decry the present state of the world. Yet how deeply do their sympathies (call them convictions, if you will) impinge on their creative lives or even on their daily activities? It would be exciting and comforting to think that most

*Francis D. Klingender, *Goya in the Democratic Tradition* (London, 1948).

leading artists lend their active and concrete support to worthy political movements. But this idea does not correspond to reality. Under special circumstances—the Chilean coup d'état of 1973, for instance—they may even band together and try to make their voices and prestige felt. But even these moments hardly show the artist to be more energetically committed to moral and political causes than is the average, decently educated citizen.

It is all too easy to think of Goya as the revolutionary who spoke out with a heroic "J'accuse!" every time he put brush to canvas, just as it is all too easy to think of him as the renegade and compromising opportunist when he failed to live up to our expectations. Unlike the French *philosophes* and the artists who were influenced by them, Goya had no curiosity or faith in systems of thought, behavior, esthetics, or politics. Neoclassicism in its heroic phases of moral commitment hardly touched him (as it did every other important European artist), precisely because it was a system, a way of methodically apprehending, comprehending, and ordering the disparate range of human experiences. Goya belongs to those temperaments who are passionately drawn to the singular and approach each portrait sitter, each commission, each event of their lives as a unique phenomenon that must be dealt with in accordance not with some morally or artistically valid scheme but with the intuitions and inspirations of the occasion. He weighed each case according to its merits. Despite his deeply felt anticlericalism, for instance, he nevertheless painted pictures celebrating the valor and wit of a monk when he happened to hear of a monk who was truly courageous and decent [99].

This habit of dealing with each subject on its own merits sometimes led Goya into traps. A large number of his autograph paintings are of appallingly poor quality simply because the subjects either repelled or didn't interest him, and he therefore painted in a haphazard or even slovenly manner. He had no routine, no automatic technique that remained constant no matter what he painted even when he was not interested in what he was doing. David produced a few uninteresting canvases and even some vulgar compositions, but he never painted a square inch that wasn't scrupulously refined in quality, sustained as he was by an implicit belief in a well-established, reliable method of seeing and rendering the observable world. The subject did not have to rouse him in order to bring out his best instinct as a craftsman because the craftsmanlike approach was independent of his interest in the subject. Goya, however, worked at full capacity only when both the artist and the man in him were fully engaged.

These considerations must be kept in mind as we approach his eccle-

siastical works. Until we have some definite proof, it would be foolish to say that Goya deliberately hoodwinked the Church in his religious paintings. We have no indication that he was either an atheist or an agnostic, but we do have proof that he continued to take the sacraments even during his last years in France, where adhesion to ritual was no longer a requirement. He was simply a shrewd businessman who realized that working for the Church would not only bring in money but would gain him the approval of those court circles he had to win over in order to establish himself as Spain's leading artist. It wasn't enmity toward the Church that led him to do shoddy, vulgar work; it was more a matter of indifference to the trite, conventional themes he was asked to paint. Sometimes, as we shall see in the case of the frescoes of San Antonio de la Florida, he tried to enliven religious themes by bringing to them a modern, pragmatic point of view, and when that happened, Goya, like anyone who attempts to interpret mysteries as if they were facts, turned boorish. But this boorishness had more to do with his inability to find convincing images for the material he was asked to illustrate than with his inability or unwillingness to believe in the legends and stories of the saints. We must, then, consider him a strongly anticlerical Catholic, who was willing to accept religious commissions as long as they contributed to his success, and an artist who let himself be swayed by the nature of the commission to do either his best or merely superficially brilliant work. To the former category belong the all-too-frequently forgotten canvases for the Borja Chapel in the Cathedral of Valencia. The latter group is best represented by the very famous frescoes for the little church of San Francisco de la Florida in Madrid.

Among Goya's early sponsors in Madrid, the duke and duchess of Osuna were by far the most intelligent and understanding. Goya worked for them on many occasions. For their summer house, La Alameda, he painted bucolic scenes, fantasies, and other decorations, and the Osunas sat for their portraits on several occasions. When they commissioned two canvases for the Borja Chapel in the Cathedral of Valencia,* Goya must have felt free to interpret the subjects agreed upon in the most personal fashion since he could count on their understanding. One other point may have been of interest to him: The duchess was a direct descendant of the Borja family, so that there existed an unbroken connection between his own time and the days of the saint's life and deeds.

The choice of saint was probably much to Goya's taste. Francis Borja, like so many Baroque saints, was neither a hermit nor a scholar but a militant activist within the Jesuit order. He dedicated his life to the poor,

*Nordström, *op. cit.*, p. 59.

and the practical cares of the humble were familiar to him. His vocation, and consequent rejection of the comfortable, respected life that might have been his, was not the outcome of mystic visions or voices but a deliberate choice based on a profound sympathy with those souls in need of solicitude. Saints of this stamp were immensely popular among advanced artists and poets of Goya's day. One need only read Goethe's moving and blithe pages describing the life of Filippo Neri, another "practical" saint of the late 16th century, to see how ardently Goya's contemporaries admired the energy, vision, and charity of this particular facet of the Catholic faith. Stylistically, the two large canvases stand in opposition to the other paintings Goya was working on at the same time. In composition, lighting, color, and brushwork, the two Borja pictures point not only to the *Caprichos* but far ahead to the Black Paintings.

St. Francis Borja Taking Leave of His Family [17] is the weaker and more conventional of the two paintings in Valencia Cathedral. Rembrandt's prints, which Goya admired, may have had something to do with the antiphonal composition of light and dark masses. The background architecture is also reminiscent of Rembrandt. What is lacking is coherence of composition and expression. All the most prominent figures in the painting are seen either with their eyes lowered or staring off into space. The conventional Baroque *repoussoir* figure on the left has an unpleasant aimlessness because it isn't integrated with the rest of the personages, and the little weeping boy on the far right also detracts from the main episode. But most disconcerting is Goya's inability to give a sense of dramatic climax to the situation. We cannot even tell who, of the two embracing men in the center, is the departing saint. The subdued sentiment of leave-taking does not adequately nourish Goya's imagination.

The companion picture, *St. Francis Borja at the Deathbed of an Impenitent* [19], is far more successful. Deathbed scenes, as Robert Rosenblum has pointed out, became increasingly popular during the last three decades of the 18th century because they afforded painters a chance to illustrate stoic themes of forbearance and dignity—sentiments that grew increasingly dearer to the imagination of the public. Death scenes with specifically religious themes, however, were rare during those years, and we must go back to the mid-18th-century *San Gaetano Comforting a Moribund Sinner* [18], by Sebastiano Ricci, to find a painting comparable to Goya's. In fact, Goya's first sketch for the final picture is surprisingly close to the sentiment of Ricci's interpretation. As in the Ricci painting, Goya's preparatory sketch shows the dying man stretched out quite decorously on his deathbed awaiting the saint's ministrations. Above him three Tiepolesque angels make ready to welcome the soul of the defunct,

17. Goya, *St. Francis Borja Taking Leave of His Family* (*Despedida de S. Francisco de Borja*). Valencia Cathedral.

18. Sebastiano Ricci, *San Gaetano Comforting a Moribund Sinner* (*San Gaetano con un moribundo*). Pinacoteca di Brera, Milan.

while, on the extreme right, a devil sneaks off, defeated by the saint's miracle. The saint approaches the deathbed with measured step and holds a small crucifix triumphantly in his extended right hand. The atmosphere indicates a mild, pervasive light falling evenly on all forms.

The final version represents a formal as well as ideological break vis-à-vis the Ricci and Goya's own conventional first sketch. The moribund sinner has gone rigid with the convulsions of his agony. His cramped body lies athwart the bed, and St. Francis Borja, rather than approaching the dying man, seems to recoil from him, his left hand thrown up in a gesture of astonishment, while his upraised hand still proffers the miraculous crucifix which showers the impenitent sinner with a spray of vermillion blood. The head of the dying man has been taken out of the central horizontal axis (the position it occupied in the sketch) so that much more space is given over to the dark, spooky atmosphere of the room. Instead of the angels, squatting monsters leer at the dying man from

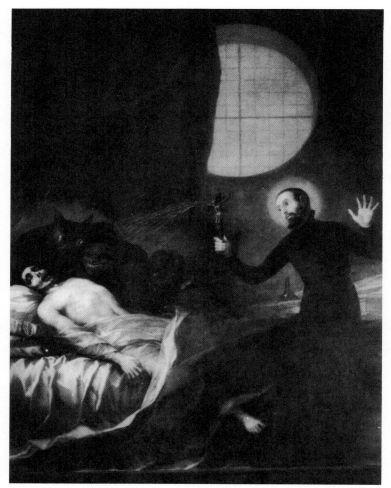

behind the bed. A sharply outlined, curtainless window lets a dreary light fall through the empty, shabby room, and there is no indication that the exorcism has been successful.

It is in this painting that Goya first revealed himself as a decidedly Spanish artist and left the internationalism of his earlier work behind. Since the days of Ribalta, Spanish painting had always manifested a tendency toward abrupt, harsh relationships between figures. Rather than cultivate the suave transitions of Italian art, Spanish art always preferred to set figures *against* each other. This dissonant mode of composition, which could already be vaguely sensed in some of the tapestry cartoons, begins to be the dominant principle in the Borja pictures.

Still more curious is the attitude toward the human body that first

became apparent in this picture. Instead of the heroic nude common to Goya's time (David!) or the pathetic nude (Fuseli!), we now have something stark and distasteful which is quite unexpected, especially after looking at Ricci's interpretation of a similar theme. Goya, in this picture, is really the first artist to depict death as something basically repellent. The human body does not find repose, nor is it capable of maintaining even a minimum of decorum or dignity. In this painting, of course, these attitudes are still expressed with a certain degree of circumspection compared to Goya's later renditions of corpses.

This picture is also important in Goya's development because it introduces us for the first time to Goya's monsters, to which we shall have occasion to return as Goya's demonology grows in menacing stature. Here, the monsters waiting to carry off the sinner's soul to hell are stock grotesques, reaffirmations of late medieval demons such as were well known to Spaniards through the paintings of Hieronymus Bosch. They are fairly conventional devils whose irruption into our world causes comparatively little consternation. There is even a certain logic implied in their appearance at a sinner's deathbed: If you live in sin, you must expect to die surrounded by emissaries of Satan.

Whereas the Borja pictures have always suffered from neglect, the frescoes of the then fashionable church of San Antonio de la Florida in Madrid [20, with details 21-26] have always attracted a large public, and since their sumptuous publication by Skira in 1955, they have become still more popular.* The little church is, after the Prado, the obligatory monument for all visitors to Madrid. The immense appeal of the frescoes to the contemporary public is easily explained, especially when one takes into consideration the taste of the fifties, sixties, and seventies of our century.

For a generation that came to maturity with the victory of Abstract Expressionism, the daring brushwork, the brilliant color, and the broad handling of detail and textures were bound to find tremendous resonance. The close-up detail reproductions published in the luxury edition cut the composition to bits and focused primarily on the abbreviated modeling techniques and high-velocity acrobatics of Goya's brush. These reproductions were widely acclaimed, and we still tend to see the frescoes in terms of the Skira layout. But one should beware of praise based primarily on the delight at finding corroboration of one's own esthetic actions in an artist of the past. If Luca Giordano's frescoes in the Escorial were presented in the same shrewdly falsifying manner as the San Antonio de la Florida

*Enrique Lafuente Ferrari, *Goya: The Frescoes in San Antonio in Madrid* (Geneva and New York, 1955).

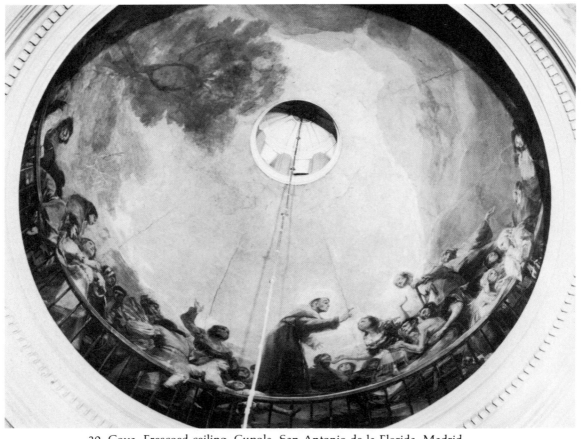

20. Goya, Frescoed ceiling. Cupola, San Antonio de la Florida, Madrid.
21. Goya, Frescoed ceiling. Detail.

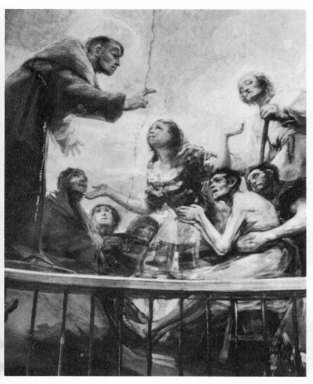
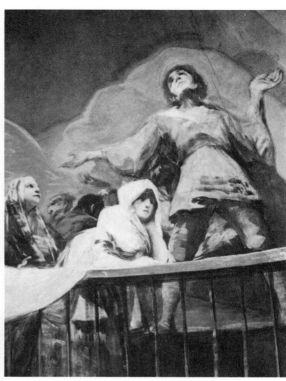

22. - 26. Goya, Frescoed ceiling. Details.

frescoes, they would probably find equally loud acclaim. However, that hardly makes Luca Giordano as great an artist as Goya. We are so eager to praise spontaneity of brushwork, so happy to see earlier artists indulge in the liberties of our own contemporary artists, that we are all too often willing to accept vulgar facility for true freedom. The expressive calligraphy of Willem de Kooning at his best is one thing, the flashy short cuts taken by Goya in San Antonio de la Florida are quite another, and it does Goya no service to admire him at his most fatuous when we have so many paintings in which his brushwork is truly admirable.

All this is not to say that the frescoes aren't breathtaking in their bravura and their lush color. All the vitality and the greed for pleasurable effects that are so characteristic of the 18th century seem to live again in these frescoes for one last time. But their greatness rests far less on the spirited manner of execution, which could easily be paralleled and surpassed by far lesser talents, than on a novelty of conception that makes them the first visible break with the tradition of the Baroque. What was hinted at in the tapestry cartoons is fully stated here.

The Baroque in Italy found its most mature expression in commissions of just this kind which involved the illusionistic aggrandizement of architectural space by means of ceiling frescoes that open up the architecture above the cornice and lead the eye to believe in the vision of endless skies and flights of angels just beyond the end of the real architecture. Goya himself must have known intimately Tiepolo's ceiling in the throne room of the Royal Palace at Madrid [27] which represents the high point of the entire illusionistic epoch of Western art and concludes an enormously fascinating adventure that began in the first decade of the Florentine Quattrocento.

Scholars have not yet discovered why Spanish artists constantly rejected ornamental commissions that it was common practice for artists elsewhere in Europe to accept. One can think of Raphael, Titian, and even Michelangelo as decorative artists. The Sistine ceiling, for all its power, is an ornamental cycle. The desire to delight the eye is always strong in artists outside Spain. But even the most astonishing works of Velázquez—Las Meninas [29], for instance—cannot be called decorative. Whereas Italian, French, and Flemish images can easily merge with architecture or with other paintings to form a harmonious ensemble, Spanish images, because of their stringent individuality, demand absolute attention and monopolize the field of vision. Looking up at the Sistine ceiling, our eyes can easily

27. Giovanni Battista Tiepolo, Frescoed ceiling. Throne Room, Royal Palace, →
Madrid.

encompass two or three major fields plus the attendant *Slaves*, their garlands, and their architectonic setting. Looking at any painting by Ribera, Zurbaran, or Velázquez, we are forced by the painters to concentrate exclusively on the action within a single frame. Any museum curator will find that it is relatively easy to hang paintings of non-Spanish schools. Their commonly shared esthetic function, their will to embellish, makes even bold mixing of French, Flemish, and Dutch paintings relatively easy. Spanish paintings, since they concentrate on an obstinate fascination with the impenetrable quiddity of all observed reality, sacrifice the element of seductive grace and strike a discordant note when displayed alongside non-Spanish pictures.

Even the ceilings painted by imported artists seem out of place in a Spanish setting. There can hardly be more open declaration of mutual incomprehension than that between the architecture of the Escorial by Juan Bautista de Herrera and the decoration imposed on it by Luca Giordano. The architecture is dense, massive, and intransigently austere. Cornices are cut in straight, blunt lines, windows are frameless, and all the areas that are usually given over to caprice in the architecture of other countries are severely blank. Imposed on such a framework we find the most carefree, airy paintings by Luca Giordano, who blithely ignores his surroundings and simply lifts the ceiling off the walls. The starkness of the architecture is in unpleasant contradiction to the painted decorations. If one looks at similar decorations in Italy—say in the Galleria Farnese or the Gesú—the effect is totally different. The architecture is so highly articulated, so thoroughly rhythmicized, that it never calls attention to itself as an opaque mass. The eye travels unhesitatingly and without abrupt transitions from the walls into the realm of pure illusion that opens up in the ceiling.

Even in the 18th century in Spain, when the imposition of a French dynasty had subjected the nation to cultural gallicization, the same divergence of concepts holds true. Tiepolo transplanted to Würzburg looks quite at home and manages to take root in such an authoritative way that his frescoes in the archiepiscopal palace look relatively homegrown. But his most mature, and in many ways more interesting works in Madrid have been generally ignored, largely because they look extremely uncomfortable in their setting. Even in a palace designed by an Italian architect (but finished, for the most part, especially the interiors, by Spaniards), the illusionism of Tiepolo misfires. Balthasar Neumann's Kaisersaal and stairwell at Würzburg are so completely imbued with rhythmic form that the architecture loses all weight and massiveness. Matter, infused with thought, levitates and becomes a transparent but still

visible manifestation of the architect's imagination. One isn't aware of looking at blocks of marble or at painted stucco but rather of a breathing, fluent space embraced by a graceful and equally fluent screen of columns, niches, and cornices that swing about like flower garlands. The architecture, in other words, leads directly into the illusionary world of Tiepolo's ceilings because the architecture itself is conceived of in illusionistic terms: Stone, stucco, and wood are turned into something that makes us forget that stone is stone, and stucco stucco. In the throne room of the Royal Palace in Madrid, this transformation does not take place. The ponderous, clumsily put together pilasters, the rigid cornices, and the unarticulated walls keep reminding us of the materials with which the artist works. Instead of transfiguring the walls, they make the density of the wall almost as apparent as if the raw brick and mortar had been left standing nude for us to see. Our eye and our imagination have to take an energetic leap and adjust to a distinctly different esthetic attitude if we are to comprehend the frescoes of the ceiling.

Yet the ceiling of the Madrid throne room [27] remains the supreme example of that magic transformation of pigment and wall surface into an "illusion" of space and light. Without perspective lines, without a single point of convergence, without any kind of narrative or space-evoking horizon, Tiepolo manages to turn square yard after square yard of blue pigment into infinite space traversed by light. Not until Mark Rothko's mature paintings has a similar transfiguration of flat color areas into limitless space been attempted.* The modest, somewhat cramped stage first projected by means of patiently calculated one-point perspective in the early Quattrocento has turned into an infinite space without losing the unity and the logical coherence of Renaissance structure.

That a painter of Goya's temperament and brio must have known and admired these frescoes cannot be proved by any kind of literary documentation. But no man gifted with an eye for color, light, and magisterial virtuosity could fail to respond to Tiepolo's last will and testament. That Mengs ridiculed Tiepolo's last and greatest works and that the academicians of San Fernando bowed to the verdict of Mengs could hardly have mattered to an artist like Goya. Yet when his turn came to produce a ceiling fresco, he took justifiable pride in striking out on his own. He presented to the world a series of remarkable paintings that are a kind of

*The comparison between Rothko and Tiepolo may shock at first, but it remains valid. Though their starting points were vastly different, both artists sought to express mystic experience by means of disembodied light and an infinity of space. And both painters, in order to achieve the sense of supernatural light, also made use of large areas of color brushed onto flat surfaces.

answer to Tiepolo. He did not belittle Tiepolo as Mengs had done. He learned respectfully from Tiepolo as much as he could. But he demonstrated that the faith that allowed Tiepolo to create a weightless, shadowless, logical realm of beauty could not be sustained by a new age. Space that had always been conceived of as sacred space, and therefore free of terrestrial gravity, now became ordinary space. From Giotto to Tiepolo, space and the energies that pulsated through space were centered on God, who was regarded as the beginning and end of all things—just as in perspective, all things stood in direct relation to the vanishing point. Space fell under the control of divine will and had a distinctly ethical meaning because it was the stage on which God's commandments became manifest. Goya changed all that. For him, space was earthly space with its concomitant gravity and its concomitant lack of religious meaning. Only objectively ascertainable events could happen in that space.

Tiepolo's illusionism was no longer viable because the spirit that made of the illusion something concretely meaningful had gone. For Tiepolo, heaven was as much a reality as earth, and when he represented heaven, though he had recourse to illusionism, this illusionism was justified by the conviction (ethical as well as esthetic) that this suprareal heaven existed. For Goya and for all subsequent artists, illusion, far from being something noble because it led men to witness those forces that would otherwise be beyond their apprehension, had become a device for trickery. Even today, when we use the word *illusion* or *illusionism*, we often imply something tricky. We also imply that the illusion will soon be followed by disillusion. Since we are no longer capable of living as if there were eternal laws regulating the ways of the universe and the ways of men, we tend to explain the actions of those who once did believe in such laws by thinking of them as being under the influence of some rapturous enchantment or intoxication. That is why most analyses of art works since Wölfflin have been carried out in the spirit of a guide whose main objective is to teach us the tricks and devices by which certain effects were achieved. Embarrassed by anything that cannot be treated factually, we want to "look through" rather than "look at" works of art. We want to see "how it is done." To the artist of the Renaissance-Baroque period, illusionism is not trickery but functions by way of analogy. Just as certain religious minds (St. Teresa and the author of The Song of Songs) describe religious ecstasy in terms of physical fulfillment, so Tiepolo described the logical coherence, the serenity, and the infinite space of a religiously conceived heaven in terms of an illusion of weightlessness and of ever-expanding but rationally comprehensible spaces. By appealing to our desire for weightlessness and

flight, he infuses into our spirit a sense of levitation and freedom from the pull of gravity.

Goya, alone of all the artists of his generation, contrived to create a viable new art out of the little that was left of man's mind, soul, and sensibility. He did not scoff at the artists of a previous era who "illuded" themselves and their public. He simply admitted that he could not follow them in their flights. Looking about him in a world that had turned ashen and harsh, he began once again that tragic but heroic cycle that is man's lot, a cycle that leads from chaos to form and back to chaos again. In the cupola of San Antonio de la Florida, the new spirit of a new age announced itself covertly in theme, in interpretation, and in the more elementary aspects of technique and formal expression. These frescoes were the first serious secularizations of religious themes. They were the first forebodings of a mind that had given up a traditional faith without converting to a new and equally "illusory" system of apprehending the purposes of our life and our world. Goya did not switch allegiance from an ethico-religious view of the world to an ethico-political system as David did. He apprehended that the faith of his contemporaries was either meaningless or conventional and self-enforced—that it was indeed an illusion. Rejecting with equal force the faith in God of his ancestors and the faith in history and progress of his contemporaries, he set about to construct a new world built of the pieces and fragments of his knowledge, his intuition, and his invincible pride in being a man—no matter how reduced in stature.

The most immediately striking divergence between Goya's cupola and previous ceiling decorations was quite simply in the direction of their dynamics. The figures on Baroque ceilings (with the single exception of Longhi's staircase frescoes in the Palazzo Sagredo in Venice) always move upward or are about to take flight.* Even in the least dynamic compositions, the ceiling of the Camera degli Sposi in Mantua by Mantegna or the cupola of the Duomo at Parma by Correggio, where figures sit or stand solidly on fictional parapets and balustrades, one never feels that they are subject to the laws of gravity, that they will fall down from their perch and come to grief on the pavement.

The iron fence in Goya's fresco is not merely an instance of his insouciant inclusion of everyday ugliness into pictures devoted to sacred themes. It is far more. It is a visual necessity which tells of an irrevocably new way of thinking about the functions and meanings of figural painting.

*There are similar decorative principles at work in the loggia decorations of the Palazzo Rosso in Genoa and in other Italian provincial palaces. But these instances are fragmentary freaks of decoration and never form a coherent system of pictorial composition.

If, for a moment, one thinks away the fence, the change will be quite clear. The figures would look as if they were about to topple from their positions. For all the lightness and speed of Goya's brushwork, these are the first ceiling figures who respond to the force of gravity and who have lost the gift of levitation that once was their natural birthright.

We can follow the development of Goya's conception of the San Antonio de la Florida cupola through two distinct stages of development. As in the case of *The Injured Mason*, the first sketch is entirely conventional. A throng of fluttering angels is in attendance, and even the composition of the figures on the ground is as heroic and dramatically heightened as it might be in a Giacquinto or Tiepolo fresco. The miracle of St. Anthony is at the center of interest and at the center of the composition. A large working sketch (now in Pittsburgh) goes against all previous usage and proposes an entirely new mode of understanding the life and the work of the saint. Most obvious of all differences is the suppression of the angelic choir that witnessed and sanctified the saint's miracle in the first sketch. The area above the heads of the crowd around the saint is now "sky" and no longer heaven. The scene on earth, too, has changed character. It is hard now to make out the saint among the figures, and it is even harder to see what he is doing. This factor, in turn, makes it difficult to understand the varying and often contradictory reactions of the other figures, some of whom remain totally indifferent to whatever it is they have just witnessed, while others comport themselves with ecstatic abandon. But since we don't really know what is happening, we can hardly be expected to understand these divergent attitudes.

Compositionally, of course, we have a marvelously ironic accompaniment to this theme of confusion. All sorts of irrelevant and fragmentary focal points are flashed before our eyes: the broad swath of drapery cast over the iron fence, the brilliant colors of the two Majas sitting in the foreground, the extraordinarily vivid patterns of the costumes of some of the other participants. Equally eye-catching is the continuous monotony of the balustrade itself. The motif is unprecedented in ceiling painting because it so flatly contradicts the celestial character that is usually given to the vaulting of churches. Even in those rare cases in which portrait figures appear in ceiling paintings standing behind a balustrade, as happens in Luca Giordano's fresco of the staircase of the Escorial, the figures and the balustrade float above us as if pulled upward by a powerful but invisible magnet. The entire dynamic scheme of motion and counter-motion in all of the earlier ceilings is concentrated along the vertical axis. The situation that is created is comparable to that of an observer looking upward from the bottom of a deep well. Only the vertical lines count. In

Goya's fresco the basso continuo of the balustrade immediately introduces a strong horizontal force into the picture by making us look through the interstices of the railing. The composition of the figures in back of the railing follows the same pattern of horizontality because they are presented to us as standing behind instead of above each other. One has the urge to chin oneself up on the cornice to see what is going on behind the first row of spectators. In earlier ceiling pictures, this itch to join the crowd never makes itself felt because of the tremendous distance the artist has put between us and his figures and because every part of his composition is surveyable, heaven has opened its gates for our benefit, and we are given a rapturous glance at its endlessness. Vast spaces are filled with air, light, and blessed souls or angels. For Goya, the sky and the space of his composition are *quantités negligeables*. The one strong vertical line, the tree that rises behind St. Anthony, is weakest in execution, modeling, and color. It is the cursory annotation one might expect to find in a stage background of a provincial theater—a clumsy abbreviation that says, "I'm supposed to be a tree."

Most surprising of all is the decoration of the archivolts and spandrels. The normal relationship between men and angels has been inverted, and instead of angels singing their Hosannas in the heavens above, they stand about rather uneasily along the cornices of the church *underneath* the mortal figures painted in the cupola. Nor is there any continuity between the figures who stand above in bright sunlight and the angels who stand in darkness broken only by artificial lights that throw disconcerting illumination upward like crude footlights. As Theodor Hetzer observed in what remains the most brilliantly illuminating article ever written on Goya, Tiepolo's angels may look very much like ballerinas, but they remain celestial ballerinas, whereas Goya's angels are pretty dancing girls in theatrical angel costumes.* It is astonishing to see how heavily Goya manipulates the jointure between wings and backs of these angelic figures. But then, once you have stopped believing in angels, the question poses itself: How *did* people of a generation ago think angels flew, how did they conceive of their anatomy? Courbet's remark, "Show me an angel and I'll paint you one," turns out to be less arrogant than one might suppose. In any case, Goya demonstrates here that one *does* need a model before one can paint an angel and that the time when angels were commonplace is at an end. There is something sardonically clumsy in the way those heavy

*Theodor Hetzer, "Francisco de Goya und die Krise der Kunst um 1800," *Wiener Jahrbuch für Kunstgeschichte*, XIV, no. xviii (1950); appears in English as "Francisco Goya and the Crisis in Art around 1800," in Fred Licht (ed.), *Goya in Perspective* (Englewood Cliffs, N.J., 1973), pp. 92-113.

and rather dusty theater-prop wings are stuck to the shoulder blades of Goya's angels, just as there is something wickedly awkward in the prosaic fall of the draperies, which no longer flutter as if animated by the free winds of heavens but fall to the ground like rather badly hemmed costumes. In the accessible language of a revered tradition, Goya pronounces the death of that very tradition and makes it clear that a new language must be found, a language that will deal with men and human events instead of superior beings who manifest the will of God.

4

The Family of Charles IV

It was through his activity as a portraitist that Goya finally established himself in Madrid and was promoted painter to King Charles IV in 1789. He was now able to give up the onerous commissions for tapestry cartoons and devote himself almost exclusively to portraiture and to the two major religious commissions that have already been discussed. The small paintings that he painted either for the amusement of the Osunas or to satisfy more imperious impulses after his illness of 1794 played a relatively minor role in his work. They became truly important only in retrospect since they were the first experiments in a genre that would ultimately grow into the overwhelming fantasies of the Black Paintings. It is best, therefore, to discuss these works in conjunction with Goya's later work.

The portraits painted before 1800 introduced a witty note of satire into the genre of court portraiture. They also revealed, for the first time, the increasingly isolated nature of human existence in a rapidly changing universe. Here and there one discovers a certain amount of venom, and Goya's underhanded satirization of his sitters goes beyond anything that earlier painters, even Hogarth, had permitted themselves. However, for all the deviations from late Baroque conventions, Goya still remained a product of the Enlightenment. In 1798 he received the culminating accolade as court painter when he was asked to paint a monumental group portrait of the royal family.

The commission coincided with a particularly dramatic moment in Goya's life. He had only recently recovered from the frightful and mysterious disease that had seriously threatened his life and left him permanently and completely deaf. The great series of aquatint etchings, the *Caprichos*, on which he had banked for increased income, proved to be a politically dangerous and financially unprofitable venture. And the

crises of his own life were matched on the outside by the increasingly desperate agony of the Spanish nation and the threatening revolutionary tempests beyond the Pyrenees. There can be no doubt that the social and political crises of these crucial years, coinciding with the personal tragedy of the artist's violent illness and permanent deafness, must have had their effect. And it was again in portraiture, in Goya's explosively frank confrontation with his fellow man, that the deepest changes in his attitudes were most convincingly and legibly inscribed. The exuberant, salon-revolutionary Goya of the 1770s and 1780s had disappeared. The artist who introduced socially tragic themes into royal tapestry commissions, but was still willing to waste his time on commissions that were essentially alien to his temper, vanished without a trace. An earnest and steadfast talent stands revealed to us in the works completed around 1800, and among these works *The Family of Charles IV* [28] is by far the most important.

Ever since Théophile Gautier described the figures in Goya's group portrait as "the corner baker and his wife after they won the lottery," scholars, amateurs, and casual visitors to the Prado have asked themselves how it was possible for Goya's royal patrons to accept so degrading a portrait. Even if one takes into consideration the fact that Spanish portraiture is often realistic to the point of eccentricity, Goya's portrait still remains unique in its drastic description of human bankruptcy.

Portraits—especially ceremonial portraits—are always the expression of an urge to eternalize. They are, at least to some degree, monuments. The artist, for reasons he makes obvious, recommends his sitter to us as worthy of our regard and as something more than the mere sum of physiogenic feature. Goya was the first artist to rob the portrait of its magic, transcendental properties. From his day, portraiture was the genre most deeply affected by the spiritual upheavals of the 19th century. It never recovered its former power and popularity.

How a portrait of such fiercely intransigent realism was acceptable to its sitters is only one of a number of puzzles that surround this crucial work. Another arises from the peculiar location of the artist, behind, instead of in front of, his sitters. Most important of all, one must consider the significance of Goya's seemingly clumsy use of a compositional prototype: Velázquez's *Las Meninas* [29]. A single glance at the general construction of the two paintings is enough to prove this universally accepted fact. In both pictures the painter himself stands behind a slightly inclined canvas at stage left; in both, the prospect is closed off by two large canvases hung on the rear wall; in both, the major figures are disposed in a very loose arrangement centering on a female figure bril-

liantly costumed (the infanta in the Velázquez, Maria Luisa in the Goya), who, with her head slightly cocked, stares straight out of the picture.

Rarely, if ever before, has a painter referred so pointedly to the work of a predecessor. Goya's use of Velázquez's *Meninas* is not comparable to the "borrowing" of motifs and compositional ideas. When Tintoretto makes use of compositional schemata invented by Michelangelo or when Rubens uses figures derived from Titian, these "borrowings" are consistently adjusted to their new stylistic environment. They do not intrude as foreign elements into an essentially alien framework, as does the position and attitude of Queen Maria Luisa, who uncomfortably apes the stance of Velázquez's infanta. Goya is perhaps the first artist to take motifs invented by earlier artists and use them with a minimum of change in conjunction with utterly changed stylistic circumstances. He not only makes art out of art, but he reveals the process instead of hiding it. He forces us to superimpose our memory of another painting onto his own work by *collating*—instead of *absorbing*—the borrowed elements. In this way, comparison with a prototype becomes an integral component of the significance of his work, instead of merely being an incidental homage paid to an earlier artist.

Without going too deeply into the problems *Las Meninas* poses to current scholarship, it is safe to say that the thematic and compositional core of the picture is bound up with the presence of the mirror behind the group in the foreground, in which the parents of the infanta are reflected. The insistent stares of Velázquez, the infanta, and the chamberlain in the background give the entire painting an element of suspense which is resolved by the putative presence of the king and queen, who stand (according to the reflection) somewhere outside the picture. Were it not for the mirror, which tells us what the cynosure of the major figures is, *Las Meninas* would be inexplicable.

In the Goya, too, the attentive glances of most of the portrait sitters are just as strongly focused on an object outside the picture. In fact, Maria Josefa, the king's grotesque old sister, pokes her head forward in purposeful, birdlike curiosity. But we look in vain for the one object that might yield a clue as to what all these people are looking at. After all the trouble to which Goya has gone to base his composition on *Las Meninas*, he withholds the one element that makes *Las Meninas* take on meaning: He withholds the mirror and its telltale reflection.

Or does he? Perhaps the very absence of the key element in *The Family of Charles IV* is deliberately meant to irritate us into finding the mirror that Goya has so sardonically hidden. Perhaps his superficially clumsy reference to *Las Meninas* was purposeful after all. We must at least hunt

28. Goya, *The Family of Charles IV (Retrato de la familia de Carlos IV)*. Prado, Madrid.

29. Diego Rodríguez de Silva y Velázquez, *Las Meninas*. Prado, Madrid.

30. Goya, *Woman Reflected as a Serpent on a Scythe* (*La mujer vibora*). Prado, Madrid.

for the mirror in the hope that if it is found, it will do for the Goya what it did for the Velázquez: deliver the answer to one of the most disturbing group portraits ever painted.

In Goya's work, references to mirrors are fairly frequent. In "Till death" ("*Hasta la muerte*"), Plate 55 of the *Caprichos*, a vain old woman primps before a mirror, undismayed by the hideous face that stares back at her. The mirror in this instance serves the conventional purposes to which it is often put in allegories of Vanity, and as such reveals nothing original about Goya's manipulation of the mirror image.

More interesting is a series of drawings in which coquettish young ladies and gentlemen admire themselves in front of tall mirrors.* Here [30], the rational relationship between reflection and object reflected has been fabulistically changed in favor of a moralized reflection. The mirror in each case reflects not the human figure posturing in front of it, but a symbolic animal image that mimics the gestures and attitudes of the protagonist. Another peculiarity of these drawings is that the mirrors themselves are equivocal in their appearance. In some drawings, the object in front of the figure is unquestionably a mirror. In others, it looks much more like a stretched canvas attached to a rudimentary easel. What is hinted at here is probably the age-old relationship of painting and mirror: art being the mirror of nature. Mirror surface and canvas surface are confusingly interchangeable in this singular series of drawings, which, significantly, dates from the same epoch as *The Family of Charles IV*.

We must also consider another important court painting in which Goya speculates on the relationship between mirror image, reality, and painted

*Nordström, *op. cit.*, p. 76.

image: the portrait of Count Floridablanca [*31*]. We know from a letter written by Goya to Martín Zapater y Clavería that Goya attached great importance to this portrait of the powerful minister of finance, for by means of it he hoped to establish himself as the most fashionable portraitist at the court of Madrid. In his letter to Zapater he speaks jubilantly of Floridablanca's satisfaction with the portrait and obviously feels that Floridablanca's benevolent reception of the picture will stand him in good stead.

In this painting, which was commissioned in 1783, Goya has represented himself (as he was to do later in *The Family of Charles IV*) in the presence of his patron. He stands lower left with his back to us, presenting an unframed, stretched canvas to Floridablanca; the count, his lorgnette

31. Goya, *Conde de Floridablanca*. Banco de Urquijo, Madrid.

poised in the direction of the canvas, stares away from the sketch, out of the picture, his head quite rigid, a slight smile beginning to grow on his lips. His secretary, standing behind him, stares out in the same direction.

What Goya has done in this portrait is to incorporate Floridablanca's approval into the subject of the ceremonial portrait, turning it into an advertisement of his gifts as a painter. The stance and gesture of Floridablanca suggest that he is comparing his reflected image in a looking glass (which must be presumed to hang just in front of him) with the painted image that Goya presents to him. His spectacles are proof enough of the fact that only a moment ago he must have been busy scrutinizing the painted portrait sketch. Now he complacently regards his mirror reflection in order to test the painter's accuracy. Successful portraiture is shown to be equivalent with fidelity to the mirror reflection.

New possibilities begin to appear in *The Family of Charles IV* if one transfers the idea of the mirror from the Floridablanca portrait and the group of mirror-sketches to the royal group portrait. For one thing, the otherwise inexplicable position of Goya behind his sitters begins to make good sense if he is presumed to be portraying them from their reflection in a mirror, instead of from a direct confrontation, which would be impossible given his position *behind* his subjects. The previously vexing problem of Goya's plagiarization of Velázquez is also solved. The mirror is still there, but it is no longer within the picture. It *is* the picture.

The original question concerning the acceptability of such an unflattering group portrait is now no longer quite so enigmatic. The reason Goya could get away with his unashamedly naked revelation of the sitters' appearance lies in the intricate situation he has set up, which is derived from the common procedure used in self-portraits. Goya has not presented his sitters as *he* saw them. He has presented them as they saw themselves. He records the unimpeachable evidence provided by the mirror image. The hard fact of this reflection is witnessed by the sitters themselves.

The implications of this group portrait are far-reaching. They concern (1) Goya's changed attitude toward the meaning of individualized human existence. They pertain also (2) to the revolutionary conception of the artist's function and the artist's relationship toward observable reality—a new conception that will become basic to the entire development of modern art. Finally, (3) *The Family of Charles IV* marks the end of one of the most eloquent of genres in Western painting. These implications are important enough to be considered in turn.

(1) The most strikingly obvious feature of the portrait is, as Gautier mentioned, its ruthless display of the insignificance of the human being. There is a definite line that divides Goya's painting from caricature.

Caricature is an art that depends on a belief in the perfectibility and significance of human existence. Even at their most vitriolic, the caricatures of Leonardo da Vinci and of later Renaissance and Baroque artists go hand in hand with an unshakeable belief in an ascertainable ideal of human appearance. Deviations from this ideal fascinate the artist either because he sees some moral lesson to be gained from caricature (that is, he believes that greed, stupidity, or other vices inimical to the human ideal leave their imprint on the physiognomy and that therefore vice can be pointed out and castigated by showing its exaggerated traces in caricature heads) or else he is so deeply infatuated with the dazzling variety of human appearance that even a hideously deformed face reveals something worthy of being externalized.

Goya's portrait is far from exhibiting any caricatural purpose. It neither points to the opprobrium of vice nor does it humorously lampoon human vanity and inadequacy. It is instead a tragic comment on a condition of human life that is essentially modern. In recent years, this condition has been discussed under the term *alienation*. Earlier generations, from the Romantic era on, apprehended it as "loneliness," "isolation," or "incommunicability." In each case, what is meant is that Goya graphically embodies in his royal group portrait: man's inability to rise to a higher ideal of himself, man's doubt in the significance of his destiny and in the guiding hand of an all-powerful divinity that has ordained the course and tenor of his life.

We need only turn to Louis-Michel van Loo's group portrait of the family of Philip V [32], a conventional piece which nevertheless manages to convince us that the sitters are not just human animals but creatures endowed with a superior nature. As princes, they embody the will of God, who, in turn, gives meaning to all things and arranges the hierarchy of the heavens as well as the social hierarchies of our mortal lives. We may think of Philip's family as pompous, but we cannot deny that they sincerely believe in the nobility of their position or that the painter shared this belief as a matter of course.

Goya and Goya's sitters have lost the faith that was still self-evident in Van Loo. There is a suspicious awkwardness about each figure in Goya's painting that tells us immediately that the king doesn't know how a king is supposed to bear himself. He doesn't know how to be himself because he doesn't know who he is. Only the children in the portrait can look themselves in the face without assuming forced and false attitudes. The eloquence with which this sense of being lost, of not being at ease with oneself or with one's environment, is expressed increases in Goya's later works and ultimately leads him to paint some of his most moving portraits.

32. Louis-Michel van Loo, *Family of Philip V*. Prado, Madrid.

We shall have occasion to return to Goya's vision of modern man after that vision matured through the experience of war and famine.

(2) For centuries, it was the artist's function to look beyond casual reality and discern behind it a hidden and consoling meaning. It was this meaning that he then projected onto the canvas by means of a coherent composition. No matter how widely esthetic theory varied from the Trecento to the end of the 18th century, no critic had ever questioned the artist's basic function as an interpreter who faces mute nature and gives it eloquence by means of his talent for discovering telling relationships and clues that escape the less talented eye of the layman. In *The Family of Charles IV*, Goya suddenly abdicates the right of interpreting the visible world and presents us with pure fact. Painting, from being an act of ennoblement, becomes an act of recognition. Goya presents us with a painting that no longer attempts to transcend or artfully simulate nature and that has no pretenses beyond that of being an impassive reflection of *what is*. This impassivity must not be confused with deliberately puzzling

pictures such as were painted during the 16th-century period of Mannerism or during the Baroque era. The perplexing images of Mannerism were based on an intellectual conceit that could be discovered by the spectator if his mind was devious and acute enough. During the Baroque period also, puzzle pictures enjoyed a considerable vogue. But in the case of these painted riddles, the artist had a distinct meaning in mind, and he teased the spectators into discovering this meaning for themselves. Goya's picture has no such ulterior, fixed meaning unless it be to make us sense the impossibility of arriving at a conclusive "knowledge" of appearances. His theme is not the difficulty encountered in solving the riddles propounded by nature but rather the tragic limitation of our senses and our mind, which never allows us to go beyond the masks of what we, by convention, call "the real world."

The painting, therefore, instead of being a finished creation, becomes an object that is capable of change even after it has left the artist's studio. It is an object among objects and not the representation of a heightened ideal. Instead of attempting to show the deeper meaning that lies behind appearances, as all earlier Western artists had done, Goya (or rather the mirror in his studio) limits himself to holding up a trustworthy facsimile. If there is a meaning to appearances, if there is a hidden value to existence and to experience, we must find it on our own. The artist remains mute on the subject of metaphysical realities.

Two episodes of our own century may serve to illuminate the modern artist's attitude toward his painting and will cast a backward light on Goya, who was the first to experience this changed relationship between the artist and his product. During the German occupation of Paris in World War II, an officer eager to trap Picasso into admitting his antifascist feelings visited the great Spanish painter in his studio. As he looked about him, he pounced on a reproduction of Picasso's *Guernica*, an overt manifesto against the barbarities of Nazism. Turning to Picasso, the officer asked, "*Vous avez fait ça, n'est-ce pas?,*" to which Picasso quickly replied, "*Non, Monsieur, c'était vous.*" The answer was not merely an ironic comment on the methods of German warfare. It implied a deeper problem that has never ceased to vex the modern artist. Can the artist today (and by today, I mean the entire modern epoch from 1790 on) be anything but a medium who transmits recognitions of the world without being able to testify to their meaning? Guernica is bombed. Picasso paints a picture of the bombardment. But it is Guernica that predominates over the painting. The brutality of the event and its sheer mindlessness cannot be conveyed in traditional terms of art. Picasso didn't "make" Guernica. He withdraws behind the event, and all he can do is to recognize its importance and call attention to it, leaving the meaning behind the event up to us.

Another episode: When a critic asked Willem de Kooning how he determined the moment at which one of his paintings was finished, de Kooning answered, "I know that a painting of mine is finished when I have painted myself out of it." In other words, there comes a point at which a modern painting is no longer the creature of its maker but becomes an autonomous object that must go on to make its own way either by asserting itself among the welter of things with which it must compete or else by disappearing from view. Goya, in *The Family of Charles IV*, also "paints himself out" of the picture by presenting us with an image that no longer purports to be what *he* saw but what the mirror reflected; in fact, the mirror surface becomes identical with the picture's surface, and Goya, far from being the creator of the image, portrays himself in the background, impassively consulting the mirror reflection and putting it down on his canvas without directly facing his sitters man-to-man. In later paintings we shall see even more vividly how Goya manages to "paint himself out" of his pictures until the pictures assume an autonomy that is both frightening and tragic. In this way, Goya initiates a long line of painters who, for one reason or another, prefer to disappear behind their works. Picasso and de Kooning are hardly the only artists who "paint themselves out" of their pictures. Manet in his *Bar aux Folies Bergère* does just the same thing (and he does it, as did Goya, by means of mirrors); Monet, to a certain extent, tries to do the same thing; and Cézanne, Courbet, Whistler, Duchamp, and many other artists follow in Goya's ideological footsteps even though they may not have known Goya's work. It is the modern condition that imposes this new attitude on artists. Goya was merely the first to recognize the condition and work in accordance with his recognition.

The hermetic quality that modern art so frequently assumes also can be traced back to Goya's portrait of the royal family. It is the first painting that plays itself out within its own limits. That is to say, the subject of the painting, instead of facing us (as had been true of every painting in the Western tradition) faces itself. There is no room for us as spectators in the painting. The queen, the princes, and Goya do not look out of the picture. They look *at* the picture they make in the mirror before them. The traditional, perspectival space-box, open at one end through which the spectator is allowed to view the scene, has been slammed shut by Goya as he interposes the large mirror between us and the royal family. The theme of the picture is not "The Royal Family presenting itself to us," as it was in the case of Van Loo's family portrait, but, rather, "The Royal Family looking at itself." The mystery and disjointed sense of participating in a scene from which, by all overt signs, we have been excluded give the

painting a certain unpleasant, sinister quality that is especially noticeable when one encounters the painting full size in the Prado. Most visitors, as well as most art historians and critics, seek refuge from this uncanny feeling by forgetting the painting as a whole and finding solace and more traditional satisfactions by admiring the incredibly deft brushwork. The hermeticism of Goya's picture is a quality that crops up over and over again in the most epochal paintings of modern art. Manet's most ambitious canvases (*The Old Violinist*, the *Bar aux Folies Bergère*, the *Execution of Emperor Maximilian of Mexico*, the *Déjeuner dans l'atelier*, and even the *Déjeuner sur l'herbe*) demonstrate this uncanny nuance of being intransitive, and certainly works by Seurat, Degas, and Ingres share the same quality. Its most graphic and overt exploitation occurs in the work of another Spanish painter: in Salvador Dali's maddeningly hermetic *Portrait of Gala*, in which the subject again faces herself to the exclusion of the audience.

(3) Most far-reaching of all are the latent connotations for the genre of the group portrait. This important branch of the art of portraiture reached its highest development in Holland early in the 17th century and remained a current and immediately understood celebration of communal life throughout the later Baroque decades. The whole meaning of the genre resides in its presentation of conviviality and friendship. Usually, the benevolent feelings that bind the various figures of the group portrait also bind them corporately to society as a whole, because most group portraits, whether republican Dutch or aristocratic French, represent people who have come together with a humanitarian purpose by means of which they wish to benefit their contemporaries. This is certainly true of the many portraits of regents of civic charitable organizations and members of guilds or academies. It is equally true of the more stately group portraits of a courtly nature, whose benevolent influence is not as immediately visible to our democratic eyes. However, group portraits such as those of Philippe de Champaigne or Van Loo, in which courtiers or the royal family are the chief protagonists, retain this primordial significance because the royal family or the court as a whole is representative of forces that hold together the social fabric. Seen from the point of view of the *ancien régime*, the hierarchy of heaven is reflected in the hierarchy of human society. A meaningful rank is therefore conferred by the grace of God on all creatures with the anointed king and his court representing the empyrean of the earthly sphere just as God the father and his archangels are at the summit of heaven.

Goya's portrait of the royal family strips the group portrait of all such ulterior significance. The family has not come together in order to

vouchsafe their subjects a vision of their august presence. Instead, they have congregated in the artist's studio in order fatuously to admire their own image. Not all their finery (which seems usurped, as Gautier implied) can give us the sense of royalty. Their stance has no authority; they are not spiritually larger than life—as Hyacinthe Rigaud's *Louis XIV* [*33*], for all his pomposity, undoubtedly is. They do not dominate the space in which they move, as do the unforgettably self-assured personages of Van Dyck or Boucher. They stand about rather sheepishly and, by the very fact of their standing in admiration of their own reflection, they lose that sense of communicating their royal power to us, their subjects. The state portrait has lost its meaning when the painter can find no justification for eternalizing the physiognomies of rulers. When the artist has ceased to believe in the worthiness of the king and queen, he cannot in good faith recommend them to our respect. He cannot, as Rigaud and all of his followers did, make us do obeisance. The coming together of these people is therefore an irrelevant event instead of being an occurrence of high import.

This strange sense of purposelessness transmits itself directly to us because all the characters in the picture studiously avoid looking at each other. There is a general sense of incommunicability, and it is this awareness of the dissolution of all social and intelligible bonds that renders the group portrait continuously more obsolete.

All portraiture was in crisis from about 1790 on. But group portraiture was throttled almost completely at the very beginning of the 19th century. Hardly any great 19th-century painters ever painted a group portrait. In most of the exceptional cases, as with Degas, the group portrait was dictated by demands of family duty. But even Degas, in his most exciting creations in this genre, chose to portray the antagonism of the figures rather than their communion. This is true of *The Bellelli Family*, and it is even more strikingly evident in *Baron Lepic Crossing the Place de la Concorde in the Company of His Two Daughters*, in which the dispersion of affection rather than the tenderness of the situation is exploited. The most striking example of Degas's handling of this element of alienation, which is emphasized rather than vanquished by people coming together, is the monumental pastel *Six Friends*: Here the divergence, the centripetal force of the sitters, becomes a compositional principle of extraordinary force.

If major 19th-century artists avoided the genre, minor artists kept it alive in a strangely zombielike fashion. Fantin-Latour's great group portraits, *Hommage à Delacroix* and *Un Studio aux Batignolles*, are qualitatively the finest products of this sort. Here the coming together of

33. Hyacinthe Rigaud y Ros, *Louis XIV*. Louvre, Paris.

friends is again fortuitous and deliberately artificial. Fantin doesn't expect us to believe in the reality of the scene *qua* scene. Again, no one speaks with anyone else, no one even looks at the same object. A silence reigns that gives refuge to each of the characters who have been lured out of their isolation by Fantin's artifice.

As for the more mundane artists of the century whose very profession as court or society artists made group portraits imperative—they, too, could not quite disengage the group portrait from the curse under which the genre had fallen. Winterhalter and Sargent always produced their best work when they were working on single portraits, and both artists preferred to paint pendants or series of single portraits rather than groups or single canvases. Sargent especially did far better work when he split up

the various members of a family (Wertheimer family portraits) and was at his facile worst when dealing with traditional groups (*Wyndham Sisters*). In the one case of an esthetically successful group portrait by Sargent, the *Boit Children*, we are back again to the theme of isolation and antagonism. A downright sinister hostility separates the children from each other as they withdraw into the disquieting darkness of the living room, whose contents are in the process of being packed for transportation.

James Tissot, the boulevardier artist *par excellence*, has left us an astonishing group portrait of *La Cercle de la rue Royale*, which seems to be a definite attempt at reviving the moribund genre. But, compared to the group portraits of the 17th and 18th centuries, Tissot's work is strikingly at odds with the normal motivations of group portraits. The purpose of these men is inscrutable. Again, nobody looks at anyone else, none of the participants is involved in any group activity or common purpose. The final impression is of a picture of sumptuous surroundings in which some incidental figures have been incorporated. For all the delicacy with which each figure is treated, we cannot retain their gestures or appearances.

The only first-rate exceptions I can think of are by the hand of that most genial of all 19th-century artists, Renoir. Innocent of the problematic nature of his environment, a true heir—and perhaps the only one—of Fragonard, he alone was capable of producing pictures like *Madame Charpentier and Her Two Children* and the *Déjeuner des canotiers*, in which the individual finds warmth and fulfillment in the company of those who are close to him.

Naturally, photography had something to do with the gradual disappearance of this once so important genre. But it is significant to note that the habit of painting single portraits still persists—as, for instance, in the portrait galleries of universities—while the group portrait has virtually died out altogether. When teams or committees are to be commemorated, the photographer assumes exclusive rights.*

In our own century, group portraiture is practically the unchallenged preserve of the commercial portrait studio. There are some isolated paintings, but even in these scattered exceptions, the artist either works like fury to force his sitters into some tight, preordained scheme or else he does everything to avoid the direct confrontation by focusing attention on such incidental details as hands or still life.

*One of the few modern group portraits that actually does achieve compositional and dramatic unity is a painting that is based on photography for method and subject matter. It represents the painter Lenbach and his family all looking at a camera which is supposedly just outside the picture in a position close to the spectator's. The focus which draws the scattered characters together is not a human event or a human character but the mechanism of the unsentient camera.

5

The Majas

In *The Family of Charles IV*, Goya interprets the problem of personality in a subversive, thoroughly modern way. Individuality, instead of being the comprehensible extension of divine will, becomes something fundamentally unknowable, something finite and essentially incomprehensible. The characters are shown staring into a mirror, eager to find out who they are. If they don't know who they are, how is Goya to know? How are we to know?

At the same time that Goya was investigating the new incomprehensibility of human personality, he painted yet another painting—or, rather, a pair of paintings—in which he moved from the general to the specific. *The Family of Charles IV* tells of general alienation: Everybody looks at himself—nobody looks at his closest neighbor. In *The Clothed Maja* (*La maja vestida*) [34] and *The Naked Maja* (*La maja desnuda*) [35], Goya focuses on one of the most fundamental of all human relationships: the relationship between man and woman.

The idea of painting two pictures of the same model in the same pose on canvases of identical format is in itself astonishing. It becomes even more peculiar when one considers that the female nude is practically nonexistent in Spanish painting. Velázquez's *Rokeby Venus* is an exception, of course, but any critic who equates it with female nudes as they were painted in Italy, Holland, Belgium, or Germany would be far off the mark. The historical and compositional mysteries that surround this painting make it another of Velázquez's great enigmas. But for all the sobriety of Velázquez's eye, the figure, though strikingly realistic, still refers to the world of mythology. *The Naked Maja*, however, is the first totally profane life-size female nude in Western art.

There has been much speculation about the two Majas. The hypothesis that the model was the duchess of Alba is probably mistaken. Perhaps the

capricious duchess might have been willing to pose in the nude, but even if one granted such a supposition, there would remain the obstacle of the face of the Maja, which has not the slightest trace of resemblance to the well-known features of the duchess of Alba. Nor can one take seriously the theories postulating a pornographic intent on the part of the artist. Hardly credible is the idea of the paintings being inserted in a frame with a spring mechanism that could change the image from the naked to the dressed figure and back again.

Yet there are some elements of these two interpretations that do hold an interesting grain of perception. The duchess of Alba theory could not possibly have arisen if it weren't for the pointedly particularized character of the Maja's face. Her portraitlike character is unlike other nudes of Western painting. It has been rightly stressed by critics and has led biographers to speculate on the identity of the model. The theory ascribing pornographic intentions to the artist derives from another quite correct impression: that of the singularly lewd presentation of the nude as well as of the dressed Maja without the slightest pretense at allegorical respectability.

These two striking aspects of the Majas are demonstrably part of the artist's intention. Goya is at great pains to insist on the destruction of every element that might detract from the total profanity of this subject. To begin with, he avoids all the luxuries of setting that usually form the *mise-en-scène* for a monumental female nude. We are introduced instead into a vague, dark space in which stands a rather commonplace and slightly shabby green velvet sofa. Plump bed pillows are propped against the backrest of the sofa, and crumpled sheets are spread, none too neatly, under the figure. The light is chalky and deprived of any atmospheric warmth. The figure, instead of being lyrically pensive or gently preoccupied with a mildly mythological narrative, stares challengingly out of the picture, obviously aware of being looked over but quite indifferent to being on exhibition.

Diderot once observed that there was a world of difference between a nude and an undressed woman. It is perfectly possible, though it would be hard to find documentary proof for such a suggestion, that Goya meant to give visibly concrete substance to Diderot's famous saying. By painting twin pictures, the process of stripping the figure of its costume suggests itself involuntarily with a directness that would have been hard to achieve if he had painted only the undressed model. But even if we had only *The Naked Maja* without her pendant, the "undressed" and not "nude" quality of the figure would still declare itself very strongly.

Even the most admittedly salacious of Boucher's paintings, the notorious *Mlle. O'Murphy* [36] still belongs to the hallowed tradition of nudes

34. Goya, *The Clothed Maja* (*La maja vestida*). Prado, Madrid.
35. Goya, *The Naked Maja* (*La maja desnuda*). Prado, Madrid.

rather than to the modern genre of "naked" models. Rich satins stream down from the cushions, and ornamental still-life groups of flowers and jewels are laid out on the floor in a lively accompaniment to the rose-and-honey body of the model. The draperies, the still life, and, above all, the

warm and atmospheric treatment of the colors all conspire to convince us that the nude state of the model is the state ordained by nature for Mlle. O'Murphy. Never once, despite all the evident charms of the appetizing girl, do we think of her as possibly existing in any way, in any surroundings, in any position other than the one that Boucher, with the magic of his intuition, has created for her. We don't think of her having once been dressed nor do we think of her having gone through the motions of undressing in order to pose for the artist. Her nakedness is, as it were, an attribute, a natural state, of her existence, and though we may delight in the sly wit of the artist who has posed her in so raffish a position, our thoughts and emotions, though directed in a pleasurably carnal direction, nevertheless are controlled by our recognition of the esthetic artifice of the situation. We don't confuse the real Mlle. O'Murphy with the picture of Mlle. O'Murphy as we are likely to do with Goya's Maja.

What is so radically different about the two pictures is not so much the erotic content but the attitude with which each artist confronts the theme of carnal love. To Boucher, for all his libertinage, the subject is still a sacred one. The irresistible attractions of the flesh are still portrayed as being part of a universal and hallowed force. There is no ambiguity, no questionable side, to the most fundamental relationship between man and woman. Under this guise, love is still an essentially sacred emotion which

36. François Boucher, *Mlle. O'Murphy*. Alte Pinakothek, Munich.

is capable of expanding from the particularized urge for men and women to couple to the far more significant, far more poetic force underlying all appearances and all forces in nature. Ostensibly we are very far away from Biblical or Dantesque erotic allegory. But we remain, still, within the sphere of the kind of conception regarding love that made the Bride of Solomon and Dante's Beatrice symbols of overwhelming powers that move man to higher recognitions and greater goodness. Love, pleasure, and goodness are still reconciled with one another and are given significance. They are part of a universal harmony.

This symbolic nature of the Boucher is fully borne out by the composition of the picture. Within the elaborate structure of this painting, the body of Mlle. O'Murphy is not an isolated element but a completely integrated, harmonious form. The curves of her shoulders and her back echo the curves of the furniture and the sweep of the draperies; the colors of her skin are attuned to and enlarged by the tints of the floral decoration and the scattered pearls. Boucher even has the audacity to use the circle of the dado in the background as a kind of nimbus that frames and "sanctifies" Mlle. O'Murphy's buttocks. At each point, the eyes (and, with them, the mind) of the spectator are drawn from the particularized to the general until the whole image resolves itself in a lightly but securely woven fabric of correspondences. The setting of the figure is a suitable matrix expressive of the capacity for love which is most succinctly summed up in the splendidly healthy and responsive body of Mlle. O'Murphy. Love, to Boucher, is everywhere. Its attractions and satisfactions speak to us from every brushstroke, every color, and every line of his painting.*

To turn from Boucher's picture back to the Maja is to come up short from love to lust. The attractiveness of the body does not draw circles and embrace all of the picture. It is not a universally operative force. Instead, it adheres strictly to the body. Everything else in the picture contradicts the gratifications promised by the female form. The shabby couch, the cold light, the gloomy, abject emptiness of the space surrounding the Maja, the utter lack of any ornament, stand in sharpest contrast to the pleasures suggested by the Maja. Her bold stare is only the crowning touch in this play on the equivocal aspects of love. Mlle. O'Murphy may

*Paul Frankl has proven that the little painting of Mlle. O'Murphy derives from the detail of a swimming nymph in one of Boucher's greatest paintings, the *Triumph of Venus*, in Stockholm. The pose is not necessarily salacious but dictated by the swimming motion for which he posed the model. But this in no way invalidates my argument. On the contrary, the easy transition of the same figure from a purely erotic picture to the larger mythological painting only proves my point more succinctly. See Paul Frankl, "Boucher's Girl on the Couch," in Millard Meiss (ed.), *De Artibus Opuscola XL: Essays in Honor of Erwin Panofsky* (New York, 1961), pp. 138-52.

not be possessed of a highly individualized or intelligent face, but at least her expression of relaxed dreaminess is congruent with the state of her body. Both are supine and attuned to pleasure. Between the body and the face of the Maja there intervenes an unsettling shift in meaning. The body, taut and arched slightly forward, is proffered in a self-conscious pose which reaches its culmination in the calculating and glacial sexual challenge written large on the Maja's alert and not in the least warm or welcoming face.

A little experiment reveals the total discrepancy between Boucher's and Goya's conceptions of the female nude: Add one or two babies to both Boucher's *Mlle. O'Murphy* and Goya's *Naked Maja*. The Boucher will appear quite naturally to be an acceptable "allegory of fecundity"; the Goya will appear tastelessly lewd. The sexual attractiveness of Boucher's nude is healthy and vigorous and goes beyond the immediate appeal of a pretty, rosy girl to suggest the normal, happy consequences of love: fertility, motherhood, the joy of newborn life. The association of Goya's figure with babies evokes no such sentiments. It is a painting that is eloquent of an ephemeral sexual encounter and nothing else.

For the first time in Western art, the female body becomes *motif* instead of being, as it always was before, a divine creature, a symbol of that force which moves the universe, man's God-given compassion. Its beauty is no longer an aspect of its goodness. A complete divorce has occurred between virtue and love. The most voluptuous·nude by Titian, Rubens, or Boucher retains a natural, spontaneous accent of chastity. It represents a transcendent ideal made human, and therefore the nude has always been one of the highest forms of painting in the West. It made manifest all that was worth living for, all that gave life its warmth and content.

The forceful impression that Goya's paintings make cannot be entirely explained by comparing them to earlier nudes. Again, one must remember that Goya is consciously linked with the Spanish tradition, and it is to this tradition that he returns here just as emphatically as he did in his deliberate play on Velázquez's *Meninas* when painting *The Family of Charles IV*.

Though, as has been noted before, Spanish art is astonishingly lacking in female nudes, there does exist a curious (and curiously Spanish) genre of nude painting, which was practiced especially during the 17th century and was entirely devoted to a scrupulously clinical description of the monsters, dwarves, and idiots who were brought to Madrid for the entertainment of the court [37, 38]. These paintings, which were meant to capture for eternity the barbarous jokes of nature, were painted as pendants showing the malformed body of the victim naked or dressed in incongruous clothes which caricatured the then-current fashions of dress.

37. Juan Carreño de Miranda,
Clothed Monster (*Mostrua vestida*).
Prado, Madrid.

38. Juan Carreño de Miranda,
Naked Monster (*Mostrua desnuda*).
Prado, Madrid.

Goya was surely aware of these paintings because they were in the royal palaces to which he had access. The analogies that bind the Majas with these prototypes are striking, and as there is no other precedent for pendants showing the same figure in a dressed and undressed state it is reasonable to believe that there is a connection between these Baroque paintings and Goya's Majas. It may very well be that Goya intended to suggest, a good forty years before Baudelaire, the demonic, the monstrous nature of bare sensuality robbed of ulterior meanings by paralleling his paintings with those of earlier ''monsters.'' Goya in this oblique fashion is the first painter to make us aware of the disturbingly equivocal qualities of love in a secularized world.*

Beyond their intrinsic power and expressiveness, the Majas are among the few paintings by Goya that actively intervened in the course of 19th-century painting, and the genealogy linking them to one of the most famous paintings of the modern era, Manet's *Olympia*, deserves to be recalled in this connection. Manet, we know from documents, saw the two Maja paintings and commissioned his good friend, the photographer Nadar, to make full-scale photographic reproductions of them. After

*Juan Carreño's naked and clothed monster is the only pairing of naked and clothed versions of the same figure before Goya's painting of the Maja. There is, however, a fascinating later pair of paintings that shows an extremely similar treatment. *The Devil's Mirror* by Antoine Wiertz (1806-65), (in the Musée Wiertz, Brussels), is tantalizing not only because it shows the same model in the same pose both naked and dressed but also because it contains another Goyaesque device as well: the mirror *moralisé*.

Nadar completed his work, Manet, in an amicable gesture of gratitude, presented him with the *Espagnole à l'éventail*, which bears the inscription *"A mon ami Nadar."* With the exception of a few details, this masterful little painting can pass as an overt "homage" to Goya's *Maja*. The model is posed in a very similar position on a sofa, which in this case is red instead of green and has neither cushions nor sheets. And instead of the total lack of ornament, Manet has enlivened the composition by the inclusion of the kitten playing with a ball of yarn in the right-hand corner. It is not improbable that it was the experience of painting a variant of the Goya masterpiece in order to thank Nadar that led Manet to paint the *Olympia*. Even without the additional proof of the Nadar painting, the relationship between Manet's nude and Goya's version would be striking enough. The bald nakedness, the calculating yet erotically indifferent stare of Olympia, who, like her Spanish sister, confronts a visitor, the deliberate contradiction between voluptuous body and icy facial expression (in the Manet this aspect is accentuated by means of the little black ribbon that separates head from body)—all are translations of the *Maja* into terms of the 1860s. Naturally, in the very act of translation, Manet brought the theme up to date and made the experience of modern Eros even more diabolical. Goya's *Maja* is a statement about the nature of modern love and modern animality. Manet's *Olympia* intensifies this modernity by bringing us into an even more particularized situation. The portrait character that was already so noticeable in the Goya has been emphasized, and the mundane accompaniments of the servant and the expensive bouquet also bring us into direct contact with a narrowly defined social situation. In Goya, the Maja may be smiling at us. But the encounter still remains somewhat generalized as an encounter between a man and a woman. By being specific, the situation in the *Olympia* becomes also more uncomfortable. Either we suppose that Olympia is staring coolly at us as we come to make a worldly offer for her favors or else we assume a third party has come to visit her, and we, since we are also witnessing the scene, have been turned by Manet into lubricious voyeurs.

For Goya and the later 19th century (with the possible exceptions of Delacroix and Corot), the nude was astringently limited to meaning only

As this book goes to press, Allen Rosenbaum of the Princeton University Art Museum has kindly drawn my attention to two pairs of small oval paintings by Boucher which represent the same model in the same surroundings and in the same pose. Only the dress is drastically different, modest in one painting, lewd in the second. These paintings certainly belong to a popular category of 18th-century pornography. But it must be remembered (1) that they exist only on a very small scale and (2) that, in each case, a certain intimacy and even decency is retained because the subject of the painting never knows that she is being observed. There is no self-consciously lascivious proffering of nakedness in these paintings.

itself. Degas, perhaps the greatest practitioner of the nude in modern times, summed up the situation in a nostalgic comment: "When I think that painters in the past were able to paint the chaste Susanna ...! Whereas I am condemned to painting a housewife in her bathtub!" The capacity to see in woman all the ideals of human life has vanished with Goya's *Maja*, and over and over again we run up against a popular phrase in the vocabulary of French critics when they deal with the problem of the nude: "*Ça sent le corset*" ("There's a smell of corsets"). In almost every case of 19th-century nudes, we are forcibly reminded of the fact that the figure before us does not incarnate any values beyond the greater or lesser attractions of the flesh (and usually, in 19th-century painting, they tend to be lesser). Nineteenth-century nakedness is a perverse anomaly instead of an attribute of innocence.

The *coup de grâce* to the female nude was intentionally delivered by the German painter Wilhelm Trübner (1851-1917) in a little-known nude in Winterthur [39]. In this picture, which is obviously dependent on the Goya-Manet genealogy, a female model is portrayed in so fragmentary a manner that only part of her legs and her buttocks appear within the field of the picture, as if they were of no greater importance than the still life that completes the composition. Fan, drapery, bouquet, and naked flesh are visually equivalent, and no hierarchic distinction is made between the values inherent in a living human body and the insentient, inorganic textiles. Trübner's painting only makes vulgarly explicit that which is already subtly indicated in the Goya *Maja* and in Manet's *Olympia*: The human figure has lost its rank and its special dignity as the esthetic and moral masterpiece of the Creator.

39. Wilhelm Trübner, *Nude with Bouquet* (*Weiblichen Akt mit Bouquet*). Sammlung Oskar Reinhardt, Winterthur.

6

The Caprichos

The *Family of Charles IV* and the two paintings of the Maja, with all of their ambiguous implications, were not an abrupt departure from Goya's earlier style. There was a gradual transition from the style of the 1780s, a style that can still be understood in the context of late Baroque traditions, to the devastatingly novel statements with which Goya challenged his contemporaries after 1800. The Valencia Cathedral murals of the stories of St. Francis Borja already began this transitional phase, which reached greater depth and amplitude in Goya's first major graphic work, the famous *Caprichos*.*

The *Caprichos* form an intellectual and visual hinge between the age of the Enlightenment and our own modern epoch. Their aim, stated quite blandly by Goya in an advertisement for the first edition, is didactic and moralizing. The artist sets himself the task of illustrating certain incongruencies, injustices, stupidities, and cruelties of his age in order to open our eyes and arouse our indignation. The purpose of the plates is therefore in perfect harmony with the aims of the Enlightenment: to eradicate evil by education. A basic assumption of the plates is also shared by the Enlightenment in general: that the human race is capable of perfecting itself and that wit, wisdom, sentiment, and tolerance are efficient weapons in the struggle that is to lead mankind from its errors and ignoble impulses. The number of works, mainly literary, that expound this 18th-century position is extremely large but can best be represented by Voltaire and Montesquieu or, in art, by Hogarth and Daniel Nikolaus Chodowiecki. But Goya's work differs in spirit from the urbanely satirical criticisms of Enlightenment attitudes by being less subtle, less patient, and less learned. Where Voltaire, for all his wrath at human obtuseness, remains humorous and aristocratically paternal, Goya becomes blunt and angry. He is not aloof, as were earlier 18th-century satirists. He does not assume the

* José Lopez-Rey, *Goya's Caprichos: Beauty, Reason and Caricature*, 2 vols. (Princeton, N.J., 1953), is the best source for anyone interested in the literary and cultural background of the *Caprichos*.

existence of a vast distance between the cultivated and the uncultivated, between himself and the subjects of his indignation. Goya may pillory the waywardness of men and women, but he never assumes as the self-righteous Hogarth does that this waywardness is alien to *him*. Even in his broadest, most farcical satirizations, one always feel distinctly that Goya has direct personal experience of the error that is being satirized and that it is not just something he has observed from a detached vantage point.

Such, at least, are the premises on which the *Caprichos* were begun, and such, also, are the premises on which the finished work was advertised. But in the course of creating this first truly major opus, Goya himself changed, and the outlook that he had at the beginning of his work was no longer identical with the insights he achieved after having gone through the process of creating one of the most startling mirrors of human and suprahuman folly. More than any other work, the *Caprichos* interpret the gradual change from late Baroque to modern modes of thought and perception. They are a unique hinge between our own age and the age that went up in flames during the very years in which they were first conceived and sketched. In these plates, Goya changes from being a child of the Enlightenment, exasperated by man's errors and vices, to being the first spokesman of a modern view of man which despairs of our intellectual capacity, has lost its faith in the essential nobility and purpose of our destiny, and stands bewildered within a dark universe in which law, order, and dignity are no longer visible or attainable ideals.

Thematically, there was relatively little that was new in the *Caprichos* except that a new intensity made itself felt which was at odds with the far more polite expressions of, say, a Hogarth or the bluff humor of a Rowlandson. The content remained traditional: social injustice, mistakes in child rearing, the mindless snobbery of aristocrats, abuses of religious power. Prostitution, superstition, greed, and other evils were taken up one by one without any stringent sequence even though we can roughly separate major blocks of subjects. Visually, however, a new, persistent note was sounded that initiated a radically new concept of composition, of seeing, and of transmitting perceptions. The rationalism of the themes was contradicted by a completely new logic of seeing that Goya later exploited and expanded in his *Disasters of War*, in his Black Paintings, and in the *Disparates*, until he had established a new way of seeing—one of the common denominators of all art from Delacroix to Daumier to Degas, Manet, the Post-Impressionists, and far into our own century, influencing Cubism, Surrealism, and Expressionism turn by turn.

To discuss the *Caprichos* in their totality, their origins in the work of Tiepolo, their themes, their technique, and their influence would require

a monograph of considerable length and cannot be attempted here. But we can take up, quite at random, several of the plates in order to illustrate some of Goya's major innovations and discoveries.

The most immediate obvious deviation from the standards of tradition can be seized in the moralizing plates—those in which Goya pursues most clearly the satirical, educational goals of other 18th-century caricaturists. One such, definitely derived from old and popular imagery is Plate 19, "All will fall" ("*Todos Caerán*") [40]. The motif of "love birds" having their wings clipped goes back to antiquity and achieved great diffusion in the latter half of the 18th century after the excavations at Pompeii gave renewed, classicized life to the image of little Erotes. The theme was overtly moralizing, but the moral was hardly ever preached with great severity. Such decorative items as an anonymous artist's charming gilt biscuit group in Parma [41] can serve as an adequate example. Two charming, elegant ladies swathed in classical draperies and rose garlands sit in what is meant to be a bucolic landscape. One is gently clipping Eros's wings while her companion looks benignly toward the struggling infant god of love who raises his hands to her in a gesture of mock despair. The mood is idyllic and bemused. And despite the clipped wings, it can be assumed that Eros will not be crippled for long in his flight.

Goya's handling of the same theme is drastically moved from the gentle world of classical allegory to the much more tangible sphere of whores and bawds. Yet to call this image realistic would be quite beside the point. We are not introduced into a brothel, as in similar scenes in Rowlandson, and for all the exaggeration of details, it would be misleading to call this page a caricature. Goya has dissolved the stanchions that separate fantasy from truthful observation and has presented us with a vision that is simultaneously allegorical and realistic. Facts about the squalor of mercenary love are stated without a sermonizing or condemnatory tone. There is a dispassionate, worldly perception of "the way things are," a flat inevitability that is quite distinct from the effects of 18th-century social satirists. Goya's predecessors present us with scenes of vice in order to admonish us to live virtuously. Goya describes vice because it exists as an everyday fact of human existence. The sense of fright that nevertheless emanates from Goya's pictures is not unleashed by fear of divine retribution but depends entirely on the uncanny, unreal, yet not altogether unfamiliar setting of the scene. And it is here that we touch on one of the compositional distinctions of the *Caprichos*: their deliberate ambiguity about the environment of the figures. "Everywhere" and "nowhere" are the eloquent settings of all the *Caprichos*.

With only a few exceptions, Goya never tells us whether we are dealing

40. Goya, All will fall (*Todos Caerán*). *Capricho* No. 19. Metropolitan Museum of Art, New York. Gift of M. Knoedler and Company, 1918.

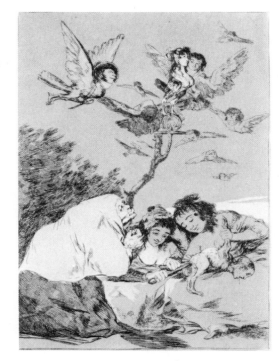

41. Anonymous, *Clipping Cupid's Wings*. Museo Glauco Lombardi, Parma.

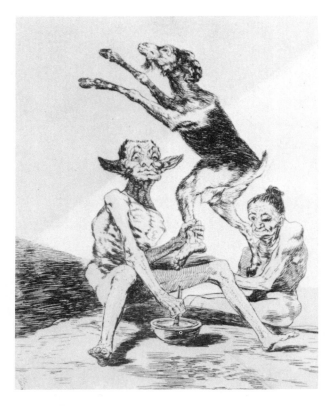

42. Goya, Wait till you've been anointed (*Aguarda que te unten*). *Capricho* No. 67. Metropolitan Museum of Art, New York. Gift of M. Knoedler & Co., 1918.

with a domestic scene or one that is laid out of doors. Nor does the lighting help us come to a decision on this point, because Goya is experimenting with a totally new concept of light, which we shall discuss later on in connection with the Black Paintings. Meanwhile, it may be sufficient to point out that the light in most of the *Caprichos* is as ambiguous as the setting. It rarely comes from a specific source; it is seldom used to illuminate the scene and generally cannot really be described as light at all. In Plate 67, for instance—"Wait till you've been anointed" ("*Aguarda que te unten*") [42]—the interlocking triangles of varying degrees of light that fill the background have very little to do with light and shadow. They are strong formal patterns that emphasize the action. As we shall see later, Goya ultimately was to do away altogether with the traditional concepts of light and dark in etchings, substituting what can more correctly be called graphic values of black, white, and intermediate grays, without direct reference to light or illumination.

The ambiguity of setting and of lighting is what lends to the *Caprichos* an air of irrationality, of a world gone awry, of figures that have lost their bearings. This must not be confused with the kind of suppression of background that we find in popular printed broadsides or in caricatures

(Rowlandson) in which the artist can afford to leave out the background precisely because he can reasonably rely on his audience to supply it. Goya, in quite a contrary manner, insists on giving us highly composed and carefully studied backgrounds—but the more we look at these "backgrounds" the more they declare themselves as having nothing to do with our ordinary perceptual coordinates. They become structural devices and expressively equivocal presences that give a severe wrench to our normal orientation.

Even in such a traditional etching as Plate 12—"Hunting for teeth" ("*A caza de dientes*") [43]—dealing with a current superstition which Goya ostensibly describes with detailed realism, there is an aura of horror that far surpasses the spectrally repulsive theme. A woman, believing that a tooth extracted from the mouth of a hanged man is an invaluable talisman

43. Goya, Hunting for teeth (*A caza de dientes*). *Capricho* No. 12. Metropolitan Museum of Art, New York. Gift of Walter E. Sachs, 1916.

against misfortune, is seen in the act of approaching a suspended cadaver. Her face is averted in terror, her hand stretched out toward the black mouth of the corpse. The theme is certainly extraordinary and might easily lend itself to the kind of Grand Guignol effects that today we are used to from horror movies. Goya might have contented himself with merely rousing our natural terror of corpses, particularly of executed criminals left hanging on the gibbet. But the plate goes much further than that. It translates the irrationality of the woman's superstition into the menacing intimation of madness that we experience directly from the eccentricity of the landscape. Something deliberately disjointed about the composition makes it hauntingly expressive of the madness that has risen to the surface in the woman impelled toward demented acts of sacrilege, a madness that lurks in the background of all of us. Where is the woman standing? On a wall? But where does that wall come from? Is it part of a building? Does it rise from the ground? Does it follow the rules of one-point perspective by diminishing in width as it recedes from us? None of these questions can be answered, and what is true of the position held by the woman is even truer of the dangling corpse. Given the large landscape view, we ought to be able to make out the gibbet from which it hangs. And what are the irregular sheets of a slightly lighter gray in the background? Are they clouds or wisps of mist? Since we are given no horizon line, we can't be sure. Besides, the nature of these jagged gray patches changes. On the right, we might think of strips of fog moving into the distance with a phosphorescent glow. But the same gray, extending to the left of the woman's tilted head, flattens out to a surface pattern and doesn't seem to have the same character or consistency as the gray patterns behind the corpse.

We can also turn to such genre scenes as Plate 25—"But he broke the pitcher" ("Si quebró el Cantaro") [44]—in which the theme, again, is perfectly conventional. A child, having misbehaved, is getting his bare bottom spanked. We can trace the theme back at least as far as the schoolroom scene in the St. Augustine frescoes by Benozzo Gozzoli. But Goya transforms the common semihumorous occurrence into a frightening experience. It is not only a matter of Goya's intensifying the bestiality of the scene by describing the mother's exasperated face as she lights into her son or by having her hold back the shirttail animal-fashion with her teeth. The true terror grows from the manner in which Goya has presented the surroundings of the figure. The desolate bareness in the prospect and the deliberate ambiguity of horizon lines force us to relinquish our normal bearings. The laundry hung up in the background takes on a spectral quality not only by being suspended in midair—it is kept in its place only

44. Goya, But he broke the pitcher (*Si quebró el Cantaro*). *Capricho* No. 25.

by the antagonistic pull of the other forms in the image—but also by means of the irrational sequence of white and gray tones that are used in this passage and that give us the sense of a desolate, indefinable light that is neither nocturnal nor descriptive of a cloudy day. The scene takes place

in a disjointed world, and, given such a setting, the human figures also seem enigmatic in their actions, emotions, and purposes.

The total appeal made by this image is not the didactic, wholesome lesson: "It is wrong to beat children." Instead, we are simply told that mothers, when pushed to the limits of human endurance by their wretchedness, will eventually turn into animals and behave brutally to their children. It is as if Goya, in the face of the pointless misery of the human condition, resigns himself to the simple statement of the facts of human behavior.

Naturally, such treatment is particularly suitable to demonic or suprareal scenes as exemplified by Plate 62—"Who would believe it!" ("*Quién lo creyerá!*" [45]—in which fighting monsters tumble through a shadowy

45. Goya, Who would believe it! (*Quién lo crey- erá!*). *Capricho* No. 62. Metro- politan Museum of Art, New York. Gift of M. Knoedler & Co., 1918.

world in which everything is indeterminate. The light crystallizes into strong formal patterns—but it becomes impossible to understand these patterns except structurally. The figures, too, begin to move into a realm that lies beyond our logical comprehension. The two fighting witches in the center have substance enough. Even though we do not know why or where they are fighting, we can at least apprehend them as volumetric bodies resembling the human frame. The horselike figure in the upper zone of the image, however, is puzzling not only in its form but also in its substance. Is it a shadow? A projection from a *laterna magica*? Is it an animal? Or is it an odd cloud-shape suggestive of an animal? Or an embroidered image on a large cloth? The identification of forms in naturalistic terms is gradually becoming immaterial to Goya.

Just as this is the first time that a Western artist deliberately confuses us about the identity of an important figure in his image, so Goya also deliberately confuses us about such essential perceptions as up and down. There is no way of telling whether the figures in this image are dropping down toward the lower frame of the picture or hurtling away from us in an uncoordinated space into the picture's depth. We are lost in a universe in which our ordinary terms of orientation no longer function.*

*Except in Oskar Hagen's *Patterns and Principles of Spanish Art* (Madison, Wisc., 1943), no study of space in Spanish painting has ever been undertaken. Hagen, too, does not carry his analysis very far but posits the peculiar flatness of Spanish painting as one of its consistent hallmarks. Perspective was never at home in Spain. The reasons for this consistent rejection of perspective at a time when it celebrated triumphs everywhere else in the Western world are difficult to seize. Hagen supposes that there is a certain continuity with the decorative art of the Moors. But there are probably deeper roots than that.

For one thing, perspective, by neutralizing and rendering transparent the surface of the canvas or panel, robs the painting *qua* object of its material essence. And paintings in Spain are always considered objects to be treated respectfully *as* objects, as things of density and weight that are as subject to mortality as everything else, while in the rest of Europe a painting is emphatically not an object but a transparent medium that allows the artist to project an equally intangible vision. The difference in attitude becomes especially crass when one compares Spanish sculpture with the sculpture of other national traditions. Italian, French, Flemish, and German sculpture all draw your attention away from the raw materials with which they work and toward an ideal of form that they transmit by a carefully worked and finished image. Spanish sculpture, on the other hand, always remains within the limits of its material presence: wood covered with cloth.

Perspective also insists that the invisible relationship between rendered objects or figures is as important as the figures themselves. Given a fixed center from which orthogonals emanate to give an ideal structure to the composition, a supranatural, ideal order comes into play which assigns a meaningful place to each figure according to a distinct hierarchy. This again is not true of Spanish attitudes toward art where dispersal is more important than concentration as a principle. Even in the most sophisticated paintings of the Spanish tradition, in Velázquez's *Meninas*, for instance, there is no distinct climax around which the other figures take their place.

This in turn leads to a peculiar isolation of the forms and makes every great Spanish painting a symbol of loneliness, of the alienation of all individual appearances from one another. Even Spanish still lifes are expressive of this pervading sentiment.

46. Johann Christian von Mannlich, *The Tribunal of Folly* (*Gericht der Narheit*). Schlossmuseum, Darmstadt.

On the verge of discovering a new world in which our sensory appprehensions become irrational, Goya is also on the verge of discovering a universe that resembles the universe of Einstein and the astronauts more than it resembles the universe of Galileo and Newton. It is the ambiguity of the setting that allows Goya to destroy all our normal approaches to perceived reality. The world into which he introduces us is uncanny, unknown, and unknowable. It is in this manner that he becomes the first artist of the modern era who proposes problems to which there are no solutions. If one compares any one of the *Caprichos* with the kind of puzzle picture that enjoyed a great vogue throughout the 18th century (Mannlich's *Tribunal of Folly* [46], for example), the difference, although rather intangible, becomes nevertheless obvious. The oddities of the earlier pictures are clues that lead to the decipherment of the painting if we only put ourselves to the trouble of interpreting all of the allusions. In the case of Goya, we realize that any interpretation of his image is bound to remain superficial. His true theme, presented in its germinal form in the *Caprichos* and expanded later on in the more mature Black Paintings and the

102

Disparates, is the inadequacy of man's intellectual and sensory apparatus for gaining knowledge of himself and of his world.*

This inadequacy of our normal perceptions begins to be exposed in the *Caprichos* in what might still be called a light vein. Goya is still in search of a language understandable by all men—an *"idioma universal,"* as the title plate of the *Caprichos* was originally to read.

All that changes when the private anguish that Goya had felt ever since the onslaught of his disease becomes a universal agony with the coming of the Napoleonic cataclysm.

*Of all the earlier painters who were overtly interested in subjects of witchcraft and sorcery, Salvator Rosa probably comes closest to Goya's preoccupations with the same theme. A painting by Rosa [47] contains no fewer than three, and perhaps even four, motifs that were used again by Goya. In the lower left is a corpse half risen from its coffin, writing on a sheet of paper, that is very similar to Goya's "Nothing" ("*Nada*") [74]. Immediately behind it rises a solemn figure completely shrouded in its winding sheet comparable to Goya's "The Beds of Death" ("*Las camas de la muerte*") [75], and hanging from the branch a hanged man is having his toenails pared, just as in "Hunting for teeth" ("*A caza de dientes*") [43] a hanged man is mutilated for the sake of a talisman. Immediately beneath this hanged cadaver, a naked witch promenades a puppet before a mirror. The use of mirrors for the sake of wreaking demonic mischief is recorded in several other Baroque paintings and seems to have been part of a divinatory ritual. It would be interesting to discover more about this popular superstition in relation to Goya's *Family of Charles IV* and the series of drawings [30] in which figures are seen reflected in mirrors. It must be remembered, however, that Salvator Rosa's use of witchcraft themes is still "rational"—that is to say, the context in which his demons and sorceresses are seen is utterly logical and in tune with our normal perceptions of space, light, and gravity.

47. Salvator Rosa, *Witches' Sabbath.* Althorpe House (Lord Spencer), London.

7

The Second and Third of May

Of all the countries of Western Europe, Spain was most incongruously out of step with the political, social, and cultural progress of the 19th century, and the head-on collision between Napoleonic troops and an almost feudal Spain created a tumult that was virtually unknown anywhere else in Europe during the agitated first decade of the 19th century. It was the popular fury unleashed by the French invaders of Spain that ultimately led to Napoleon's defeat. The disasters at the Berezina and at Leipzig began at Saragossa and at the Puerta del Sol in Madrid.

The anarchy into which Spain was thrown during these years had a double origin. The immediate, superficial cause was the Napoleonic invasion. Its more profound sources lay in the degree of corruption to which Spain had gradually sunk ever since the reign of Philip II. The system of government, the condition of society had rotted the very fabric of Spanish public life so that the response to provocation from the outside was not organized by a central body. Nor was resistance against the French inspired by a commonly shared ideal. Instead, events were dealt with fitfully either on a purely personal basis or by small pseudo-armies. The extravagant individualism from which Spain had always suffered was brought to its most extreme and anarchic expression by the total lack of a coordinating or directing force within the nation. The variety of response to the French invaders and to the changed system of law and order that they brought with them is incalculable because each Spaniard capable of thought had his distinct ideas and emotions about the matter.

Goya's position during these crucial years is difficult to determine. We can be fairly sure that before the invasion, he was an adherent of a liberal faction that advocated the adoption of the concrete ideals of the Enlightenment. Those he admired most—reformers like Gaspar Melchor de Jovellanos—were dedicated to ending Spain's feudal isolation. They were

men who admired French achievements in philosophy and political theory, as well as English forms of government. But they were also dedicated Spaniards. When faced with the conflict between his admiration of superior French political and cultural institutions and French subjugation of Spanish national sentiment, each man took his own stand, and each was at variance with his colleagues. Some of these men were forthright in the declaration of their position. Goya was not. Some may consider his conduct during the French occupation as merely prudent and sensible; others may consider it cowardly; and still others may think of it as admirably clever and diplomatic. Goya the man is dead, and his actions as a man are beyond our judgment. Goya the artist is still alive among us, and his actions as an artist can be evaluated and interpreted. And though the actions of the man are questionable and equivocal, Goya's position as an artist is quite clear. He was as capable of compromise in painting as he was when it came to political allegiances. But whenever he compromised his standards as a painter, he revealed it with great clarity: He painted visibly inferior paintings. And when he painted in accordance with his own conscience and perceptions, he painted pictures that have become the cornerstone of our modern civilization—paintings concerned exclusively with violence, the meaning of death, and the meaning of actions to which the artist bears witness.

The grim Spanish tradition that always favored a taciturn, unembellished view of death came to the fore again in Goya's art as he projected the first images of a modern world in which all attempts at consolation are either empty or hypocritical. In the conflicts of the Napoleonic wars, Goya perceived, in their most concentrated form, the blind powers that we still confront today as helplessly as Goya did. With great sobriety he left us a record of the deeds, the limitations, the fears, and the hopes of modern man. We may, along with many critics and historians, find fault with his work on esthetic or technical grounds. There is many a shabby passage, many a cheap shortcut. Compared in technical integrity, his contemporary, David, is a superior artist. But Goya is unquestionably the painter of our day. Anyone who has looked even cursorily at the newspapers of the past half-century will find that the most significant news items were illustrated by Goya more than a hundred and fifty years ago. The speculative, esthetic development of Western art may derive more directly from David than from Goya (although this point could also be argued in Goya's favor). But there is no doubt that very few men or women of today would feel at home with the characters and situations described in David's paintings if those characters and situations were to be brought to life for them. Whereas with Goya's pictures—even the most enigmatic—we feel an

immediate familiarity. It is difficult, today, to imagine what one's emotions and thoughts would have been had one been allowed to witness Josephine's coronation. But there is no doubt of our response to Goya's Black Paintings or *Disasters of War*, even if we don't fully understand them. At one level or another, Goya's paintings are our spiritual home in a way that David's pictures, alas, can never be.

David is capable of historical abstractions. Basing himself in part on the precepts of Roman *virtus* and in part on the political enthusiasms of the French Revolution, David can see violence and bloodshed as a source of future good. In his work, combat and death assume a moral significance that is pure and lofty, and when he sounds the heroic note he is always fully convinced and sincere. The sublime, disinterested anonymity David achieves in his finest works manifests itself in the whole range of his art. In his brush technique he carefully obliterates haphazard effects of personal calligraphy. In his compositions he subjugates momentary inventiveness to the (to him) superior laws and principles deduced from Greco-Roman examples. David gives constant proof of his sincere devotion to austere, suprapersonal goals. His artistry is such that he can convince us of his propaganda: It is always propaganda for ideals he had experienced intellectually, emotionally, and morally.

Capable of intellectual distance, capable also of distilling what he believes to be the universal significance of the moment, David is the perfect interpreter of the Napoleonic legend. He convinces us always of his true faith in the man of destiny. Goya, however, is the spokesman of Napoleonic facts. Looking at David's Napoleonic masterpieces, we can understand his enthusiasm—but we can no longer share it. Looking at Goya's visions of the Napoleonic Iberian campaign, we both understand and share his sentiments. To Goya, historical facts are not symbols of a glorious future toward which man aspires. The brutality of facts is never redeemed by an imposed or deduced moral meaning. Where David contemplates facts and draws from them moral or political conclusions, Goya proceeds from a totally different point of view. Despite its extraordinarily high degree of closely observed reality, David's *Death of Marat* [48] attains greatness by an awesome transfiguration of terrifying fact into allegorical apotheosis. We are aware of standing in the presence of a Republican altarpiece dealing with the martyrdom of a great revolutionary. David's hope that printed copies of his painting would be placed in schools and other public places as an inspiring admonition to future generations of stern republicans was well justified because the nobility that emanates from the painting is indeed uplifting and edifying.

A corpse by Goya could hardly be exhibited in schools as an admonition

to loyalty and self-sacrifice. There is no fixed ideal to which the vision of the corpse is adjusted. Goya confronts a cadaver without palliative conventions and without attempting to derive a moral lesson from it. There are no lessons to be learned from the contemplation of death. There is nothing to do but, in the words of one of the *Disasters* subtitles, "Bury and shut up" (*"Enterrar y callar"*). We come away with a sinking feeling of the futility of all death and all violence, not with an exalted ideal of the nobility of self-sacrifice in the name of a great cause.

David regarded the world around him from the fixed point of view of an unassailable idealism to which the facts of life and history were subjugated. He interpreted and ennobled reality until it fitted into a preconceived system of politico-ethical meaning. Goya responded directly to each case on its own merits without any *parti pris*.

David had a ready-made, highly sophisticated technique by means of which he could render his ready-made, highly sophisticated view of the hidden meaning of historical events. Goya's responses were dictated not by moral convictions but by his immediate response to a given situation, and his technique was equally varied. When the response was indifferent, the technique was equally indifferent. David never painted a slovenly picture; Goya painted many. On the other hand, Goya never "fabricated" a picture, whereas David produced many a canvas that can only be defined as a "machine": a finely turned product, admirable in its manufacture, esthetically enjoyable, containing a minimum of personal conviction. Goya was variable and capable of finding new solutions to new problems, whereas David, seeing things *sub specie aeternitatis*, rarely saw new problems and rarely devised new solutions.

In life, as in art, the two masters were equally diverse. David's allegiances were always clear-cut, and he spurned compromises. Goya's position was always ambiguous, and he allowed plenty of margin for arranging his affairs in the most advantageous way. David rejected offers of fame and fortune from a dynasty he held in contempt. Goya eagerly pocketed his pensions even after he had fled from a regime that had proved fatal to all he held dear.

Because we lack telling documents, our speculations regarding Goya's character and moral position must, unfortunately, remain hypothetical. The romantic biographers who depict Goya as an emancipated, adventurous, and humanitarian hero have, in terms of fact, as much right to their opinions as those who take a more skeptical view of his life. Only in his paintings did Goya refuse to compromise. He never allowed any subterfuge to obscure his understanding of the tragic changes that had annihilated all past methods by which man used to make his peace with the world.

48. Jacques-Louis David, *Death of Marat*. Musées Royaux des Beaux-Arts de Belgique, Brussels.

David, politically loyal to a creed he believed in, accepted exile but painted pictures that were at best neutral and at worst insipid. Goya paid obeisance to the powerful of this earth but painted pictures that are relentlessly eloquent of all the evils that plague modern mankind. From the beginning of the Napoleonic invasion of Spain, Goya was confronted with the most concentrated form of all the powers that have controlled human existence from his day to ours.

108

At this point we must glance, however briefly, at the events that gave a maniacal imprint to the history of Spain from about 1800 to Goya's death in 1828. Unrest and the undermined authority of the monarchy in Spain led Napoleon to conclude that his intervention in the Iberian Peninsula would meet with little if any resistance. His advance across the Pyrenees in 1808 was unopposed at first, but, by the time his forces had penetrated as far as Saragossa, the Spanish people unaccountably rallied against the invaders. Their resistance was to continue unabated for five years in the form that is now peculiarly linked with modern warfare: the "little war" or, as it is still called with its Spanish diminutive, the *guerrilla*.

Meanwhile, on March 19, 1808, in order to give greater impetus and wider popularity to the cause of the Spanish resistance forces, Charles IV and Maria Luisa, aware of their own unpopularity, had abdicated in favor of their son, who became Ferdinand VII. Realizing that he had underestimated Spanish strength, Napoleon summoned the old king and queen to Bayonne, on the French border, and induced them to barter the Spanish crown for a respectable but modest annual income, and they retired into exile in Italy. Ferdinand was kept for almost six years under military guard in a French chateau.

One might suppose that a crown thus ignominiously sold to a casual usurper might lose its prestige. But to the Spanish people, the betrayed crown was more worthy of defense than it had been when it still graced the heads of legitimate monarchs. The Spanish people's hatred of the French troops grew in intensity, and the bitterness of defeat by the enemy and treason by the monarchy caused the next several years to be marked by the incomparable cruelty of mutual reprisals. In their total confusion of ideals, goals, and practical interests, as well as their unsparing cruelty and moral anarchy, the Spanish campaign and the retaliatory guerrilla action were the truest prototypes of modern warfare.

Napoleon's principal commander, Marshal Joachim Murat, doubtless intended to establish a more equitable, efficient, and honorable government for Spain than that which Spain had enjoyed under the Bourbon-Parma monarchy. But the Spanish people, who had accepted abominably inept foreign rulers several times in the past merely because they had been established by the ostensible grace of God, balked at a benevolent king forced on them by the sober dictates of political exigency. Clandestine military attacks, civil unrest, and bloody reprisals followed.

The English, seizing on Napoleon's weakest flank, sent Arthur Wellesley (later duke of Wellington) with a large expeditionary force to undermine Bonapartist strength in Spain. The liberal English, so much admired by the intellectual, political, and cultural avant-garde in Spain, finally arrived,

109

and at first it was thought that a hopeful reprieve had come for the desperate people of Spain. But Wellesley's dispatches to the Home Office are evidence that his presence in Spain had nothing to do with the ancient dream of Spanish national liberty and self-determination. After plotting against the Spanish parliament, the Cortes, in session at Cadiz, which was trying to redress some of the medieval injustices of Spanish politics, Wellesley wrote to the British secretary of war, Earl Bathurst: "I wish you would let me know whether, if I should find a fair opportunity of striking at the [Spanish] democracy, the Government would aprove of my doing it." To which Bathurst responded: ". . . if you strike a blow at the democracy in Spain, your conduct will be much approved here." Such was the attitude of the British who had come to "liberate" Spain from French tyranny. And Wellesley's cynicism was matched by the high-handed dispensations of the Allied Powers after 1814.

Ferdinand VII, who had betrayed his parents and his people, who had groveled at the feet of Napoleon and traded off his crown at Napoleon's behest, was recalled from exile in 1814 and reinstalled on the throne he had occupied so briefly after his parents' abdication in 1808. With him there returned to Spain all the vices of feudalism without any of the faith, chivalry, and cultural fervor that had marked the medieval centuries. The Inquisition was reinstated and reinforced beyond the limits of its power during the 17th century. Political repression, justice by torture, blind censorship, the ruthless suppression of all attempts to introduce modern industrial methods and economic legislation, along with a vast system of ecclesiastical and civil spies, made of Spain the most horrendous and exaggerated example of legitimist reaction. Even Metternich and the French Bourbons looked aghast at the severity of repression in Spain.

Goya's initial enthusiasm for the French Revolution probably continued and even took on greater strength and hopefulness with the accession of Napoleon. It is likely that his views were similar to those of Beethoven, who dedicated the *Eroica* Symphony to Napoleon and, later, wrathfully indignant at the emperor's betrayal of the cause of liberty, struck his name from the score. Goya certainly sympathized with the ideals of the empire. Unfortunately, those ideals were only a thin pretext for a policy of conquest and military expansion. Because of the anomalous reaction of the Spanish people, the true ruthlessness of Napoleonic strategy was revealed more nakedly in Spain than anywhere else. Spain had strayed so far from the European family of nations that the French troops regarded the Spanish people with ideas and feelings that were later to inspire colonial armies in Africa and Asia. To Napoleon's troops, the Spanish

people, in distinction to the populations of Austria, Holland, or Prussia, were hardly human and certainly not invested with the right to the normal measure of respect doled out to other subjugated nations. The behavior, arrogance, and depredations of the French troops would surely have alienated even the most ardent Bonapartist. Goya's hatred must have been unbounded—but few of his portraits are as sincerely admiring and sympathetic as those he painted for the officers of the army of occupation. Taken as a man, Commandant Guillemardet, for example, was intelligent, sensitive, thoroughly likable, and Goya painted him as such—independent of Guillemardet's position in the French occupying army. Yet we have no right to ascribe this to a servile, self-interested compromise on Goya's part.

During those years of anguish, uncertainty, continuous bloodshed and betrayal, Goya produced comparatively little. There are several small scenes showing the clandestine operations of guerrilla bands in the Sierras, and undoubtedly he was at work on the preparatory drawings for *The Disasters of War*. The small scenes of cannibalism (in the Musée des Beaux-Arts in Besançon) may also stem from this period, although there is little agreement among scholars about the correct dating of these astonishing but essentially minor works.

The impact and the passions of Napoleon's Spanish campaign lasted much longer than the actual period of war and occupation. Once the Napoleonic troops had withdrawn, Goya painted two masterpieces dealing with the events of 1808: *The Uprising at Puerta del Sol on the Second of May [49]* and *The Execution of Madrileños on the Third of May* [50]. Despite the very specific nature of the events portrayed by these two monumental canvases, their meaning has increased so that by now the paintings have come to symbolize the horror of all modern warfare.

Lafuente Ferrari has justifiably dated what he calls *"la esplosión de la pintura moderna"* with these pictures.* Certainly the sinister light they shed not only on modern war but also on the *condition humaine* makes them fundamental documents for our understanding of a revolutionary era which has perpetuated itself to our day in an unbroken series of catastrophes. The formal aspects of modern art have been constantly changing during the span of time that separates us from Goya. But the underlying convulsions that make these stylistic revolutions inevitable remain the same. We are still suffering from a disease of which Goya was the first to describe the symptoms. *The Second of May* and *The Third of*

*Enrique Lafuente Ferrari, *Goya: El dos de Mayo y los Fusilamientos: Estudio crítico* (Barcelona, 1946). This is among the best analyses of Goya's war imagery.

May have become dates of international history, and they initiate the annals of modern art.

Probably these paintings were meant for a triumphal decoration on the occasion of Ferdinand's return to Madrid in 1814. But just what part they might have played in such a parade is difficult to determine. This is especially true of *The Third of May*, which completely explodes all traditional limits of festival paintings. *The Second of May*, however, might well have fitted into a scheme of illustrations meant to demonstrate to the returning Ferdinand the continued loyalty of his subjects even under the domination of foreign invaders. It is by far the more conventional of the two paintings and in every respect lacks the power, originality, and grandeur of its companion piece. Still, it remains an astonishing prelude to *The Third of May* and is equally without predecessors in the history of painting.

The insurrection that flared up in the Puerta del Sol on 2 May 1808 was spontaneous, fierce, and typical of the unpredictable, erratic course of Spanish guerrilla campaigns, just as its motivation (loyalty to a worthless crown prince) is morally debatable. The battle raged undecided for several hours, and only the crushing superiority of Murat's mounted Mamelukes finally carried the day for the French. It is possible that Goya witnessed the battle, but there is no certainty as to his whereabouts on the fateful day. Whatever the actual background, the painting gives the undeniable impression of being an eyewitness account, and even though it may be uncertain in many passages and hasty and unresolved in others, Goya's conception of the battle picture is radically new.

Battle pictures have a long, venerable history. In Western art, Leonardo da Vinci's *Battle of Anghiari*, the first great climax of heroic proportions, established a standard of composition and attitude that continued to the end of the Baroque. In the center of the composition, two antagonistic forces collide in an intricate whirl of motion and countermotion. Each of the battling forces has an equal weight in a clearly balanced composition. At least visually, the combatants are conceived as equally valorous, strong, and capable of achieving victory. The spectator is put in the privileged position of observing the courage and force of battling men without having anything to lose or gain by their clash. Even in Raphael's great *Battle of Constantine*, where Christianity triumphs over paganism, a viewer can remain fairly neutral because it is taken for granted in all battle pictures that Providence will ensure the victory of right over wrong. In the greatest of Baroque battle scenes, Velázquez's *Surrender of Breda*, the chivalry of both armies again becomes the true theme. More than any other painter of historical scenes, Velázquez had the generosity of temper to give full expression to the worthiness of a defeated enemy.

This neutrality of spirit, which in Velázquez is not a matter of indifference but an active principle of manly ethos, quickly degenerated into what might be called the decorative or picturesque battle genre of the late 17th and 18th centuries. Charles Lebrun's grandiose, operatic battle pieces celebrating Louis XIV, as well as the smaller battle scenes by Adam van der Meulen, share this quality. In the former, the outcome is already decided—Louis XIV by his very presence ensures victory—but the battle is carried on against a powerful, valiant enemy. In the latter, the battle is of interest only as a picturesque element in a landscape. The battle is meant primarily as a visual entertainment and has neither historical nor ethical significance.

The Second of May is unlike any earlier battle picture. Goya (unlike Leonardo) introduces us into the thick of a battle without giving us any assurance that we are in the culminating center of the fight around which all the rest revolves. There are no major axial directions indicated in the composition, and there is no crucial coming together of forces at a given point.

A confused, tumultuous cavalcade comes out of the obscure distance and suddenly, only a few feet from where we stand, swerves sharply to the right without any visible cause. Direct combat is fragmentary and disjointed. A maddened Madrileño stabs the flanks of a horse that rushes past him. A wounded Mameluke is dragged from his saddle. A cuirassier in flight leans backward and menaces an unseen opponent with his raised saber. There is no concerted mass effort—only the blind confusion of a moment in which the causes and reasons for hostility have been forgotten under the blinding desire to escape death by killing those nearest at hand. (With a similar effect of unintelligible dispersion of forces, Stendhal, at the beginning of *The Charterhouse of Parma*, describes the Battle of Waterloo: Everyone, including the hero, rushes about without the slightest awareness of what is happening or where the center of the struggle is. An unprecedentedly modern note is sounded by Goya and Stendhal: Only fragments are capable of being encompassed by our modern limited perceptions. The totality of any experience escapes us.) In *The Second of May*, standing directly among the combatants, we cannot see which way the battle is going. We cannot even tell whether we have become embroiled in a casual clash between mounted soldiers and civilians on foot. And certainly the heroic aspects of the Battle of the Puerta del Sol, which roused the entire population of rural Spain to follow the example of the capital, are very far from our thoughts as they apparently were far from Goya's intentions.

The Second of May is also the antithesis of the great battle epics painted by Napoleon's court painters and inspired by the example of Baron Gros.

113

It is even possible that Goya may have known such vast popular canvases as Gros's *Napoleon at the Battle of Eylau* or his *Battle of Nazareth*, since contemporary etched reproductions were circulated in France and may well have crossed the Pyrenees to serve as propagandistic broadsides in support of the French army. But whether or not Goya knew the official battle pictures, his painting defies the conception of "the man of destiny" by opposing to it the anonymous mass of modern mankind. Goya's contemporaries painted battle pieces from the vantage point of the military strategist who calculates the correct deployment of his forces, reckons up his chances against a known enemy, and tries by means of superior strength or superior feints and ruses to gain precise military advantages. The spectator is privileged to stand at a point somewhere in the vicinity of the great general so that he can perceive the full course of distant fighting and admire the man who, like an orchestral conductor, controls and dominates all the field of vision. The battle is summed up for us in the heroic figure of the general, who godlike, foresees and parries every eventuality. The composition must be clear in order to center on the figure of the invincible hero. The battle rages in front of us, never around us. The austere and clairvoyant previsions of Napoleon are given a visual metaphor by Gros, who disposes his massing, his colors, and his lines of force as authoritatively as Napoleon laid down his plan of attack. There are no unknown quantities, and there are no forces that are not knit up with the whole.

In Goya, the contrary effect is achieved. There is no compositional center, there is no single protagonist who sums up and controls the divergent forces. Our eye is as deprived of leadership as the combatants who murderously attack each other in the dust of the Puerta del Sol. Goya has done away with the theatrical, "directed" aspect of all other battle pictures. It may be that he was not yet able to give an adequate form to the forces he had unleashed, that he destroyed a tradition without fully knowing why it had to be destroyed or what might be the implications of his destructive gesture. In that respect, *The Second of May* could be considered a failure. Its lack of acclaim may be due to a basic misconception on the part of critics who approach it as if it belonged to the category of history painting. Perhaps it is wrong to speak of *The Second of May* as a history painting because the very word "history" implies a series of events that can be understood in their logical interconnection and from which we can draw certain meaningful inferences. Perhaps Goya's vision of history as it manifests itself in *The Second of May* could be better described as belonging to the realm of the chronicle that records as accurately as possible what witnesses thought they saw happening without indulging in any didactic speculation.

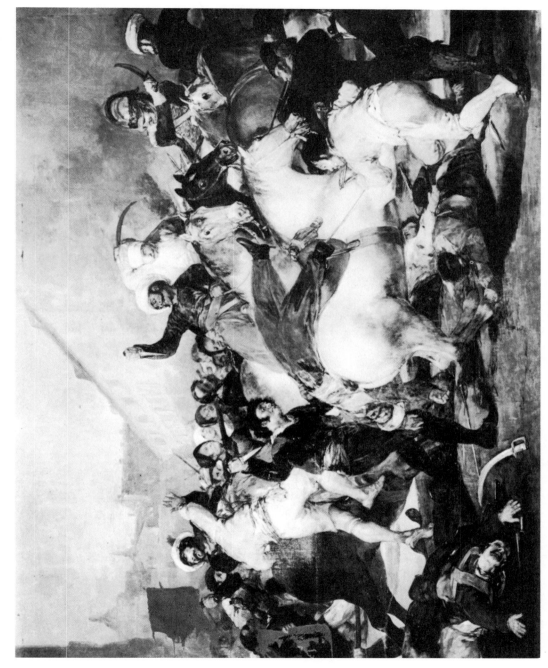

49. Goya, *The Uprising at Puerta del Sol on the Second of May (El dos de Mayo)*. Prado, Madrid.

If one regards Goya's total *oeuvre* from the point of view of modern civilization as a whole, then certainly there can be no doubt that *The Third of May* is Goya's most important achievement. In this painting Goya created not only a new means of expression—this he was to do in the Black Paintings, too—but also a new means of understanding the experience of life itself during the modern epoch. *The Third of May* belongs with that very restricted group of works that leave esthetics, art, and art history far behind to become instead archetypal images that condition the very tenor of existence after their completion. The Parthenon marbles, the mosaics of San Vitale, the frescoes of Giotto in Padua are among the works that extend far beyond the moment of their creation and signal to us across the centuries that a decisive, irrevocable, and irreversible change has taken place in man's course on earth, in his consciousness, in his regard of himself and his hopes, duties, and destiny. Such works remove themselves from ordinary criticism and from even the most refined esthetic speculations. Other works may be more moving or more expressive or qualitatively superior. It is possible to think that Rembrandt's paintings and etchings are superior artistically to the Parthenon figures or to Giotto's modest narratives in the Arena Chapel. But Rembrandt—or any other artist who works in his vein—remains within the realm of the personal. Rembrandt is a singular, miraculous genius. He enlarges our perceptions and refines our sensibilities, he inspires emulation, he ennobles us—but he does not change the very substance of life. He is not, as are the monuments which for lack of a better word I have spoken of as archetypes, a mysterious fissure in time and space through which one seems to perceive a radical manifestation of change in the historical climate of Western civilization. True, the art of the Quattrocento is quite unlike the art of the Cinquecento, and Michelangelo's frescoes in the Sistine Chapel are partially responsible for that change. But there remains an essential continuity of sentiment, a constancy of understanding between past and present. With the creation of Giotto's frescoes in the Arena Chapel and Goya's *The Third of May* we come to works that sever the cord, that sound the signal of a fateful turn (be it confidently cheerful or tragically enigmatic) in the affairs of men.

Two massive formations of men face each other across a narrow gap. A common stable lantern cuts through the ominous nocturnal darkness and pins the group of Madrileño rebels against the execution wall. This group culminates in the central, most brightly lit figure of a man kneeling amid mowed-down corpses, flinging his arms wide in a last gesture of what might be interpreted as rabid defiance or desperate appeal. Rising from the darkness on the right are huddled figures about to face the

enemy's fire. The soldiers who constitute the implacable firing squad are seen from the rear and are entirely cast in the shadowed area of the canvas. Their enormous shakos and the even-tempoed repetition of their bandoliers, scabbards, and broad belts bind them into one massive form which terminates in the insectlike spikes of their menacing gun muzzles and planted bayonets. In the far distance, a solitary steeple shows feebly against the night sky. But the darkness is so dense and the focus so completely concentrated on the foreground that nothing distracts the eye. No setting, no atmospheric effects, no compositional harmonies distract the eye or the mind from the climactic encounter between executioners and victims.

The abrupt juxtaposition of figures in this picture has the most unsettling effect, and no visitor to the Prado has failed to experience a marked and shocking disparity between it and all the other paintings housed in the same museum. Without exception, all the other pictures declare themselves as composed realities. Raw facts have been contemplated, rearranged, and then presented to us. Art was meant for our pleasure or for our instruction; someone has taken us by the hand and guided us. With *The Third of May* we are suddenly thrust unguided into a brutal scene of murder and anguish. The true force of the picture lies in its ferocious shock value. The terror and the cry of the central figure go beyond the picture frame and ring out at us. Goya has seized the moment with the unabashed bluntness of his temperament and forced it upon us in its raw state and without the tact of artifice. There is much here that might be called vulgar, and certainly the spirit of this painting embodies the beginning of the modern advertisement that aims at calling attention to itself at any price. Goya thrusts aside all traditions in a way that will deliberately make us aware of the traditions he is about to destroy. Just as in *The Family of Charles IV*, Goya insists on reminding us of certain earlier harmonies in order to make their disappearance all the more devastating.

In structure and in basic theme, this painting grows out of a long tradition of martyrdom pictures. The piercing light, the last, heart-rending appeal of a life about to come to a violent and undeserved end, the spectral darkness, the brutal indifference of the executioners—all these elements have appeared in a hundred varied guises throughout more than fifteen centuries of Christian art. Horrifying mutilations, cruel torments, spilled blood, and expiring men and women have appeared on the altars of every European nation, and even the fastidious and delicate Rococo never shrank from fierce depictions of martyrdoms. Tiepolo especially attained the full heights of his talent in this genre without ever disguising the brutality of

his drama. Such pictures as the magnificent *Martyrdom of St. Agatha* in Berlin or the forceful *Martyrdom of St. John* in the Colleoni Chapel in Bergamo are unsparing of blood and agony. Yet in all of these paintings one can fully enjoy the artist's mastery, his brilliant display of palette, and this magical evocation of lights and textures without ever being taken aback at the discrepancy between the cruelty of the subject and the casual delight we take in the multitude of visual delectations set before us. For Tiepolo, the last of the great Baroque artists, there is no essential discrepancy between the beauty of his painting and the horror of the subject matter because he perceives the saint's martyrdom as something infinitely beautiful which must be rendered in a harmonious, even enchanting, fashion. To Tiepolo and to all Christian painters before Goya's age, martyrdom is beautiful because it is proof of the highest moral harmony. Martyrdom brings God close to earth.

In the case of Goya's painting, we feel a fully justified reluctance to indulge in any kind of esthetic appreciation of his artistic imagination or his technical skill. The subject is so compelling, so devoid of ulterior meaning, so incapable of being resolved by the grace of divine will, that we shrink from the cowardice of evaluating *The Third of May* on any terms but its own. Brushwork, palette, compositional ingenuity seem irrelevant because Goya refuses to allow us to look at his picture with detachment. He forces us to take sides; he demands that we declare our positions. Actually, from about 1800 on, the work of every painter either contains or is thought to contain a polemical challenge—one that is either deliberately placed there by the artist himself (as in the case of Courbet) or else read into the paintings by the public. To the contemporary public, even such politically neutral paintings as Matisse's landscapes looked so bold and unconventional in color and design as to indicate that anarchic forces were at work.

And yet despite its anonymity, it is precisely into *The Third of May* that Goya poured the most intense and deliberate pictorial intelligence. For the last time he paints a picture that still bears a full didactic charge. For the last time he paints a picture in the hope of changing the hearts of men. For the last time he tries to wake us from "the sleep of reason" ("*el sueño de la razón*") into which the world has fallen as if drugged by continuous years of violence and bloodshed. The appeal of the central figure who faces the firing squad is identical with Goya's appeal. He calls out in the hope of being heard. (All of Goya's later pictures, with the exception of a small handful of vapid official commissions, are painted as if there were no eyes to see them except his own.) He wants to teach a lesson, and he has recourse to the most forceful means in order to make

the conclusion intransigently clear: He insists on conveying the terror without the Aristotelian pity that in previous paintings of martyrdom led to catharsis. In this respect, too, this painting is among the first truly modern pictures: It does not seek to transubstantiate the theme with which it deals. There is no catharsis—no means of making our peace with facts Goya thrusts upon us. The unbroken tradition of Spanish painting, which, unlike Franco-Italian painting, never became permeated with esthetic speculation but always remained firmly religio-ethical in purpose, appears before us in all its fullness. After this it subsided and did not arise in its vengeful, outraged grandeur until the fateful year 1937, when the bombs dropping on Guernica recalled Picasso to the obligations of being a Spaniard.

The lantern with its sharp light is the painting's central element not only compositionally but also thematically. The basic principles of illumination that Goya employs here depend on early Baroque traditions that were first fully formulated by Caravaggio and then broadcast by his direct and indirect disciples. A sharply concentrated light source gives bold relief to the major forms of the composition, thrusting other areas into suspenseful darkness. Using the same methods, Goya has reversed all the traditional values and intentions of this venerable and effective Baroque scheme of lighting. In Caravaggio as well as in the work of Caravaggio's followers, the light is always equated with the light of God. Even when this light is actually present in the composition in the form of a torch or a candle, it still represents "illumination" in the most religious sense of the word. It is the gift of heaven which permits us to perceive the truth. It is also the visible evidence of God's blessing. This is especially true of martyrdom scenes in which light is manifest proof of the ultimate transfiguration of the tormented victim. This ennobling quality of light is evident even in secular paintings by the Protestant Rembrandt, whose light always indicates compassion and a prodigiously heightened awareness of the mysteries of human love. With Goya, the light is not an emanation of God. It is no longer the signal of the miracle of transfiguration. Quite the contrary, it is the conscienceless implement that assists the executioners in accurately carrying out their gruesome duty. It is a common lantern bereft of symbolic and consolatory meaning, and it is on the side of the assassins. It hunts the victims in the darkness and delivers them to the pitiless muzzles of the French riflemen. Such a light must necessarily reveal a world that is quite different in substance and meaning from the world revealed to us by the mystic glow of Baroque "illumination."

It is not only the light that is secular, brutally glaring, and an implement

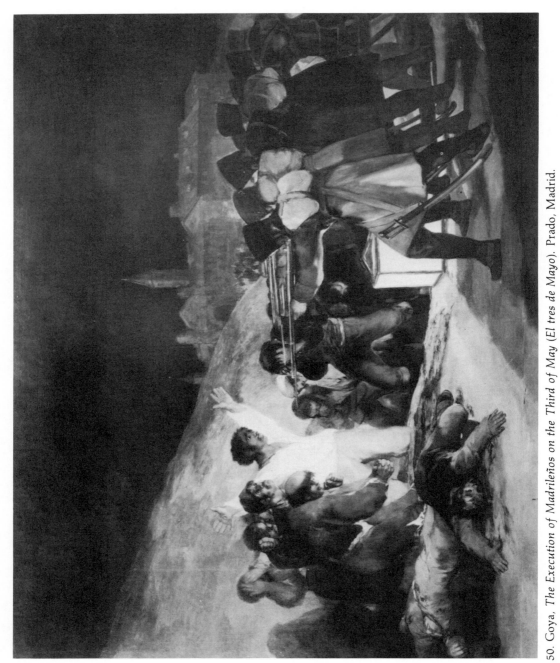

50. Goya, *The Execution of Madrileños on the Third of May (El tres de Mayo)*. Prado, Madrid.

in the hands of the executioners. Goya has chosen a perspectival point of view that makes us accomplices after the fact. What Leo Steinberg has brilliantly demonstrated to be true of Caravaggio's Cerasi Chapel pictures is, *mutatis mutandis*, true of many Baroque altars.* We are placed in relation to the narrative figures so that we will feel ourselves physically as well as spiritually on the side of the saints. Some of the aura of their sanctity, some particle of their moral fortitude falls on us and makes us worthier of partaking in the ritual mysteries of the faith, opening up a direct path to the consolations of religious exercise. But in the world of *The Third of May* there is room for us only behind the French execution squad. Whoever does not walk in the procession of the condemned stands among the executioners. The heart-rending quality of the appeal of the young man about to be shot lies partly in its being addressed not in the oratorical manner to a neutral audience or to God, but in the urgent and heedless intimacy that exists between the murderer and the murdered—and in this most concise of dramas we are cast among the deaf murderers. To survive is to be guilty of complicity.

At this point another divergence from the tradition of martyrdom paintings becomes evident. A *sine qua non* of martyrdom scenes is the ecstasy of the martyred saint, whose plea for salvation is always heard and granted by God. Angels bearing the palm of martyrdom, an outpouring of heavenly light, or some other symbolic representation guarantee God's blessing. Death—especially sacrificial death—brings us close to the divine presence. Our prayers fall immediately on God's ears. The foreknowledge of the soul's salvation consoles the martyr for the physical torment of his death. By implication, all Christians are incited to offer their death and their pain to God, who will not abandon them in their hour of greatest need. But the appeal of the victims in Goya's painting is made into an unheeding darkness which does not even throw back a hollow echo. The French soldiers, depicted entirely from the rear, are so totally bent on their office that they cannot have eyes or ears for anything but the task they have been ordered to perform.

In the figure of the central protagonist, Goya concentrates all the indications that justify and even make imperative our evocation of earlier religious paintings. Not only is the figure seen in a position that has become the canonical attitude of Christ in the Garden of Gethsemane, but his right hand bears unmistakable signs of the stigmata. Goya has resorted to much the same method that he used in *The Family of Charles IV*. He has deliberately and even clumsily reminded us of an earlier prototype,

* Leo Steinberg, "Observations in the Cerasi Chapel," *Art Bulletin*, Vol. 41 (June 1959), pp. 138-90.

and then, by pulling the props out from under us, forced us to recognize that the values and the significance of the earlier representations have utterly vanished from the modern scene. He presents us with a protagonist in the traditional pose of Christ, with the traditional attributes of Christ (the stigmata), and even clothes him in the canonical colors of the Catholic Church (yellow and white are the heraldic colors of the Church), but all these attributes and reminiscences are in vain. The victim with the outflung arms never achieves the sanctity or the meaning of Christ. In his way, he is as anonymous, as bereft of character as the French soldiers. Goya is not naive. The process of deindividualization which he has clearly symbolized in the massive consolidation of the mechanical firing squad is equally apparent in the pitiful cortege of the victims. All previous altars and all previous monuments were raised to the memory of heroes and their exemplary destiny. *The Third of May* is the first altar to the anonymous millions whose death is irrelevant. Anonymity becomes a condition of modern man. But Goya is still capable of dealing with anonymity without having recourse to the official cant embodied in later monuments "To the Unknown Soldier." He tells us clearly that there is as little sense in dying as there is in killing.

It would be wrong to speak of the central figure as the hero of the composition. He is only the protagonist. His fate is not an individual fate, his death is not an event of special worth and special sanctity. For spread out on the ground in the foreground just beneath the central figure there lies a bleeding cadaver, and the position of this corpse makes it quite clear that he, during the last moments of his life, had flung up his arms in the identical gesture of despairing appeal that is now made by the central figure. Death is no longer an individual occurrence beheld and judged by an infinitely aware God. It is instead a repeatable, impersonal disruption of life devoid of special significance.

Goya's composition implies a continuity of time and action that no previous painting ever had. The "moment" chosen by Goya is not comparable to the "moment" chosen by any Baroque artist in a martyrdom scene or to the "moment" chosen by David in his overwhelming *Death of Marat* [48]. For all previous painters, the manner of life and the manner of death of their heroes are unrepeatable and conclusive. By the example of their fortitude in death, we are urged to find strength to face our own trials with virtue. Goya has not singled out such a climax. He merely shows us one of many identical moments. The corpse on the ground [51] only an instant ago kneeled in the same position as the man in yellow trousers. Out of the darkness there rises a slow procession of new victims who will assume the same posture and suffer the same fate. Death proves

51. Goya, *The Third of May*. Detail. Prado, Madrid.

nothing. It does not serve as an example; it is not something extraordinary that makes time come to a stop. Nor does it mark the transition to something more glorious than life.*

* Certainly death crops up in countless paintings and sculptures throughout Europe. But not one of these paintings from other countries has the power to project the utter finality of death that occurs almost constantly in Spanish art. Even 18th-century Spain does not deviate from this national steadfastness in the face of death, although death, as a theme, is generally banished from 18th-century nonfunerary art. Here and there, however, references are made to death, as, for instance, in Jörg Zürn's *Crucifix* [52]. The bottom of the cross is attached to a graceful rocaille representing Golgotha and, according to tradition, Adam's grave is indicated by means of a skull from the eye sockets of which a snake wends its graceful way [53]. Both skull and snake are pleasingly absorbed into the rhythmic forms of the Golgotha rocaille. Francisco Salzillo (whose life span, 1707–83, partially overlaps Goya's) treats the theme with typically Spanish sobriety to achieve a stunning effect that suddenly transposes human death to quite a different dimension. The body of Christ, as in Zürn's crucifix, is properly graceful in attitude and conventionally modeled [54]. The head of Adam, however, which is attached at the bottom of the cross, shows a skull that is still in a state of decomposition rather than being clean bone. And in the greedy mouth of the skull there still sticks the Apple of the Tree of the Knowledge of Good and Evil [55]—the instrument of man's perdition, of original sin, and of death. Adam's death is not put back into the distant perspective of the beginning of all time. It is instead terrifyingly operative among all mankind today. Sin still chokes us to death. No image outside of Spain gives such concrete form to the "liveliness" of death. No image (before Goya's time) interprets the putrefaction of death with such reportorial impartiality.

The quality of this modern conception of death can best be judged by glancing again at the corpse with its shattered head in the left foreground [51]. It, too, represents a unique novelty in the total repertory of Western representations of the human figure. It cannot truly be categorized under the heading of "figure painting." Instead, Goya has treated it more like a still life. A repulsive clump of mangled and bleeding flesh has been flung down on the earth in a graceless attitude. With great mastery, Goya has switched the perspectival point of view in this passage of the picture so that we look down on the corpse, whereas our eye level for the rest of the painting is calculated more or less along the central horizontal axis. Compared to the corpses painted by earlier artists—and there have been some fairly brutal corpses, such as the hollowed-out carcass in Rembrandt's *Anatomy Lesson of Dr. Dijman*—this is the only truly convincing corpse. All the others retain the aureole of man made, as Genesis tells us, in the image of God. Even the eviscerated *Slaughtered Ox* by Rembrandt retains all the serene dignity of something that once was beautiful. It retains the suggestion of being capable of resuscitation, of being called back to life at the sound of the last trumpet. No such resurrection awaits the dead in Goya's world. The stark finality of death, the ruthless cancellation of all traces of life, make it hard to believe that this hideous lump of disintegrating flesh once was capable of motion, of feeling, of laughter, or of tears. It is as if it had always been a corpse.

Even later artists hesitated to describe death in such drastic terms. Compared to Goya's corpse, the dead bodies that litter the ground of Delacroix's *Liberty at the Barricades* are heroically beautiful and almost attractive. The same holds true of Géricault's corpses in the *Raft of the Medusa*, and only in the studies of corpses that Géricault made in morgues and dissection rooms do we find a distinctly germane attitude toward death [56]. Still, even in this most radical picture ever painted on the theme of death by a non-Spanish artist, finality and the total devotion to experienced truth achieved by Goya are not attained. In Géricault one still senses a strong vestige of deliberate artifice and artfulness which is quite absent from Goya. Géricault shocks us, and his motivation, his presence are very much part of the picture. The revulsion caused by his severed heads is strong and immediate—but it is contrived, and part of the shudder we feel as we look at the Géricault is due to a pleasurable estheticized thrill. Essentially, Géricault's statement concerns art while Goya's statement concerns death. Géricault has made a great painting out of a frightful subject. Goya is far from being interested in proving a point about the independence of painting from subject. In Géricault we can still admire the virtuosity of certain passages: the delicate range of discoloration in

52. Jörg Zürn, *Crucifix*. Bayerisches
Museum, Munich.
53. Jörg Zürn, *Crucifix*. Detail.
Bayerisches Museum, Munich.

the white cloth, for instance, as it is stained by blood in different stages of clotting. Goya's technique is no less masterful. But he has taken great care to efface it utterly. Certainly, it would be foolish to suggest that anyone approach the Géricault in an analytical manner. The first and foremost response is one of horror. But at some point in our contemplation of the picture we are justified in looking at the brushwork of the artist as a detachable quality that can be enjoyed for its own sake regardless of the subject. In the Goya we are never invited to entertain similar attitudes toward the painting, and if we do so, we do so in order to escape from an unbearable situation and not because the artist has suggested a way out. The subject and the calligraphy cannot be divided from one another, and even if we arbitrarily choose a detail so small that we can no longer recognize anything but brush and pigment, the intrinsic repulsiveness of

the subject would come through just the same. Goya has arrogated to himself the right and the liberty of taking his cue not from traditional concepts of acceptable technique, but from the subject alone. The jumble of brushstrokes, the sluggishness of the pigment, the dissonance of reds

54. Francisco Salzillo, *Christ of the Facistó* (*Cristo del Facistó*). Murcia Cathedral.

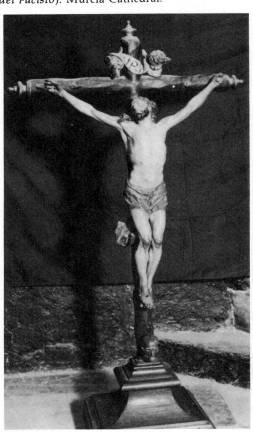

55. Francisco Salzillo, *Christ of the Facistó*. Detail. Murcia Cathedral.

56. Théodore Géricault, *Guillotined Heads*. National Museum, Stockholm.

are, on an abstract level, the exact equivalent of the lurid grisliness of the mangled head. Goya has painted an ugly subject in an ugly way. Géricault paints a similarly ghastly subject with consummate skill. There is a last trace of Baroque theatricality left in Géricault. His severed heads are eloquent. They still communicate terror and pity. Goya's corpse communicates nothing at all except ultimate, complete extinction. It is conceivable that the ghosts of Géricault's guillotined men might return to haunt us as ghosts. With Goya's corpse it is as if the living, breathing man, who now is but a lump of flesh, had never been.

The Disasters of War

The *Third of May* is the monumental crystallization of a long, scrupulously assimilated experience. The stages of this experience are recorded, incident by incident, in a series of prints known collectively as *The Disasters of War (Los desastres de la guerra).* The *Disasters* are at once the beginning and unrivaled climax of modern graphics. The testimony to chaos, bestiality, and terror, the rejection of conventional consolations that are given a general, universal monument in *The Third of May* are given personal and particularized form in the *Disasters.*

Most of the scenes recorded in the *Disasters* probably had their beginnings in notations made on the spot. All of the pages have an inevitability and an impetuousness that give them the double impact of being at once truthful testimony of all that is vulnerable, vile, insane, and cruel in man and an urgent exorcism of such knowledge regarding the nature of the human beast. Unlike the pages of the *Caprichos,* these scenes were not etched in order to shake and waken the beholder. They were created because his art is the only defense and the only sustenance left to an artist in the face of what Goya witnessed. These plates obviously had to be created by the artist without any further thought about their ultimate purpose. Goya never intended them for publication during his lifetime. They were not presented to the public until more than fifty years after the artist had died and more than seventy years after he had first engraved them. It may be possible that Goya hoped once—as many artists and writers have hoped since—that the time might come when mankind would reach a level of sensibility at which the mere record of the insensate and purposeless cruelties of war would serve as a salutary warning to all men. If he ever entertained such vain hopes, we are not informed of them, and certainly he seems to have abandoned such ideas after the restoration

57. Goya, Sad presentiments of what will happen (*Tristes presentimientos de lo que ha acontecer*). *Disasters* No. 1. Metropolitan Museum of Art, New York. Mortimer Schiff Fund, 1922.

of the Bourbons revealed itself as even more degrading and regressive than the Napoleonic regime. The last pages of this remarkable series were probably the result not of the war but of the equally cruel years that followed.

What is now the first page [57] of the series was probably executed late because in spirit and technique it belongs to the more allegorical images with which the *Disasters* end. Instead of showing us an actual scene from the war, as he does in the major body of the *Disasters*, he shows us instead an elderly man who has sunk to his knees in the surrounding darkness, his arms flung wide in a gesture of questioning desperation which is quite akin to, though far more muted than, the gesture of the central figure in *The Third of May*. The Biblical source also seems to be the same: the scene of Christ at Gethsemane. The title of the page emphasizes the Biblical analogy. "Sad presentiments of what will happen" calls to mind

Christ's pleas for the bitter cup to be taken from him. The elderly man of the first page, probably Goya himself, prays that he may be spared the visions that are to follow. But just as Christ resigned himself to the cross, so the artist must resign himself to seeing what his implacably sensitive eyes reveal to him. Technically and formally, this plate is among the more conventional of the series. The nocturnal mood is achieved by the traditional use of massive cross-hatching. In many ways, this image stands under the sign of Rembrandt. Only the spectral use of double images (insubstantial faces and animal figures which float about in the darkness and are hardly recognizable unless one turns the page on its sides) links this plate with the world of nightmare visions that first appear in the *Caprichos*.

The other pages of the *Disasters*, with the exception of the last fifteen, are entirely free from references to the world of nightmare or madness. More than any other graphic series by Goya, the *Disasters* are dedicated to observed actuality transmitted with gruelling directness. The subject matter is of so urgent a nature that it seems to find its own, direct mode of expression just as panic will find relief in a cry of terror rather than in a sequence of coherent words. The artistry of Goya lies in the indomitably sensitive perception that functions even in the face of the most sickening heaps of mutilated corpses. If there is one motto that can stand as the key to the entire series, it must necessarily be "I saw this" ("*Yo lo vi*"), the caption of Plate 44 [*58*]. Just as he abdicated his right as interpreter while painting the portrait of the royal family, so here, while confronting blind bestiality and things that "One cannot look at" ("*No se puede mirar*"), the caption of Plate 26 [*59*], he rejects the artist's prerogative to do anything but bear witness. There are horrors that must not be tampered with, a pain so intense that even compassion is insulting. To go beyond the mere description of such terror and such anguish is to belittle it. There are no inferences to be drawn from it, there are no lessons to be learned from it, there is no hope of ever achieving the absolute, the categorical ruthlessness and self-sufficiency of such an experience. Henry James's father called such an experience a "vastation," a gratuitous demolition of all that had once been pleasurable or meaningful in life, a realization of the stark anarchy that reigns in the outside world as mindlessly as it does in the interior world of irrational lusts and fears.

In many ways, Goya, in the *Disasters*, resembles more the few photographic news reporters of genius and dedication of the 20th century than he does any of his contemporaries or predecessors. Like the news photographer, Goya seeks to bear witness to the fundamental nature of man's eternal warfare against himself, he seeks to bring to the attention of the

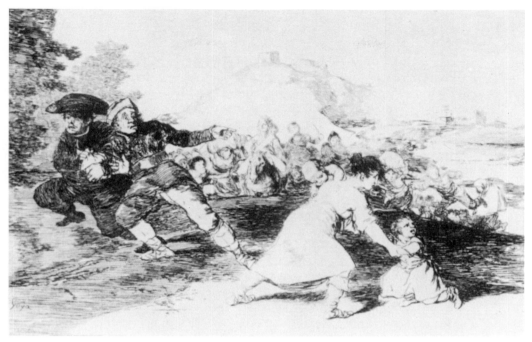

58. Goya, I saw this (*Yo lo vi*). *Disasters* No. 44. Metropolitan Museum of Art. Harris Brisbane Dick Fund, 1932.

59. Goya, One cannot look at [this] (*No se puede mirar*). *Disasters* No. 26. Metropolitan Museum of Art. Mortimer Schiff Fund, 1922.

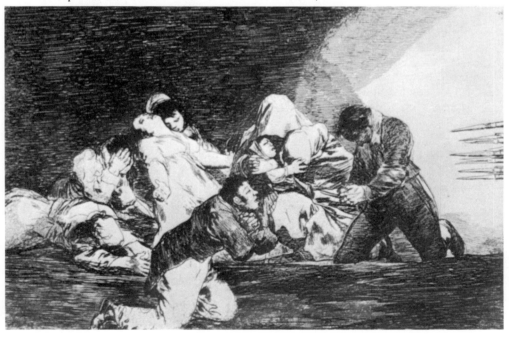

fatuous and the forgetful the fact that the world is divided into two races: the complacent and the wretched. Both states of mind are equally incompatible with the dignity man might achieve. And both states have lost the juncture between them that once lay in the common belief that it was God's ordained will that misery and heedless selfishness should live side by side.

The analogy between Goya and the modern news photographer goes beyond a mere similarity of purpose: that of bearing witness to the essential realities of our world. The means that Goya employs and the novel relationships that bind him to his subject as well as to his finished work are also comparable. For like his later colleagues, Goya "focuses" on a *motif* in a way that is much closer to the procedures of a sensitive photographer than it is to earlier printmakers. In order to achieve the maximum of expressive content, the photographer must control (by means of focal length, aperture, etc.) our manner of perception without tampering with the facts that are perceived. Motif takes precedence over composition. He is free to move his camera to achieve as great an impact as possible. But the great news photographer cannot arrange the elements of his image. Like the news photographer Goya rejects the harmony sought by all previous image-makers and substitutes immediacy of testimony to observed fact. Whereas earlier artists (and many of Goya's successors as well) were concerned with their ability to transform realities into a pleasing and instructive picture, Goya (in his *Disasters*) and the modern news photographer convey observations. Their quality can be judged primarily by their intuitive ability to find the most highly charged view of things as they are. One enters on earlier images guided by the artist in the intricacies of his artifice. Goya and news photographers do not allow us time to gradually enter their pictorial space but aggressively arrest our attention with the immediacy of a blow.

A visual comparison illustrates better than words Goya's peculiar modernity of attitude toward ascertainable reality. When one glances at *A Harvest of Death: Gettysburg July 1863* [60] and then turns to Plate 18 of the *Disasters* [61], the similarity of intent, the equally brutal sobriety and the shocking immediacy of the two images clearly establish a common denominator between the two images.

If one adds to this visual experiment a third picture, Jacques Callot's view of a battlefield [62], Goya's proximity to photography becomes even more striking. Callot's calligraphy, his obvious arrangement of rhythms and accents, declares itself immediately. Goya's image seems as incontrovertible as the image produced by an impassive camera shutter. Naturally, this is not to say that either Goya or a gifted photographer is deprived of

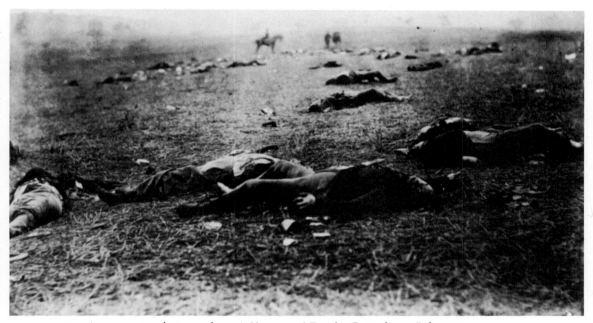

60. Anonymous photographer. *A Harvest of Death: Gettysburg, July 1863.*
International Museum of Photography, George Eastman House, Rochester, N.Y.

personality and of highly individualized emotional and intellectual reactions. One can recognize a Goya print as being Goya's just as one can recognize the authorship of a photograph by Paul Strand. But now the personal element in art is included almost inadvertently in the images that are produced. The artist strives after anonymity, and if his personality shows just the same, it is projected in spite of himself and not through any carefully studied stance.

Looking at the graphic arts and at modern photography in broad historical perspective, it becomes quite obvious that Goya's etchings can profitably be compared to certain aspects of photography (especially news photography) while the work of Mantegna, Dürer, or Rembrandt is totally incompatible with it. Even though technically and economically there are certain parallels between graphic art and photography (both are almost infinitely reproducible, both reduce imagery to black and white, both are created by physical change wrought on the surface of a plate, and both are meant to be broadcast very widely and at small expense), pre-Goya

133

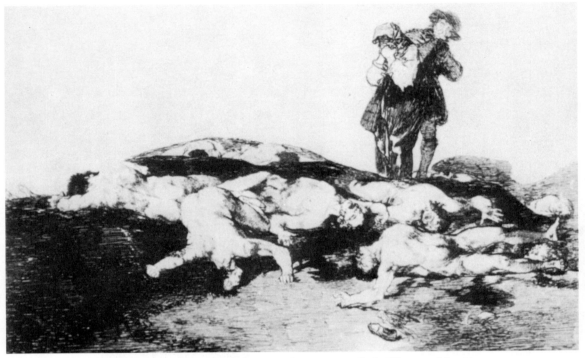

61. Goya, Bury [them] and shut up (*Enterrar y callar*). *Disasters* No. 18.
Metropolitan Museum of Art, New York. Harris Brisbane Dick Fund, 1932.

62. Jacques Callot, The Peasants' Revenge (*La Revanche des paysans*), from
Troubles of War (*Misères et malheurs de la guerre*). Metropolitan Museum of
Art, New York. Rogers Fund, 1922.

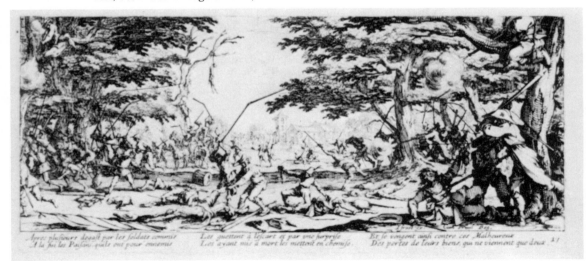

printers begin with a mental image that reconciles esthetic, ethical, or religious ideals with palpable realities. Leonardo's dictum of art being a thing of the mind holds true even when, as happens in the case of some Dutch engravers, topographical truth in landscape etchings is a criterion. Goya, and those artists of the 19th century who belong to the avant-garde of their epochs, deal less and less with the authority of their own artistic imagination and more and more with conveying the sense of an obsessively urgent reality which stimulates their fantasy but lies beyond their rational control. In artists before and after Goya, there remains a certain interaction between the artist's individuality and the exterior world as perceived through the individual's senses. But the beginnings of the creative process are reversed. The Renaissance-Baroque artist takes human dominion over brute reality as a matter of course and deals with reality in the light of his steadfast beliefs. In Goya, and in artists following him, this sense of the individual being as lord of Creation is lost and the outside world obsesses and challenges him by being beyond his grasp, unknowable and indomitable. Rather than shaping reality and interpreting it, the artist and his work are shaped by the mysterious demands that the outside world makes on him. Meryon, Daumier, Guys, Degas (the last a talented amateur photographer) have their distinct place in this genealogy. They take their cue from the introvertible call of an autonomous world that is alien to human desires and aspiration. They submit to this reality and content themselves with representing teasing fragments that for a fleeting instant promise to reveal hidden meaning. They try like hunters to surprise their quarry in its most unselfconscious moments. They stalk it either as detached but restless *flâneurs* (Guys, Degas) or as grim avengers (Daumier).

The usual argument that photography "freed" the artist to advance toward positions that are totally independent of the description or transcription of realities is as erroneous as it is superficial. Photography did not liberate the artist from imitation. It indicated, instead, an entirely new ethos for dealing with observed facts, and in this intricate dialectic between artist and physically ascertainable reality, photography and painting influence each other reciprocally in the most unexpected and significant ways, so that it becomes idle to draw up a balance sheet of which art influenced the other more profoundly or more decisively.

It might be argued that the violence and intransigent brutality of Goya's subject matter are what give his work its peculiar modernity and inescapable directness. But one need only revert to Callot's magnificent *Troubles of War (Misères et malheurs de la guerre)* to see that subject matter itself is not sufficient to explain the extraordinary power of Goya's prints. In

subject matter, Goya is hardly different from Callot, whose work may well have provided not only an inspiration but also the very title of Goya's work. Goya's *Disasters* represents the discovery of an entirely new pictorial idiom. Thematically, the two series of prints, Callot's and Goya's, stand in much the same relationship as the Old and New Testament. The basic subject of argument is the same in both series. Both artists deal with inhumanity as the two Testaments deal with man's salvation. But just as the New Testament introduces a new logic into the system of salvation and posits a new view of the sacred history of man and of God, so Goya's new dispensation is based on a totally new conception of the conflict between hoped-for moral order and actual immorality.

For Callot, mankind is still the elect among all the creatures of the Lord. Even in his iniquity, he can receive absolution; even hanged or broken on the wheel, he remains true to his origins, which are "in the image of God." For Callot, living in an age that believed human justice to be the product of divine inspiration, atrocious punishments were part of a logical scheme of things. The arsonist paying his debt to society by being quartered enters into a sensible frame of divine retribution with which the artist has no quarrel. The rather detached virtuoso effects with which Callot renders the most hair-raising scenes of pillage, torture, and death do not in any way contradict his subject matter. On the contrary, they are eminently suitable for the purpose he has in mind of illustrating the terrible but rational drama of man's transgression and God's retribution. One can (and perhaps should) take exception to Pierre-Paul Plan's description of Callot's work in his monograph on the artist: *"Ce sont toujours des guignols divertissants qu'on nous montre avec le talent le plus surprenant"* ("We are shown entertaining horrors with the most surprising talent").* Yet there is, in essence, a quality of the spectacle about Callot. He is a witty, observant stage director who, because of his enormous flair, can make his actors do the most astonishing things. In one extraordinary passage [62], an elegant figure kneeling by the side of a body stretched out on the ground raises in his hands what looks like an intricate, arabesque heap of ribbons. When we look more attentively and have recourse to a magnifying glass, however, we realize that the ribbons aren't ribbons at all but the fresh entrails of the eviscerated corpse on the ground. Still, even after we have made this macabre discovery, the elegance of the visual episode tempers the latent horror, so that it hardly disturbs us. Callot represents cruelties with such aplomb that he conveys to us, through the sheer beauty of his design, the beauty of a world in which even grisly occurrences take on a logical coherence, a rational consequentiality that

*P.-P. Plan, *Jacques Callot, maître graveur* (Brussels and Paris, 1914).

takes the edge off their horror. From this point of view, Callot is able to do justice to the ideal of human dignity and goodness at the same time that he also presents to us the fact that, all too often, this ideal is violated by the wickedness of sinners.

Plate 14 of the *Disasters* [63] is quite typical of the general vision that Goya presents. We are not told, as we were by Callot, that the men who have already been hanged or are about to be executed deserved their punishments because of their crimes. Nor does Goya go to the other extreme of enlisting our sympathy by telling us that they were unjustly sentenced and executed. Both these appeals would depend on a stable and reliable standard of justice. Instead, Goya insists on our making a choice without allowing us recourse to logic or conventions of legal justice. We are told only that two men have been hanged and that a third is being

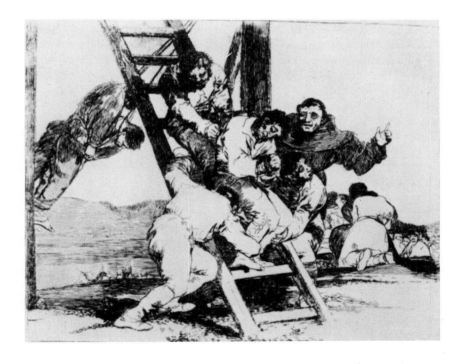

63. Goya, Hard is the way! (*Duro es el paso!*). *Disasters* No. 14. Metropolitan Museum of Art, New York. Mortimer Schiff Fund, 1922.

dragged up a ladder to be killed in the same manner. The legal aspects of the case or its moral rationalization matters as little as does the age-old boys' cry, "He kicked me first!" "Who killed whom" and "Who killed why" are matters that needn't concern us—which, indeed, if one looks at Goya's plate, *shouldn't* concern us. We are not given the chance to judge the case. Either every fiber within us calls out to stop the killing or else we seek cowardly refuge by trying to "get the facts straight so that we can judge." But there is no time to get the facts straight. Few plates in the *Disasters* are so urgent as this one. The impact is instant and physical. Even so realistic a drawing as Anibale Carracci's *Hanging* [64]—which is a sport, a freak among old master drawings—does not have the impact of Goya's Plate 14. Again, it is the total *Weltanschauung* of the artist that must concern us. For Carracci, the hanging is, for all its repulsiveness, a justifiable act. Justice, either true or perverted, has taken its course, and there is time enough to wait for Gabriel's trumpet to see whether the hanged wretch or his judge is the true culprit. Such scenes were drawn, by Carracci and artists like him, as curiosities. They were never intended to be worked up into major creations because the realistic depiction of an event had little value to these artists. It is in the noble and imaginative interpretation of reality that the artist sees his true function, and even

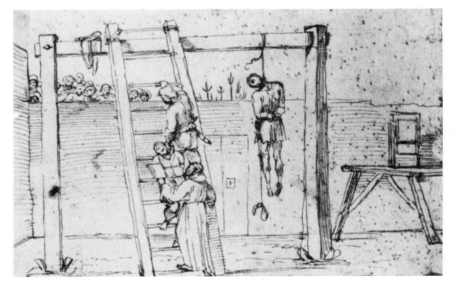

64. Anibale Carracci, *Hanging*. Royal Library, Windsor Castle.

though there exists a gulf between the art of Carracci and Caravaggio, they have this outlook in common. The artist, not the subject, decides on stylistic exigencies, interpretation, composition, line, and color. The raw material has been thoroughly articulated and wrought in the image of the master's own temperament.

Plate 14 of Goya's *Disasters* starts from entirely different premises Goya maintains the autonomy of an observed fact and suppresses his own reactions to what he has seen in order to give greater independence to the facts. All earlier artists visibly heightened and concentrated their effects so that we can enjoy their artifice and the unique character of their perceptions while looking at scenes that are, in themselves, agonizing. The most realistic of Baroque martyrdom scenes simultaneously offers consolation for its horror by letting us discover the inventiveness of the artist's genius as it stands revealed in his presentation of the scene. The persuasiveness of his visual inventions and his generosity in letting us share in his intelligent devices are our reward. In Goya, all these venerable principles of visual rhetoric (in the best sense of the word) are discarded. Goya wants instead to vouch for the impersonal, impassive transmission of observed fact. He merely finds the one vantage point at which the scene most completely reveals itself. He forces us to see with *our* eyes, not with his. The critic who draws attention to Goya's ability as an artist actually does Goya a disservice. Images such as these are clear evidence that the artist intends us to be exclusively preoccupied with the unbearable inhumanity of what is happening before our eyes. In the face of what happens all around us, the talent and the ingenuity of the artist seem trivial.

Even when one does turn to a compositional analysis of Plate 14 and notices the intricacies involved, the basic objectivity of Goya's attitude does not change. Of course, he arranges *his* diagonals in such a way that the swing of the two hanged men in the left background gains a sickening momentum. He *does* suppress features of the foreground in order to emphasize the figures, and he cuts the composition at the top and sides so that the figures and not the scaffolding of the gibbet will occupy our attention. But these changes, arrangements, and omissions are not dictated by a desire for a more harmonious composition or an esthetically viable effect. The adjustments are made entirely in order to serve the brutal transmission of a brutal fact. We are never asked to admire Goya's artifice. We are asked to wake up to the horrors from which we normally hide. Artistry is subjugated to fact. It becomes a means rather than an end—just as a photograph of the Battle of Gettysburg is meant to bring home the facts of the battle and not the patriotic meaning of the soldiers' sacrifice. Abraham Lincoln's rhetoric calls to mind not the soldiers lying exhausted

or dead on the battlefield but the figure of Abraham Lincoln trying hard to make the sacrifice seem worthwhile. We never think of the photographer when we look at Mathew Brady's photographs of the Civil War. We think only of the devastation and bloodshed. Reading the Gettysburg Address tells us nothing about what happened to an obscure Pennsylvania village and a great deal about Abraham Lincoln's political and oratorical talents. Looking at a photograph of the Battle of Gettysburg conveys everything we ought to know about the battle and leaves patriotic or historical speculation to our own mood and caprice.

Plate 15 [65] can be considered either the germinal point of departure from which *The Third of May* grew or a reduction of the painting. The present state of research on Goya does not permit us to decide these fine points of chronology. In a more compact but less dramatic form, Goya transcribes the vision of wasteland in which an endless succession of victims bound to stakes are executed by bands of soldiers. The means used for evoking the essential sensation of endlessness are as impressively simple as they are novel. They derive from spatial experiments initiated in the *Caprichos*.

Pictorial space, since the early Renaissance, has been a closed system. Even the most daringly elaborate ceilings by Tiepolo remain, in their essentials, hermetically closed off. The limits of the field of vision are extremely important, and it is from this very assured understanding of the pictorial limits that the structure of each composition is derived. Even if the central vanishing point of the perspective lies outside the frame of the image, the position of this central point can be logically deduced from the given data of the composition. In those cases in which the frame cuts across an entering or exiting figure so that more space is suggested than is actually visible within the borders of the frame, the system of spatial construction remains unharmed—just as an actor who is about to leave the stage can either call back something to the actors who are still on stage or engage in conversation with invisible characters beyond the teasers without damaging the coherent unity of the stage set. Whenever such a peripheral and fragmentary figure occurs, it reinforces rather than diminishes the basic principle of a finite space gravitating around an equally fixed (if not always visible) center. In this respect, Renaissance-Baroque pictorial space is harmoniously congruent with Renaissance-Baroque systems of universal space. Both systems have a single point of perspective in common. From this simple point, all forces radiate outward and to it all forces ultimately return. Pictorial space is therefore a universe scaled down in size to make it comprehensible to the human mind. It demonstrates the same logic, the same beneficent will toward order that are the central principles of a

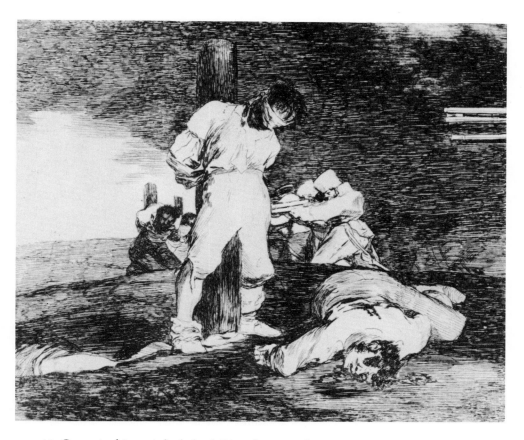

65. Goya, And it can't be helped (*Y no hay remedio*). *Disasters* No. 15.
Metropolitan Museum of Art, New York. Mortimer Schiff Fund, 1922.

divinely ordained cosmos. Even in Tiepolo's grandiose frescoes in Würz-
burg and Madrid which seem to expand in all directions, we feel secure
and steady. For all the tenuousness of the structural relationships, for all
the perpetually self-enlarging spaces, we feel no vertigo, nor do we feel
that the logical coordinates of up and down, left and right have been
disturbed. Space, instead of engulfing us, sets us free. We are not lost in
a cold and alien void. We are instead impelled upward in a carefully drawn
path toward the origin of an all-pervasive light—the light that emanates
from God. Tiepolo's space has a climax, even if that climax is not made
immediately visible.

Goya's space no longer grows from a fixed center, and without a fixed
center we cannot take our bearings in the directionless world he shows us.
In Plate 15 of the *Disasters*, as well as in most subsequent pictures, there

is the emphatic notion that the event not only is insane in its blind cruelty but that it occurs in a universe equally bereft of reason, direction, or meaning. It is an abyss that stretches to all sides of us and even opens menacingly behind.

Goya's space can be best illustrated by thinking of a glass-bottomed boat through which one looks into the marine life of the sea. The frame of the glass is not like the frame of a painting. The frame of a painting, before Goya's time, is a fixed limit within which the artist composes his figures. The actions that are seen within the limits of the glass-bottomed boat are haphazard. They come from a larger, amorphous space, drift into view, and disappear into an unintelligible vastness beyond the frame. Nor do "up" and "down" mean the same thing for the pictorial frame and the glass-bottomed boat. All we can say of the configurations that appear within sight of the glass-bottomed boat is that they are fragments whose real relationships elude us.

The framed picture plane of earlier painting, on the contrary, contains within its limits all the clues we need for a rational interpretation of the image, and all objects within the frame are related to each other—and not to something that is out of our field of vision. This kind of infinity, which has no center, no beginning, and no end, necessarily implies that whatever we single out can be nothing but a fragment. And we are made emphatically aware of the fragmentary nature of our perception. Whereas artists of the Renaissance-Baroque epoch convince (and console) us by presenting us with something that life constantly withholds—that is, something entirely consistent with itself, something so self-contained that it lives beyond the exigencies of time and destruction—Goya insists on making us aware of the fractional, incomplete, and ephemeral nature of all human experience.

The grouping of Plate 15, for instance, is such that we understand immediately that we are looking at only one link of an endlessly repetitious chain of the same event. To the right of the image, from where the rifle barrels project, the madness of killing continues, and in the obscure darkness of the horizon the procession wends its hopeless way. Here, in opposition to the Renaissance tradition, we *are* made aware of spaces that are larger and possibly more important than the space we have actually before us. The rifle barrels cannot be compared to the customary figure cut across by the frame—always an incidental figure. In Goya's hand, the cut-over figure is one of the two protagonists in the universal drama of killing and being killed. That this protagonist should be invisible to us as a human force and appear only as a bunch of gun muzzles heightens the panic to an intolerable degree. When we look at Goya's picture, it is as if

there is nothing in the world, nothing to either side of us, but mechanically executed murder. Our eye as well as our imagination is impelled outside the frame of the picture itself, and one has the uncanny sensation engendered by all invisible threats. The real danger lurks just around the corner or behind one's shoulders, and one feels exposed on all sides.

Even in the most audaciously suspenseful paintings of the Baroque—for example, Rembrandt's *Danae*, in which a large nude figure on the bed gestures expectantly at the approaching but still invisible lover—we do not have anything like the unsettling situation we find in Goya. The lover in Rembrandt's painting is hidden from us only for a moment. We are given every reason to believe that he will enter into the prepared stage the very next moment, and then the drama will have reached its meaningful climax. With Goya it is not a question of a suspended climax but rather a question of an eternal suspense without beginning or end. Even if we were to shift the frame of Plate 15 to the right, until the soldiers who hold the rifles come into view—even then, we would not have come to the climax because there would be yet another group of executioners "just around the corner." The episode is not finite, integrated, and meaningful within itself. Its significance lies precisely in the fact that it is infinitely repeatable. The story is not over after the shot is fired the way all previous pictorial stories are over after the logical climax is past. It goes on and on, and it is the ultimate tedium of horror that is the true essence of this plate.

The similarity that exists between Goya and later photographers has already been touched on. But again a comparison with photography is instructive. The spirit of Goya's image is close in spirit to an anonymous photograph made during World War II [66]. The photographer has selected a fragment showing a series of corpses hanging from trees in a deserted avenue. We are told nothing of who is hanged. Nor do we know whether or not the cause for which they lost their lives was meaningful. We are simply shown the aftermath of a mass execution. No further information is given. The esthetic corollary lies in the fact that no deliberate structure is given, either. No controlling perspective ties the elements together. No compositional climax tells us that what we are looking at has importance and has a decipherable meaning that can be measured against an ascertainable moral scale of values.

A concomitant of this kind of seeing is the destruction of that which, for lack of a better expression, one must call the hierarchy of composition. In all the innumerable compositional schemes invented by artists in the four centuries of the Renaissance-Baroque tradition, a distinction is made between central and peripheral parts of a composition. In Baroque paintings in which *repoussoir* figures are used to give greater relief and greater

143

66. Anonymous photographer, *Hanged Partisans at Bassano.*

suspense to the more important protagonists, the logic of separating out the significant forms from those that are more or less accessory remains intact. Even paintings devoid of literary or narrative content, such as landscapes or still lifes, follow this rule. The most casual view of a Dutch landscape or the most neutral still life is still so articulated that there is a distinct center at which the expressive potential of the composition is most compact. Other areas of the painting, though they may be painted with equal care, are ancillary.

In Goya's work, beginning with court portraits of the 1770s, those parts that held minor positions in the hierarchy of Baroque composition—that is, landscape, background draperies, furnishings—are either suppressed entirely or are so blatantly devalued that they almost parody the landscape, background draperies, furnishings used in earlier paintings. We can observe this effect in the *Marquesa de Pontejos* [107], a portrait in which Goya didn't even bother to keep up the pretense of a landscape.* Then,

*See page 224 for a discussion of this portrait.

in the *Caprichos* and in the two *Majas*, Goya finally left out altogether what had become nothing but a vestigial structure. The backgrounds of many of the *Caprichos* are an indeterminate blank, and about one third of the canvas area in the *Majas* is an almost undifferentiated neutral tone.

In the *Disasters*, the entire field of the plate is potentialized, and every form within this field, whether it be a void or a volume, plays a part that becomes progressively more equal in value to every other form within the same field. Naturally, the development of this kind of composition is very gradual. In the *Caprichos*, the tenor of almost every one of the plates is extravagantly bizarre so the dislocations of space are not as noticeable because they form part of the decidedly nightmarish nature of the whole series. Now, in the *Disasters*, Goya's themes are drastically real, and divergences from our standards of normal experience become more strikingly evident.

Plate 33 of the *Disasters* [67], for instance, partially illustrates Goya's handling of forms in this new manner. Each form is the equal of all others

67. Goya, What more can one do? (*Que hay que hacer mas?*). *Disasters* No. 33. Metropolitan Museum of Art, New York. Mortimer Schiff Fund, 1922.

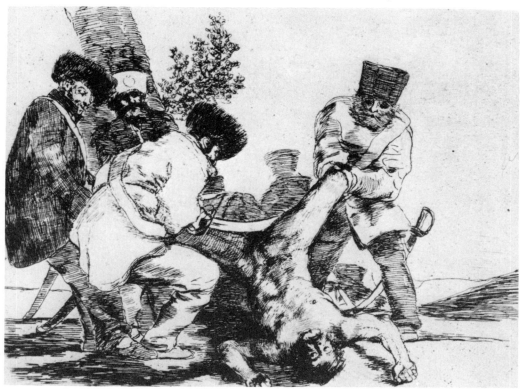

without any great distinction being made between animate and inanimate, protagonists and bystanders. The left leg of the martyred Spanish partisan simply disappears from view (it is impossible to see what happens to it even in those parts that are in full view) and merges with the tree that rises in the left upper background, so that the major configuration of the plate is a gigantic V shape described by the tree, the left leg, the man's crotch, and then upward again through the right leg to the bandolier of the soldier on the right. Each one of these forms is given equal value in the visual dynamics of the image. Tree and man are equally charged with the horror of the scene, and the figure of the martyr is no longer exalted as having lived and died under special dispensation. What is true of the major structure of the painting is also true of the relation between the active participants of the scene and the witnessing bystanders. Both in position and in execution, the figure of the man on the extreme left is every bit as significant within the total expressive content of the plate as is the tortured victim.

Still life and costume are given equally important functions, as happens here with the swords and scabbards. The sword hewing into the body of the naked man is not held up, as it so often is in similar scenes of Christian martyrs being beheaded or maimed. It is seen instead as if it were at rest. But the scabbard worn by the man on the right comes into play with the bandoliers of the two figures on the left, bringing into the picture a lunging swing, which comes to its climax at precisely the right point: where the naked sword meets naked flesh. Patterning becomes almost as important as composition here, and pattern depends on the impartial repetition of forms. The word "impartial" is especially important in this context because it is the visual impartiality with which Goya renders objects that enables him to achieve a surface appearance of moral impartiality. These plates are sober and devoid of melodrama. The last twist of the knife consists not so much in showing us more cruel forms of torment but in demonstrating the seeming irrelevance of what is happening.

Baroque artists frequently, avidly show us scenes of torture and murder. But in every case, the artist takes a moral stand and either interprets the scene as God's judgment on the wicked or orchestrates his compositions so that we are immediately moved to pity. This pity is then given suprapersonal meaning by being resolved in divine consolation: The martyred saint is given his glorious reward as his soul flees the earth and finds refuge and redress before God's throne. So compact and orderly is Baroque composition that the dream of cruel death and glorious resurrection can be swiftly and convincingly told within the same picture.

Goya's martyrdoms distinguish themselves by not being sacrificial in nature. No purpose is being served by all this anguish and blood. All things and all occurrences are equal in value and have no way of revealing a higher purpose in either death or life. If there is to be a point to all this slaughter, then we must find it for ourselves. Observed experience is insufficient. By seeming impartial in his construction of figures and events observed, Goya goads us into taking a spontaneous and purely personal position. No one who witnesses the bland ferocity of these events can escape taking sides, and by taking sides, one involuntarily gives significance to human life and death even though life and death are without *a priori* values. The visual syntax of Goya's patterns marks more than a revolution in esthetics or in the perceptive sensibility of modern artists. It is demanded by an equally revolutionary moral purpose. It proclaims that the only true meaning of existence arises from our instinctive rebellion against the meaninglessness we witness in nature and in history.

The equivalence of forms can be demonstrated in many of the plates. Plate 32 [*68*] gives us a particularly concrete example. Here the insentient

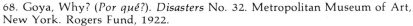

68. Goya, Why? (*Por qué?*). *Disasters* No. 32. Metropolitan Museum of Art, New York. Rogers Fund, 1922.

tree trunk is given the same moral importance as the soldier who brutally shoves his foot against the garrotted man's shoulder. The tree becomes an accomplice to murder. Its position within the overall configuration of the plate is exalted to the point of turning an immobile piece of wood into an active participant in murder. But there is more. The strokes of the burin used for the description of the form and the surface of the tree trunk are exactly duplicated in the left leg of the soldier who pushes forward with his left foot. The leg almost looks as if it were a branch of the tree. Leg and tree are (visually) equally responsible for the death of the partisan. The dispassionate infliction of pain, the cool, offhanded way in which soldiers mutilate their enemies—that is what Goya now recognizes as the hallmark of his epoch. The episodes of carnage are in themselves unimportant. It is only the charge of mindless bestiality, of workaday callousness that makes them at once universal and banal. Over and over again we are shocked more by the impartial, heedless manner in which people go about the business of killing or burying or witnessing starvation than we are by the killing itself. The last remnants of declamatory pathos, the last remnants of deliberately pointing a moral lesson are rejected by Goya.

The matter-of-fact presence of purposeless murder professionally attended to reaches its climax in Plates 36-39 [69-72]. The soldier in Plate 36 [69], looking up at his handiwork with the self-satisfied quasi-innocent smile of a simple-minded man who has done his job well and confidently expects his share of praise, is a ferocious indictment of murder excused by being commanded. One can't help but be reminded of the Nuremberg trials at which each new atrocity was explained away as having been committed "on orders from military superiors." Plate 38 [71] is a somewhat more tenebrous recapitulation of the same theme. The exclamatory "Barbarians!" ("*Bárbaros!*") of the caption stands in strongest contrast to the calm, almost playful professionalism of the marksmen.

In Plates 37 [70] and 39 [72], which go beyond the ghastly humors of Plates 36 and 38, Goya buries the comforting myth of man being made in the image of God, of man being the incarnation of the highest good and the highest beauty of the universe. The body of man, for untold centuries represented as an object of reverence, is for the first time rendered as corrupt and repulsive, bereft of nobility, and bearing no trace of the spirit that once inhabited it. The impaled corpse of Plate 37 is still preparatory to the total disintegration demonstrated in Plate 39. Even deprived of its arms, the figure retains a certain gesture, a certain eloquence. The exhaustion of the dimmed eyes, the mouth gone rigid in the last scream of pain, and the general contrapposto of the figure maintain a tenuous relationship with the more classical conception of the human figure. In

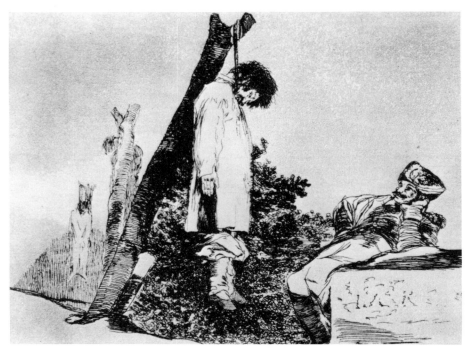

69. Goya, Not [in this case] either (*Tampoco*). *Disasters* No. 36. Metropolitan Museum of Art, New York. Rogers Fund, 1922.

70. Goya, This is worse (*Esto es peor*). *Disasters* No. 37. Metropolitan Museum of Art, New York, Mortimer Schiff Fund, 1922.

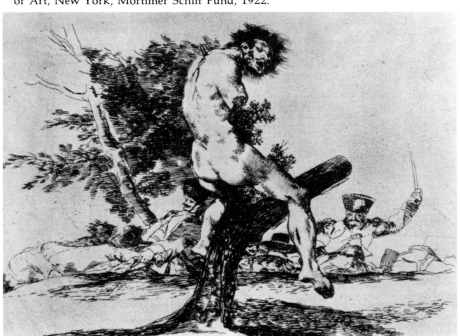

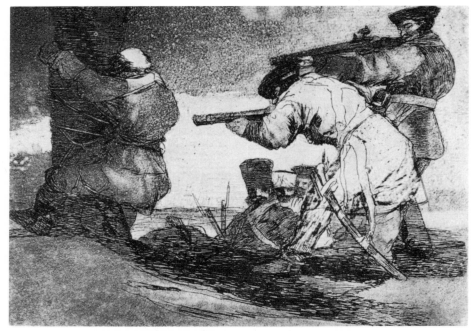

71. Goya, Barbarians! (*Bárbaros!*). *Disasters* No. 38. Metropolitan Museum of Art, New York. Mortimer Schiff Fund, 1922.

72. Goya, Great courage! Against corpses! (*Grande hazaña! Con muertos!*). *Disasters* No. 39. Metropolitan Museum of Art, New York. Mortimer Schiff Fund, 1922.

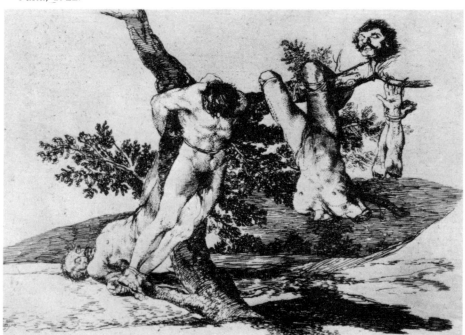

Plate 39, we have arrived at a point at which the human body turns to carrion no different from the carrion of animals. Once again, Goya has had recourse to forced comparisons to make his meaning clear. The figure bound to the tree at the center of the page is strongly reminiscent of traditional representations of St. Sebastian. The gently swaying curve of legs and trunk as well as the pathos of the head fallen forward give a conventional, choreographic impression. Even in death this figure retains the integrity and grace that were its attributes in life. By its attitude it can still reveal something to us of the former vigor and beauty of life. Tragedy, pain, and death are cadenced and made consonant with pleasing form. But this figure is so well integrated with the shape and rhythm of the tree that it has very little visual independence. The really startling form that we see at first glance and from which we can hardly remove our eyes is the clearly outlined, truncated torso hung upside down, the impaled head, the dangling arms. Pitilessly, the cadaver is exposed like so much meat in a butcher shop. The preeminence of the inviolately expressive and appealing human figure is destroyed. This corpse means nothing more than what it appears to be: a disjointed accumulation of limbs that have lost their coherence. The obvious relationship between this plate and one of the most powerful images of the 20th century, Dali's *Premonition of Civil War* [73], is probably more than fortuitous. There is no need to imply that Dali had Goya's etching in mind at the time he painted his great picture. But surely the Spaniard Dali, overwhelmed as he was by the imminent tragedy of the Spanish Civil War in 1936, must have had recourse, quite unconsciously, to one of the most complete expressions of violence and suicide. In both images, there is a curious and sickening confusion between the organic shapes of the human body and the twisted shapes of inanimate things. In both, the utter isolation of a torn-apart body outlined monumentally against a void landscape is the essential form chosen, and in both, the gesture of appeal and of agony passes unheeded. There are other points of similarity, as well, such as the compositional effect of the severed head being joined to an indeterminate horizontal object that rises to a peak in the middle to hold the head.

It is instructive to compare this nihilistic conception of the human corpse to similar representations. The Middle Ages were certainly not without their *"affres de la mort,"* and hideously corrupt corpses are plentiful in tomb carvings, in popular moralizing broadsides, and in monumental frescoes representing either the Dance of Death or the Triumph of Death. Such forcefully expressive sculptures as the tomb in the chapel of the Knights Templar at Laon certainly don't represent cadavers as attractive objects. But in every case, the depiction of the

horrors of death has a salutary purpose, for it is meant as a reproach to human vanity. And though the corpse that is laid to rest in the earth may be a revolting spectacle, it nevertheless conserves the dignity and the integrity of the human figure, and it is in the semblance of this human shape that the soul will again find its home when the earth gives up its dead for divine justice. The Renaissance accepted the use of corpses in art only if the dignity and individuality of the body remained untouched. Even an eccentrically realistic tomb effigy such as Francesco da Sangallo's tomb in the Certosa of Florence is after all a tribute to Cardinal Acciaiuoli's ability to triumph over the ugliness of old age by means of his inner dignity and worth.

The Baroque, which favored themes of gruesomeness, knew nothing comparable to Goya's conception. In Rubens, in Bernini, and in all of their followers and predecessors, the corpse is always elegiac, always graceful and expressive of resurrection. Such images as the portrait of a dead nun by a follower of Philippe de Champaigne in Geneva, though they are certainly unemotional and faithfully reproduce the pallor and rigidity of death, don't horrify or sicken us. They are, essentially, later variants of the medieval theme "All things must pass" and are meant to recommend the soul of the departed to our devotions. Even Rembrandt's *The Anatomy Lesson of Dr. Tulp* is in this tradition. Though the corpse is that of an ignoble criminal and far from attractive, it is nevertheless the cynosure of all the men in the picture. It is also the visual axis that holds the whole composition together. Since it is an example used to teach men about man, it serves an uplifting, noble purpose. The most moving passage in the painting, the counterpoint of Dr. Tulp's eloquent hand and the splayed, dissected hand of the corpse, is in itself a hymn to the nobility of which the human anatomic mechanism is capable.

It would not be altogether off the mark to suggest that the young Rembrandt intended to make yet another exuberant demonstration of his youthful disrespect for conventions by painting a shocking bravura piece. Such vulgarities were not foreign to him; he exulted in his unparalleled naturalism, which was intentionally meant to challenge the more decorous idealism of his Italy-oriented colleagues in Amsterdam. In any case, the corpse of *The Anatomy Lesson of Dr. Tulp* remains a freak in the history of Baroque art, and Rembrandt himself turned away from this heartless, deliberately lurid depiction of the human body.

In his next *Anatomy Lesson*—that of Dr. Dijman, dated some twenty years later—Rembrandt emphatically reverses his position. Despite the fragmentary state of the picture, it is obviously one of his most ambitious and mysterious paintings—one in which he touches, as he so often does

73. Salvador Dali, *Soft Construction with Boiled Beans: Premonition of Civil War*. Philadelphia Museum of Art. Louise and Walter Arensberg Collection.

during his old age, on the ultimate fate of man. This later composition has none of the shock value of its predecessor. It is composed, instead, along lines clearly inspired by Mantegna's *Dead Christ*. Solemn and without the theatrical intensity of spotlighting used in *The Anatomy Lesson of Dr. Tulp*, this composition sets out to attain new goals. Instead of the startling apparition of a decomposing corpse nonchalantly being studied by self-

consciously posing burghers, we have a stately, symmetrical composition, the main axis of which is held by the disemboweled corpse. The features of the face are somewhat veiled, and the severed scalp forms a warm nimbus about the head. We are instantly moved to reverence and compassion by this profoundly majestic interpretation of death. Even scraped clean, even when reduced to an anonymous teaching specimen, the human figure still commands respect and what the Romans called *pietas*.

The figure of a corpse sinking into its tomb (Plate 69 [*74*]), while writing the word "Nothing" ("*Nada*") on its own tombstone, marks the furthest point in Goya's desperation. The later plates of *The Disasters of War* return to a more familiar, though not always understandable, form of expression. Some comment on the futility of human charity, on clerical abuses, on the heart-rending scenes of famine that came in the wake of war, and some are startling indictments of those who remain complacent in spite of the horrors they witness.

One of these plates stands out as the most prophetic and fearsome because its allegory is couched in hideously realistic form. In Plate 62 [*75*], Goya makes his supreme statement concerning the condition of modern man, and he does so in the simplest, most emphatic manner possible. A great mass of corpses (the debris of a bombardment? of famine? of pestilence?—it hardly matters) has been laid out in the nocturnal streets preparatory to being carted off the communal grave. Each of the corpses is hidden in its shroud, but one is not quite dead. Unconscious, impelled only by the terrible energy that animates all of us without reason or purpose, this zombie has arisen from the heap of cadavers and wanders blindly off into the night. There is nowhere to go, and even if there were, he couldn't see his goal because the shroud falls over his eyes. Yet on he walks with the clumsy steadfastness of a golem. Life is converted into mere locomotion.

Given such a reduction of the sum of life to "Nothing," it is not surprising to find Goya slurring over such established axioms of art as the individual identity of objects. Frequently, under the impact of chaos, forms lose substance and voids gain density for no apparent reason. Returning to Plate 33 [*67*], we find that a special form, resembling in silhouette the French Mamelukes' uniform, rises just above the blade of the executioner's sword. Are we to think of this shape as a person, as the shadow of a person, or as a capricious form denoting some other, enigmatic presence?. At the same time, an unexplained shape appears between the two spectators in the upper left portion of the plate. Here, instead of the space that ought to separate the shoulder of the man in the white headpiece from the chest of the man in the black cap, we find a mass of etched lines

74. Goya, Nothing. The event will tell (*Nada. Ello dirá*). *Disasters* No. 69.
Metropolitan Museum of Art, New York. Mortimer Schiff Fund, 1922.

75. Goya, The Beds of Death (*Las camas de la muerte*). *Disasters* No. 62.
Metropolitan Museum of Art, New York. Mortimer Schiff Fund, 1922.

that are identical with those used to describe the tree. But judging by the rest of the tree, these fill-in lines are certainly not there to denote part of the same tree. And when it comes to depictions of the human figure, it is often impossible to tell back from front. Human shapes are wracked and wrenched into so many unnatural positions that we are frequently hard put to "read" them with any assurance of understanding their position correctly. The degradation of the human figure under the impact of torment and agony can best be illustrated by drawings that Goya executed either during the period in which he was working on the *Disasters* or slightly later. Dealing with the torture chamber, the most impressive of these drawings [76] shows a man tied to two racks, and so torn and twisted is he by pain and by the antagonistic pull exerted by torture instruments that it becomes impossible to tell front from back. By comparison, earlier depictions of torture by Callot or Magnasco or Urs Graf are merely piquant bits of gallows humor.

Similar deformations occur in other plates of the *Disasters* as well as in *The Third of May*. The human body is no longer a manifest ideal shape that demands respect. It becomes, instead, a vehicle for expression that can be changed about and used with an almost offhand indifference. Naturally, earlier periods had changed the proportions of figures and rendered them with varying degrees of realism. But the essential respect for the human body as an expression of divine order is basic to all artists from Giotto on. The change in attitude in Goya (and in a different way also in the work of Goya's contemporary, John Flaxman) can best be compared with the change that occurred at the time of the disintegration of the ancient classical world. The human body loses its integrity and becomes a mere abbreviation, a form that is reminiscent of the body but no longer praises its beauty or shows any interest in the organic coherence of its various parts.

It would be wrong to ascribe the ambiguity of Goya's figural painting to indifference or sketchiness. Once the figure becomes anonymous (as happens first in the executioners of *The Third of May*), it is automatically dethroned. The nude, which had been one of the basic elements of art, suddenly becomes problematical. Flaxman, in England, purifies the nude to such an extent that it loses all its physical, volumetric presence. The succeeding Romantic tendencies often go to the opposite extreme, and Géricault's nudes, especially the studies, have a naked beefiness about them that is the very antithesis of earlier nudes. Just as the female nude becomes a questionable, equivocal subject for modern artists, so does the depiction of the human body in general raise problems about the very meaning of human existence. But only Goya and David seem to understand

76. Goya, *What cruelty* (*Que crueldad*). Album C. Prado, Madrid.

fully the implications of the moral revolution which requires of the artist that he find an equally revolutionary visual idiom. Goya searches for this new visual language with consistency in all of his important works. David generally represses his forebodings by appealing to the authority of classical forms and the classical ethos which he imposes on the exigencies of his time. Only in his *Death of Marat* [**48**] does he achieve a rigorously

contemporary expression, and certainly it is in this picture that David comes closest to the purport of Goya. With this difference: David aspires to create a picture that will bestir his contemporaries, as well as their progeny, to remember the martyred hero of the Revolution and to steel themselves for a better, more ardent life of social sacrifice worthy of his idol. He proclaims a new religion. Therein lies his strength. Goya proclaims no new Christianity. He discovers only horror and its devastating companion: Nothing. When he does try to end the series of the *Disasters* with a sign of hope couched as a question—"Truth has died. Will she rise again?" ("*Murió la Verdad. Si resucitará?*")—his otherwise authoritative hand begins to hesitate, and he creates the two weakest plates in the entire series. Therein, perhaps, lies *his* strength: He cannot delude himself.

In the face of these grim admonitions that seem to be beyond hope and beyond appeal, and in the face, also, of the fact that Goya never tried to publish the *Disasters* during his lifetime, one cannot help but ask if they are addressed to anyone at all. Why admonish the world, if you believe that your reprimands will go unheeded because it is the fate of mankind to be either killer or victim? A page from a martyr who lived in our own day and age may help us. In her memoirs, Nadezhda Mandelstam writes: "I have often asked myself whether it is right to scream out when you are beaten and people trample on you. Wouldn't it be nobler to burden oneself in demonic pride and to face the torturers with disdainful silence? But I have arrived at the conviction that in this last scream there are the last traces of human dignity and confidence in life. By screaming, a man defends his right to live, sends a message to those who are still free, demands help and resistance, and expresses his hope that there is still someone left who can hear. When nothing else remains, one must scream. Silence is the ultimate crime against humanity." Goya's own deafness was the smallest part of his tragedy. It is our deafness that brings his tragedy to its climax.

9

The Black Paintings

The Disasters of War were Goya's last effort at reaching an audience, but there is no record of his ever having approached printers or editors in an attempt to print the plates. The earliest known edition was printed in 1862, more than a quarter of a century after the artist's death. We, the generations of the future, are the audience Goya hoped to reach.

Goya's growing political, intellectual, and human isolation may well have led him to decide to paint for no one but himself. The Black Paintings, executed in 1820-23 on the walls of his little farmhouse, Quinta del Sordo, outside Madrid, are in effect the most extreme manifestation of the growing misunderstanding and estrangement between modern society and the artist. It is true that many subsequent artists painted or drew or carved works of art that they intended to be enjoyed and understood only by themselves. But never before and never since, as far as we know, has a major, ambitious cycle of paintings been painted with the intention of keeping the pictures an entirely private affair. The very fact that Goya had recourse to fresco painting instead of the more usual canvas and oil is proof enough that he never expected his paintings to be displayed in public, and since very few people made their way out to visit Goya's retreat, these paintings are as close to being hermetically private as any that have ever been produced in the history of Western art. They were painted because of Goya's urge—for us quite undefinable—to fix haunting images onto the wall for the sole purpose of regarding them in solitude.

In the Black Paintings Goya broke with every tradition of art as communication. He never intended to exhibit them. He never composed "program notes" for them as he did for the Caprichos and the Disasters, and, lacking even the slightest trace of his having explained the paintings to his friends and heirs, it seems highly probable that he never spoke

about them with anyone. Perhaps Goya lost all interest after he had finished them, for although he was always canny and shrewd about turning his work to profit, he didn't make any arrangements concerning these pictures when he returned to Madrid from France to settle his financial affairs. Perhaps the Black Paintings served as a kind of exorcism, which, once accomplished, held no further interest for the artist. Perhaps he himself never fully comprehended their meaning.

Such speculation could be reinforced if one takes into account another painting Goya executed at the same time the Black Paintings were begun—the *Self-Portrait with Dr. Arrieta* [77], one of the most profoundly moving of his late works. As the legend underneath the figures tells us, Goya had been struck down by a violent attack of his old illness. Though all hope had been abandoned, Dr. Arrieta, one of his few remaining friends, had persisted in his attempts to recall the artist to life, and his courage had been repaid. Almost miraculously, Goya survived the crisis and went on to live another nine fruitful years.

Goya has represented himself in a gray dressing robe, his hands lying limp on the raspberry-red counterpane, his shoulders supported in an upright position by Dr. Arrieta, who sits behind him and silently persuades his patient to take a glassful of medicine which he holds in his right hand. Goya's puffy head is thrown far back in a gesture of revulsion, as if he were struggling against the solicitous ministrations of his physician. He has obviously reached that point of mortal exhaustion so familiar to doctors at which he rejects all help and wants only to be left to die in peace. Even the kindest help becomes an importunate irritation to the patient. But the doctor knows that to be truly kind he must be implacable, and with the clamplike embrace of his arm and the impenetrable set of his whole face forbids his patient's flight into death.

At either side of the vigorously painted, chromatically rich group of the doctor and his patient there appear vague slate-dark figures that seem to vanish into the blackness of the sickroom. These figures have all the insubstantiality and all the harrowing presence of the demons and monsters of the Black Paintings. Painted in the same broad, bold manner, they have a similar phosphorescent luminosity. At the extreme lower edge of the composition, the blanket ends abruptly and makes way for an ocher field on which the following words are inscribed: *"Goya agradecido a su amigo Arrieta: por el acierto y esmero con que le salvó la vida en su aguda y peligrosa enfermedad, padecida a fines del año 1819 a los setenta y tres de su edad. Lo pintó en 1820."* ("Goya, in gratitude to his friend Arrieta: for the compassion and care with which he saved his life during the acute and dangerous illness he suffered toward the end of the year 1819 in his seventy-third year. He painted this in 1820.")

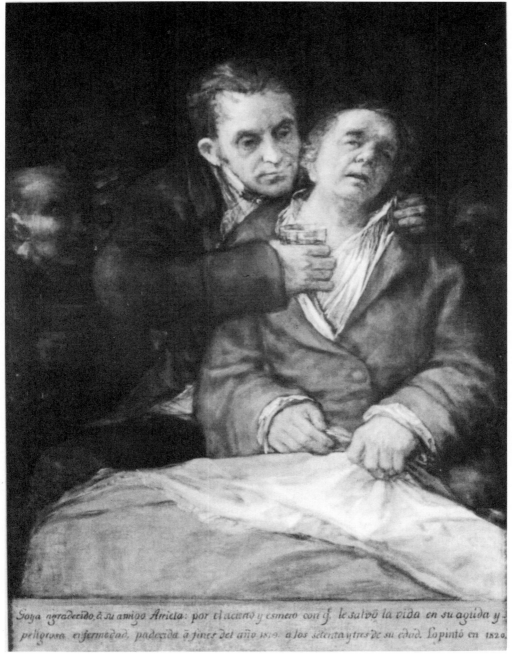

77. Goya, *Self-Portrait with Dr. Arrieta*. Minneapolis Institute of Arts.

The intrusion of writing at the bottom of paintings is not unique in Goya's work. Several earlier portraits contain such captions at the bottom of the canvas. But in this case Goya clearly intended to evoke a familiar form of religious painting: the ex-voto, which was then, as it is now, enormously popular in Spain. The form of the ex-voto is almost always the same. The major scene generally narrates some catastrophe that befell the votary: an attack of fever, a bad accident, a dangerous brawl. Hovering above the ground there appears either the Virgin Mary or one of the intercessor-saints to whom the little image is dedicated. By a single gesture or by his mere presence, the intercessor-saint averts the imminent disaster. At the bottom of these crudely colored, primitive images there generally appears a short statement about the nature of the mishap and a fervent attestation to the miraculous power of the saint to whom the image is dedicated. As in a notarized document, the name of the recipient of divine grace, as well as the date of his recovery, officially concludes the text.

Goya transposes the concept into a secular idiom. It is the miracle of Dr. Arrieta's profound humanity that averts the menace of death. And the catastrophe is not only to be thought of in terms of the sickness that has undermined Goya's strength. The glass of medicine Dr. Arrieta proffers combats the sickness, but his embrace, his courage put to flight the shadowy figures of the background [78, 79] and keep them from preying on the sick man. In a way, this painting not only is an ex-voto to a physical return to health but also depicts the resurrection of a spirit which has suffered under the onslaught of demonic obsessions. Goya has wrestled with the demon and has won because of his friend's steadfastness, loyalty, and devotion. The most striking motif of the composition, however, remains the curious antagonism between doctor and patient. Goya strains against the doctor's solicitous gesture as if he were struggling against being helped back to health and life. But Dr. Arrieta forces the glass of medicine on him with mild insistence and forces Goya's head forward, away from the shadowy figures of the background.

The religious connotations of this painting go beyond the obvious ex-voto significance. There is a strong allusion here to communion—a secular communion of friend to friend. In the same year, Goya painted two of his most important religious paintings, both of which deal with communion: the *Last Communion of San José de Clasanz* and the *Christ in Gethsemane*. Like the angel of Gethsemane, Arrieta presents a cup to Goya that leads to salvation. And like Christ, Goya rebels.

If one posits that the *Self-Portrait with Dr. Arrieta* is the prelude to the Black Paintings, then one can, at least superficially, interpret the Black Paintings as the outcome of Goya's fearful voyage to the very edge of the

78. Goya, *Self-Portrait with Dr. Arrieta*. Detail. 79. Goya, *Self-Portrait with Dr. Arrieta*. Detail.

tomb. Dr. Arrieta, in the self-portrait, interposes himself between Goya and the fantastic shadowy figures that crowd in the background. His care and his friendship have driven the specters of fever into the obscurity of the sickroom. And it is not altogether unjustifiable to think that Goya, once he had regained his strength, went on to banish these monsters altogether by giving them concrete form on the walls of the Quinta del Sordo. Naturally, we have no documentary proof of the relationship between the *Self-Portrait* and the Black Paintings, but the similarity between their backgrounds is self-evident. In fact, the background of the *Self-Portrait* is more akin to the Black Paintings than it is to the foreground figures of Dr. Arrieta and Goya. Thematically and technically the pictures are related, and the chronological sequence also cannot be disregarded. Though all attempts at solving the riddle of the Black Paintings can be presented only as pure hypothesis, it is not altogether unjustifiable to think of the visions presented in the Black Paintings as being visions of those paralyzing forces from which Dr. Arrieta rescued Goya.*

* As this book went to press, I received an unpublished article by Professor John Moffitt of New Mexico State University which investigates Goya's *Self-Portrait with Dr. Arrieta* against the background of Spanish rituals obtaining in the sickroom of a moribund patient. In this article Professor Moffitt shows that according to established tradition, it is a friend (and not a relative) who must be called in to defend the moribund against the onslaught of the devils of despair. This fascinating discovery is one more indication of Goya's attempt to translate religious traditions into the idiom of his own nihilistic times.

Perhaps this also explains the resistance Goya puts up against the doctor's ministrations in the *Self-Portrait*. Having experienced futility, alienation, and darkness to their full during the hallucinations of his illness, Goya resists being dragged back to life. For it is in the paralyzing, nullifying nature of the Black Paintings that their true venom lies. Insidiously, these paintings instill a sense of acedia, that torpor of the soul that renders life unpalatable and a burden without reward or meaning. The vast indifference of the universe corrodes one's will to live. It is not sheer horror or panic that produces the lethal force of the Black Paintings but the purposelessness of all encounters and all experience. Listlessness, indifference in the face of death, is what may have beset Goya during his sickness and caused Dr. Arrieta to force his cures on his unwilling patient. Perhaps the *Self-Portrait* is an ex-voto meant to testify to the miracle of affection, which alone can overcome the mortal sin of acedia. And perhaps the intervention of this miracle put Goya under the obligation of accepting again his duties as a man and as an artist. Such an obligation would certainly begin with Goya's giving pictorial expression to what had threatened him most during the most anguished moments of his sickness. Perhaps, then, the Black Paintings show us the reasons for Goya's being tempted, during the crisis of his sickness, to abdicate from life—an abdication clearly stated in his resistance to Dr. Arrieta.

In the first page of the *Disasters*, we already saw that Goya figured himself in the guise of Christ in the Garden of Gethsemane. Is it too much to interpret the subsequent *Self-Portrait with Dr. Arrieta* as the presentation of the cup of bitterness? Like Christ, Goya recoils from the cup, and like Christ, he is persuaded to take up his mission again and fulfill his destiny. Christ's destiny was achieved by finding salvation in death. Goya's fulfillment came when he found the courage to continue to live in the face of all the threats to the very meaning of life which he boldly held up to his own eyes by giving them distinct shape on the walls of his house.

When we come to the interpretation of the individual pictures that comprise the Black Paintings, we tread on dangerous ground. Each image is so irrationally distorted from the coordinates of common logic that we cannot help but be tempted to interpret them in accordance with our own fears and anxieties. The paintings speak of the void, the emptiness that surrounds our lives and our actions. Our first impulse is to fill the menacing vacuum of these pictures with some meaning. Goaded by the fears Goya has unleashed in us, we try to reduce his enigma to the level of the puzzle. A puzzle presupposes a known answer; an enigma does not. In self-protective reflex action, we try to pretend that enigmas are

merely difficult puzzles and set out to find the appropriate answer. But there is little point in setting out to find an answer when confronted with the Black Paintings. They represent an enigma and not a puzzle. The best we can do is point to certain connections, clues, and allusions that might guide us in our precariously personal and unverifiable interpretations.

Unique as they are, the Black Paintings nevertheless have their germinal origin in Goya's earlier paintings. The monsters and the hallucinatory sense of being transported into a world in which our normal experience is put in question, the darkness and the sense of impending cruelty and bestiality—all that is already familiar to us from the *Caprichos*, the *St. Francis Borja at the Deathbed of an Impenitent* [19], and the little grotesqueries Goya painted for the Osunas' Alameda palace. But these early monsters and monstrosities derive their vitality and meaning from being juxtaposed with a normal world into which the monsters have erupted. By this token, monsters are merely irregular manifestations that scandalize our sense of the fitting and the natural. They exist only, as the frontispiece of the *Caprichos* informs us, when reason sleeps. It is only the slothfulness of our minds that allows these monsters to exist.*

In the Black Paintings, the monsters are not intruders but the rightful and eternal inhabitants of the external as well as the internal universe of men. Waking or sleeping, reason encounters what is unreasonable or antireasonable. It is impossible to say whether or not the monsters we face while asleep are fiercer, more real, and more pervasive than the monsters that attack us when we wake from the nightmares of our oppressed souls to the equally ferocious nightmare of what by convention is called the real world.

Mute terror is the keynote in all of these paintings (with the exception of the *Manola*), and this is the terror of cruelty begotten of fear. The momentum of terror and cruelty and the desperate loneliness are certainly equally strong in the *Disasters*. But in the *Disasters* the cruelty derives from a specific human situation that can be observed by Goya and by those few who are willing to listen to his observations. The fear inspired by the *Disasters*, though it doesn't find consolation and goes from desolation to desolation, is still a healthy fear. We mourn over the dead and mutilated because, in spite of ourselves, we still hold that survival is worthwhile. There is still room for compassion ("*Caridad de una mujer*"); there is still room for courage ("*Que valor*"); there is, above all, the possibility of understanding the causes of all the slaughter: greed, stupidity, pride, lust, the heedless obedience to authority. The fastidious mind

*See footnote, page 103.

may recoil from even attempting to reason with brutal, complacent soldiers who hack at dead bodies. But these soldiers, however depraved and contemptible, are still human. In the Black Paintings, Goya leaves the recognizable human scale behind and deals instead in pervasive, incomprehensible malevolence. Stupidity, violence, desperation beget retaliatory stupidity, violence, and more desperation because the governing element is no longer to be studied and analyzed at a distance or with an appropriate degree of emotional sobriety.

The infectious nature of evil is the beginning and end of Goya's Black Paintings. The fear of being killed turns us into killers. The fear of a totally vacant universe turns us into vacant mechanisms who react only under the stimulus of terror. We turn on elusive menaces with the same blind ferocity that we attribute to our obscure enemy. Our fear of destruction attributes to the lurking dangers that surround us all the cruelties with which we would like to annihilate our own aggressors. An unending cycle of fear engendering cruelty, which in turn engenders more fear, opens up as the only perspective of human existence in a universe bereft of an all-powerful principle of goodness.

It would be difficult and perhaps pointless to find a direct illustration for this religion of terror that Goya discovers and expresses in these haunting paintings. But perhaps the *Duel with Cudgels* [80] comes closest to incorporating irrationalities that can be defined but that can never be cast into rational visual or verbal discourse because, by that very token, they would lose their essential irrationality. To speak rationally of the horrors of Auschwitz—to take an example from our own immediate

80. Goya, *Duel with Cudgels* (*Riña a garatazos*). Prado, Madrid.

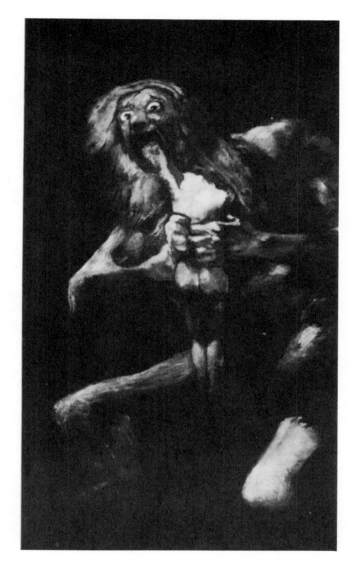

81. Goya, *Saturn Devouring One of His Sons (Saturno)*. Prado, Madrid.

history—is to automatically diminish the real meaning of Auschwitz. But not to talk of Auschwitz is perhaps an even greater crime. Caught between the impossibility of doing what he thinks of as his duty and the urge to attempt it anyhow, the modern man of genius and sensibility must come very close to madness indeed.

Of all the pictures in the cycle, *Saturn Devouring One of His Sons* [81] has proved the most essential to our understanding of the human condition in modern times, just as Michelangelo's Sistine ceiling is essential to understanding the tenor of the 16th century. If we accept Apollinaire's

definition of all modern art as "convulsive," then surely we have here the first image that corresponds to the definition of modern art laid down by one of the leading critics of our age. The convulsive nature of the painting has made it into an emblem of our times.

The title may very well be misleading. It attempts to bridge the gulf of the painting's incomprehensibility by having recourse to an analogous subject taken from classical iconography. (We must remember that the titles of all the paintings in this cycle were invented not by the artist but by critics long after Goya's death.) The major figure, in this instance, does not have any of the attributes usually associated with Saturn (scythe, hourglass, etc.), while the smaller figure actually goes *against* the iconography of the Saturn theme since it hasn't the slightest resemblance to the body of an infant. As with the other Black Paintings, one must take the title with a grain of salt.

Because of its distasteful aspects, the story of Saturn devouring his children is rarely treated in 18th-century art, and when it does crop up (in a little ivory at Brunswick or a decorative porcelain at Naples), the theme is treated with the benevolent humor that the 18th century reserved for the more barbarous myths of ancient Greece.* Earlier on, in the 17th century, Rubens had illustrated the myth in a painting that was certainly known to Goya since it formed part of the royal collection [82]. Rubens's interpretation, though not one of his more memorable works, nevertheless endows the theme with dignity by turning the myth into a drama in which, given the premises of the story (that is, the prophecy made to Saturn), we easily manage to suppress our revulsion and dwell instead on the finely observed, perfectly rendered interplay of action and expression. Though the story is brutal in many of its aspects, Rubens as well as his public also knew that it was merely a legend expressive (or symbolic) of the Greek spirit, since it marked the transition from chaos to an ordered universe. Quite fittingly, therefore, the Rubens painting is to be understood in relation to the rest of the cycle that dealt with the fate of the pre-Olympian Titans.

Goya's version of the myth makes no allowance for anything but madness and ferocity. While Rubens's figures act out their destiny in a dramatically utterly convincing, ultimately rational way, there is nothing but silence in the Goya. Rubens allowed the attached child to scream for help. Goya doesn't portray a single normal or foreseeable reaction to what is happening. Not only is the savage ogre in his painting totally unrelated to the appearance of human beings; his victim is similarly ambiguous. At

* For the astrological meanings of the theme, which might have important implications for this painting in view of Goya's "saturnine" mood while painting the Black Paintings, see Rudolf and Margot Wittkower, *Born Under Saturn* (London, 1963).

82. Peter Paul Rubens, *Saturn Devouring One of His Sons*. Prado, Madrid.

first, because of the soft curves of waist and hip, we have the impression that it is a woman who is being devoured by the raving monster, but if we look closer, we notice that the anatomy of the victim doesn't really make much sense. The bleeding stump on its right is too big to be an arm, and it is impossible to reconstitute the mutilated body in a satisfactory fashion. Everything is inexplicable, everything is enigmatic and menacing, speechless with horror. In Rubens, as in the original Greek myth, there lies a deeply felt moral judgment. The bestial element is the principle of chaos and must be supplanted by the moral order and awareness of a better world—in this case, the world of the Olympian gods and heroes. In Goya, there is no such judgment, no such hope. The instinct of attack is raised to a universal principle: Chaos is the origin and the end of life. Madness is rendered in the distraught vocabulary of madness.

It may be possible that still another story plays into the creation of this powerful image, which, together with other works by Goya, stands at the very beginning of modern art and modern self-awareness. To Goya's contemporaries, the story of Saturn was not the only story that involved the killing and eating of infants. Among the persistent legends that were constantly fostered, especially by more ignorant clergymen, there was the quite widely believed notion that Jews, in order to make their Passover bread, needed the blood of a Christian infant. Goya, who had all his life fought against harmful superstition and false beliefs, must have been familiar with this old story. All over Europe, printed broadsides, as well

83. Anonymous
sculptor, *Kindli-
fresserbrunnen.*
Marktplatz,
Berne.

as painted and even sculptural representations of this story, kept the
population eternally agitated against the Jewish communities. Most of
these monuments and paintings have disappeared, swept away during the
19th-century liberalization of religious policy. However, a few, such as
the *Kindlifresserbrunnen* at Berne [83], still survive. It may be that a
thorough investigation of popular images and broadsides will reveal that
illustrations of the ritual eating of children on the part of Jews were still
widespread in Spain and that Goya, always alert to the vigor and
expressiveness of popular imagery and popular imagination, derived his
image from the so-called blood-libel legend as well as from the Greek
legend of Saturn.

Certainly Goya's version of the Saturn legend is eccentric beyond the
point of recognition. All the grandeur of a meaningful legend that stands
for the constant progress made by man and by the universe has been laid
low. In the Greek legend as well as in the pictorial tradition of which
Rubens is the best exemplar, Saturn, for all his cruelty, remains a heroic
protagonist. Goya's figure is not. In spirit, he corresponds much more to
the evil, gluttonous figure we encounter in the tradition of the blood libel
(*Kindlifresser*). He isn't a figure at all. Even his anatomy is like a

condensation of the darkness that surrounds him, a shifting, indefinite shape culminating in panic and terror. Goya, in this picture, was concerned with more than the telling of a cruel Greek legend. Perhaps he was concerned instead with representing a pictorial metaphor of blind fear which engenders recriminatory terror which in turn breeds more brutality, just as the superstitiously believed story of the Jews killing babies caused the countless bloody massacres of Jews. Real bestiality is born of imagined bestiality. Though it is impossible to prove such a hypothesis, the multiplicity of Goya's intent in these paintings is so deep and varied that one feels authorized in looking beyond their traditional titles for more archetypal sources of inspiration.

In *Atropos* or *The Fates* [84], Goya again includes a small number of clues that seem to suggest a classical myth only to contradict such a conventional interpretation. In this case, we see hovering, floating figures one of which is intent on spinning while another holds a pair of scissors aloft. The spinning and the cutting of thread are immediately reminiscent of traditional renditions of the three fates. But Goya destroys this easy interpretation by including a fourth figure that cannot be explained away, while another figure prominently displays what might be either a lorgnon or a magnifying glass. It may well be that Goya began this painting, as well as the *Saturn*, with a fairly definite theme in mind which was then altered and superseded by the obsessive and inexplicable intervention of a more personal and enigmatic symbolism that rose to the surface while the artist worked. This reliance on the unforeseeable accidents arising from the act of painting itself is not entirely new in art. Leonardo records similar instances in his own work, and X-ray photographs reveal that

84. Goya, *Atropos* or *The Fates* (*Atropos o El Destino*). Prado, Madrid.

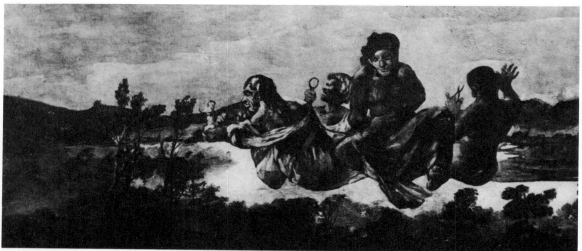

Rembrandt must also have experienced the irresistible temptation of following a devious and unexpected path that presented itself during the process of painting. But never before had an artist committed himself with such abandon to the happenstance of subconscious forces beyond his control, and only much later, in the work of Kandinsky, Klee, and the Surrealists, was this source of inspiration consistently and deliberately tapped.

Confronted by these grim and senile specters, we cannot translate our interpretation into a logical sequence of words. There will always remain a residue of the inexplicable no matter how insistently we track down the possible meanings that Goya may have had in mind. Yet it would be obviously foolish to state that these paintings are meaningless. They address a completely new range of sensibilities. Pictures such as these may elude intellectual analysis, but even while we puzzle over the mysterious content of the image, we realize that we have "understood" it.

These pictures are as advanced technically as they are spiritually. It is instructive to compare their brushwork with the technical facility of the frescoes of San Antonio de la Florida [21–27]. In the earlier frescoes there is all the brio and all the elegantly abbreviated calligraphy of Venetian Baroque painting pushed to its extreme limits. But, for all the elisions, for all the suppressed detail, the uses to which this broad brushwork is bent remain determinedly descriptive. The brilliant slashes of silvery white, gray, and mauve which evoke silky textures are part of a virtuoso performance that aims at pleasing a discriminating public.

The breadth of brushwork of the Black Paintings can no longer be considered calligraphic, nor is its purpose that of describing textures and forms in the most rapid-fire tempo. The brush moves independently of the form that it ultimately delineates. The configuration of color areas that arise from this technique produces the effect of figures, faces, or landscape only secondarily, and tension is built up between the brushwork and the image that is produced by it. That is what is responsible for the uncanny and disquieting impression one has of all the figures being on the brink of corruption and dissolution. The brushwork, deprived of all intent to please by its grace and lightness, becomes so brutally evident that it constantly threatens to submerge and extinguish the image. Like Saturn, Goya's brushwork in these paintings is about to devour the images that are its offspring.

Figures and actions become increasingly ambiguous, and, oddly enough, the less we see, the stronger the accent of the menace of annihilation becomes. Such paintings as *The Witches' Sabbath* (*El Aquellare*) [85] and

85. Goya, *The Witches' Sabbath* (*El Aquellare*). Lázaro Gardiano Museum, Madrid. →

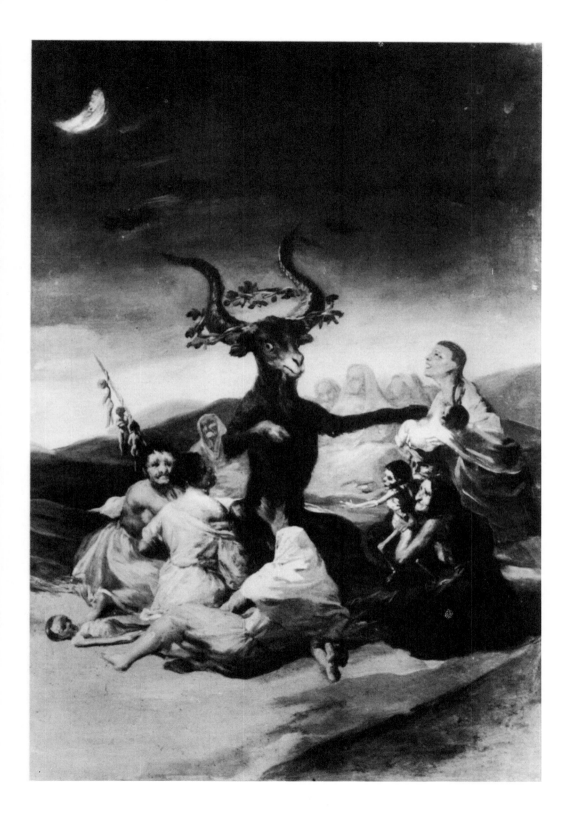

The Pilgrimage to San Isidro (*La romería de San Isidro*) [*98*], horrifying though they are in their massing of repulsive faces and disconcertingly hysterical grimaces, are far less hallucinatory than the *Man Mocked by Women* [*86*] or *The Dog* [*87*]. In the former paintings, we can still hang on to more or less literary explanations that give direction to our thoughts and thus save us from having to face the vast areas of darkness and ignorance in which we live. We can exclaim over the brooding quality that Goya has caught in his *Witches' Sabbath*, and by the very act of identifying the scene as a witches' sabbath, we have imposed a rationale on the picture which shields us from having to contemplate the chaos and the nothingness that is the real theme of the Black Paintings.

In *Man Mocked by Two Women* [*86*], we no longer have any clues—not even the teasingly deceptive hints of narrative that can be found in *Atropos* and *Saturn Devouring One of His Sons*. We cannot understand why these figures have come together or what the meaning of their encounter might be. The man, facing us, with his hands somewhere in the darkness of his crotch, is possibly masturbating or exposing himself. The sickly grin of his face certainly seems indicative of some sort of sexual compulsion. There may be an element of self-mockery in this painting, some equation between the ironic loneliness of the exhibitionist (whose aim of attracting people is constantly thwarted by the means he obsessively adopts to capture attention) and the artist who also bares himself without shame or restraint and who is also doomed to being railed at as an aberration.

Perhaps there are also other considerations here that touch on Goya's mysterious attitudes toward all that concerns sexuality. It is odd that Goya, who is generally frank to the point of crassness, is unnaturally reserved when it comes to the portrayal of male nudes. In such paintings as *The Cannibals*, in which a male figure, his legs far apart, is set against a light background, there is no suggestion at all of genitals, and in all the multitude of naked male figures in the *Disasters*, details that are generally considered necessary in the rendition of the nude male figure are never included. Goya's unrelentingly realistic observation of nature continually stops short here, even though the prudishness that was later in the century to invent fig leaves hadn't been heard of yet. On this point psychiatry may still have a great deal to teach us.

The Dog [*87*] is probably the most surprising and most eloquently succinct of all the Black Paintings. We are allowed to see only the upward-

86. Goya, *Man Mocked by Two Women* (*Dos mujeres y un hombre*). Prado, Madrid. →

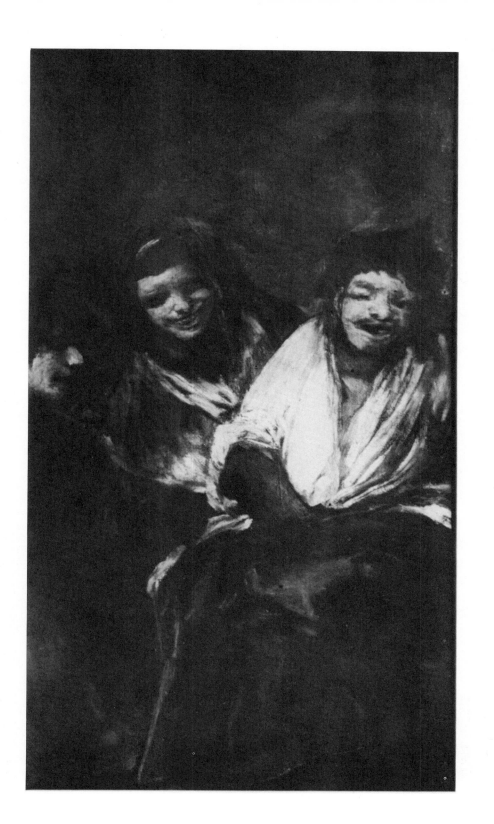

staring head of the dog and are left free to think that the animal is either sunk to its neck in quicksand or that it is merely cut off by the rising line of a shallow hill in the foreground. The remaining three-quarters of the picture is given over to an area of scumbled colors of a gray-to-celadon hue, evoking very vaguely a dim, cold phosphorescent glow. There is no other form discernible, with the possible exception of a transparent conglomeration of slightly denser paint in the middle of the sky, which could be read as a vaporous, insubstantial face but which might just as well be a purely fortuitous illusion.

The motif of a dog staring to the upper right occurs in *The Witches' Kitchen [88]*, one of six macabre decorations Goya painted in 1798 for the Osunas' Palacio della Alameda. Clearly meant to be entertainingly terrifying, these paintings are slightly akin to similar themes painted by Alessandro Magnasco, only Magnasco uses the themes as a playful pretext for virtuosity, while Goya is more convincing and substantial. Some of the themes derive from popular plays; others, including the one under discussion, are closer to popular conceptions of sorcery and witchcraft. The scene in Goya's painting is dominated by a large chimney from which a rope stretches to the left side of the picture. A lamp, hung among bones and other grisly ingredients of sorcery, sheds its light on the figures below. A male demon, seen from the back, is caught in the attitude of urinating; a dog-headed man stares up the chimney flue, watching a black goat in her flight; and a kneeling figure on the ground holds a torch over a flaming brazier, a flask, and two skulls. The elements are taken from the standard lore of witchcraft, laced with scatological humor. The surroundings as well as the action are unfamiliar, but they are by no means inscrutable. Since we know that witches behave in a certain way, we can follow Goya in this mild incursion into the world of the conventionally supernatural.

Typologically, the dog of the Black Paintings is of the same breed as the dog of *The Witches' Kitchen*, and, since the direction of the stare and the way the head is held also correspond, it is probably justifiable to think that the two paintings are related in some devious way. But whereas *The Witches' Kitchen* is a conventional spook entertainment, full of the transparent humbug of medieval demons and goblins, *The Dog* tells of quite a different foreknowledge of terror.

We do not know what the dog stares at. The action is entirely intransitive. Nor do we know where the dog stands, floats, or sinks. All the data that are usually given as a matter of 'course in paintings have

— 87. Goya, *The Dog (Perro semihundido)*. Prado, Madrid.

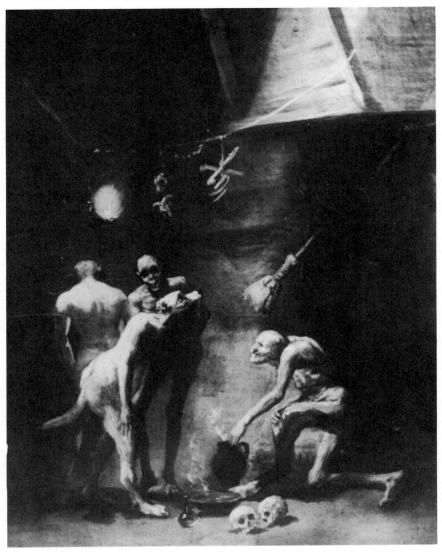

88. Goya, *The Witches' Kitchen* (*La comida de las brujas*). Pani Collection, Mexico City.

been either withheld or rendered equivocal. Dogs being generally associated with the sentiment of faithfulness, we are tempted to interpret this dog's patient gaze as an act of devotion. Perhaps it is hoping to see its master appear from above. But, as we look at the picture and gradually absorb the meaning of the indifferent, amorphous, blank space above the dog's head, we realize that whatever the dog is waiting for will never

materialize. Nobody and nothing are aware of the dog's existence. A brooding indifference reigns in the dusky emptiness. There is a modicum of suspense in the picture, but, unlike suspense in Gothic tales of the period, it will never be broken and resolved. Suspense, extended through an eternity of futile waiting, seems to be the only function of life in the great void. In one of the *Disasters* [74], Goya had etched a corpse that sinks back into its tomb after inscribing the word *"Nada"* (*"Nothing"*) on its sepulchral slab. The anarchic emptiness and purposelessness of existence are hinted at in this page in a graphic but still rather literary fashion. *The Dog* is a tragic emblem of meaninglessness. The pathetic hope of the beast is not betrayed by an unseen master. There *is* no master, and consequently there is no justification for the dog's upward glance. But even such a bare interpretion is probably off the mark just because it *is* an interpretation. *The Dog* may very well be an undecipherable signal emitted by some mechanism that is either beyond or below the human intellect and intuition. Desolation, steadfast boredom, and the panic of being lost in infinity are brought together in a single, irreducible image which stands like a prophetic symbol over the time that separates us from Goya's day.

Countless pages have been written about the meaning and function of light in painting, but the problem of darkness has hardly been posed except insofar as it is a function of light. For instance, though there have been many studies of nocturnes in the history of art—from Gentile da Fabriano through Correggio, Caravaggio, Rembrandt, and Watteau to David and Delacroix—in each case, it has been essentially the scarcity, the diffusion, or the pinpointing of light that preoccupied critical writing on the theme of the nocturne. Darkness as such, darkness as a power in its own right and not just an effect of diminished light, has never been discussed. Nor was it ever a vital force in art until our own day. And today, the whole question of light and dark has changed its aspects to such a degree that we still have no adequate vocabulary to express these values in criticism. To say that Caravaggio paints dark scenes is one thing. To say that Ad Reinhardt paints dark pictures is quite another matter. Caravaggio controls his illumination and often reduces it to an unparalleled minimum in order to intrigue the eye, in order to force us to make our way carefully and thoughtfully in his pictures. His darkness has still other meanings: It can give intensely dramatic relief to the little light he *does* paint, and by this means it conveys to us in direct, almost palpable terms the sanctity of light that he (and his contemporaries) understood as the light of God. We are made to feel an immense gratitude for the steadfast light that falls through the night and that illuminates saints in contempla-

tion, martyrs as they face death, and other scenes that testify to the perpetual presence of God. In referring to David's Caravaggism, Friedländer points to a survival of these principles, even though in David's painting, light breaking through darkness is the light of an abstract, universal Reason rather than the light of a specific, incarnate God.*

The light Rembrandt employs in his late paintings, the light Goya by his own testimony admired so intensely, is of quite another character, although it is certainly allied to Caravaggio's ideals. Rembrandt achieves a radiant emanation that glows forth from faces, textiles, and jewels without being caused by a fixed, exterior source of illumination. It isn't God shedding light on man that is the revelation of his art but the God in man shining forth through the dark coils of mortality. It is an innate quality of all life to be possessed by this inner splendor of a superhuman virtue. Susanna's modesty is translated into just such a soft glow, as is Bathsheba's recognition of the tragic destiny of her carnal beauty; Lucretia bringing the ultimate sacrifice to honor; the groom of *The Jewish Bride* placing his hand on his wife's bosom in a gesture that is both a caress and a pledge of faith—all these figures, as well as Rembrandt's late landscapes and still lifes (the magnificent *Slaughtered Ox* in the Louvre, for example), partake of light that originates in the heart of base matter and penetrates the darkness.

Still, whether it is a light cast from outside like a beacon or a more mysterious glow trembling through the obscure, dense mass of all material things, it is always light that is victorious; it is the light that we are told will abide and ultimately triumph over darkness. The blessedness of vision—physical and spiritual vision—is emphasized, and even the darkest painting gives the impression of darkness being employed by the artist to give even greater stress to the miraculous nature of the coming victory of light. It is the darkness that precedes a promised dawn.

Goya's use of illumination is more elusive from the very beginning. Even the early portraits—for example, *Manuel Osorio de Zuñiga* [112]—have no satisfactory light structure. We merely assume that there must be light because we see colors and shapes. In the portrait of Don Manuel Osorio, we can't even tell whether we are outside at night or inside a darkened room. The source of light is ambiguous and frequently contradictory. Over and over again in Goya's court portraits, shadows are either left out completely (without any compensating, explanatory high-noon lighting) or else they are so capricious as to confuse rather than help the eye.

It is in the *Caprichos* that Goya first begins to do away with conventional

*Walter Friedländer, *From David to Delacroix* (Cambridge, Mass., 1952).

uses of light altogether. He restricts himself, instead, to a graphic range of black, white, and in-between grays. Shadows of figures disappear. Light sources are obliterated, as is the idea of self-illumination that we find in Rembrandt's etchings and in Tiepolo's *Capricci*, works that Goya must have known by heart.

In *The Third of May*, light and light source reappear. But they reappear in the radically changed guise that has already been discussed. They no longer symbolize illumination but are the impartial servants of the good and the wicked alike. The intention must have been deliberate. There exists an immense tradition of painting in which the lantern placed on the floor is an invitation to religious consolation (the light that emanates from the Christ Child on the floor of the stables; the lantern of St. Irene as she cures St. Sebastian's wounds) or to pleasure (as happens in the more secular Dutch paintings in which the nocturnal lantern light incarnates the pleasures of tavern intimacies). Considering this endless procession of nocturnes, Goya's inversion of the function of light as the servant of the brutal can be understood as a conscious innovation. Light no longer exists to allow us to navigate safely in a treacherously obscure world. It serves, instead, to horrify us and to force us to witness untold atrocities. "One cannot look at this" (*"No se puede mirar"*) [59] reads the caption to one of Goya's plates from the *Disasters*—a distinct prayer to be relieved of the necessity of seeing things one no longer wishes to see. Is this cry conceivable in the mouth of any painter before Goya? More than other men, painters have always staked their very existence on the joy and the importance of seeing. In the *Disasters*, the desire to close one's eyes to the light first becomes apparent. Darkness begins to dominate, and whatever light we may see with our eyes closed is not the result of truth, reason, and all the other attributes of "illumination." The light we see with our eyes closed is the light of nightmares, of fever, of hallucination. It is a light that has no substance and that vanishes without a trace into the dark in which it was born.

In contrast to the Baroque tradition, the Black Paintings are born out of a matrix of awesome darkness. The effect is surprising and quite new. Even with a frequently high-pitched palette, Goya manages to achieve the effect of total darkness. The name Black Paintings, though it doesn't derive from the artist himself, is essentially correct, for light in these paintings is not the victorious protagonist in the drama that is played out between light and dark. Blackness is the decisive element. It returns constantly, not only along the edges of forms but also as the ground tone that shimmers through the superimposed layers of pigment, so that the eye is constantly aware of there being a solid mass of darkness against

which the fleeting, unstable lights are perceived. We have arrived at a modern interpretation of light and dark most concretely expressed in the work of Ad Reinhardt.

During the first quarter of the 19th century, Goya was not alone in facing the difficulties of pictorial lighting. Ingres was frequently criticized for not being able to represent light rationally. And indeed, the light in all of his paintings has an ambiguous quality. His powers as an artist are revealed best in those paintings that have reached a degree of distance from realistically perceived experience so as to leave behind all questions of illumination. In any case, light within a composition is not one of the crucial elements in the art of Ingres. His contemporary and rival Delacroix is generally associated with the germinal state of what was later to be known as *plein-air* painting, and certainly Delacroix was extraordinarily sensitive to nuances of light. Especially his African landscapes bear witness to his constant preoccupation with the interaction between pigment and light. Yet if one compares even the lightest of Delacroix's paintings with paintings of the 17th or 18th century, the difference becomes quite obvious. In the pre-19th-century works, light is achieved casually and without effort. It is not a "problem" as it is for the Romantics and their successors. Light is the indivisible attribute of all things and finds its entrance into painting quite naturally. In Delacroix, light is something the artist has to struggle for. It is an essence that exists for and by itself. It is not the all-pervasive spirit it once was. The general tenor of Delacroix's important canvases, with the possible exception of *The Massacre at Chios*, is somber and smoldering. Twilight and darkness are Delacroix's most familiar hours, and even when he copies Rembrandt, what distinguishes his copy from the Rembrandt is, precisely, the light: labored, slightly self-conscious, and dying in Delacroix, steadfast and unquestioned in the Rembrandt.

Courbet's art also emphasizes the tenebrous, and the quality of light in those canvases that most closely approach the later Impressionists' ideal (*Les Demoiselles du village*) nevertheless bears all the marks of self-conscious struggle with the problems of lighting in a landscape. Courbet's monumental efforts, such as the *Funeral at Ornans*, *Music After Dinner*, *The Stone Breakers*, *The Studio*, *Les Demoiselles de la Seine*, and *Le Sommeil*, seem to be set against a darkness that breaks through along the edges of the lighter colors, giving every pigment, even the lightest, an aureole of darkness.

The fact is that our vocabulary for describing the qualities of black and of darkness is severely limited and awkward. We can describe colors and degrees of brightness with adequate accuracy. When it comes to describing

their opposites, we fail. That is why the light of the Impressionists has frequently been discussed and described and praised. There can be no doubt about it: The Impressionists *were* primarily interested in rendering, analyzing, describing the element of light and succeeded in doing so with a profundity of feeling and a brilliance of technique that still leave us dazzled today. But when we compare the light in any Impressionist canvas with the light in a Vermeer or a Velázquez (artists ardently admired by the Impressionists), we become aware of differences that cannot be explained away by the difference of technique. In Velázquez and Vermeer, light is accurately observed and accurately rendered to its slightest, most refined nuance (just as it is in Impressionist painting), but even though we are aware of the mutability of their light, we never receive the feeling of its being ephemeral. No matter how tenuous the light may be in Velázquez's interiors, it is nevertheless constant, it is a lasting reality that gives meaning and worthiness to each object. In Monet or Pissarro, it is the *fugitive* quality of light that primarily occupies our interest; and, just as important, the relationship between light and the objects that are touched by the light is seriously disturbed. Light no longer celebrates or ennobles the humble object but triumphs over it. At the same time, light is no longer eternal and universal, but a physical element as capable of dying as any other thing on earth. For the Impressionist, art ends when night descends. Can anything be more expressive of a radically new understanding of light? In many ways, the paintings of Ad Reinhardt, though they are almost completely black and exclusive of light, are spiritually as well as historically more closely linked with the bright canvases of Impressionism (which begins the development that debouches in abstract painting by partially robbing the object of its independent importance) than they are with Caravaggio, whose dark canvases are superficially so close in tonality.

Goya's Black Paintings first propose a new and fundamental shift in the modern artist's consideration of light and color. Though Goya himself wasn't responsible for the title that is generally given them, the Black Paintings are aptly named, and their blackness still accompanies the artists of our own epoch. Whether one goes to the equivocal, muted obscurities of Cubism or the brilliant, gaudy images of Surrealism, whether one dwells on the energy-laden luminosity of Jackson Pollock or the lurid *Women* by Willem de Kooning, the light of modern art is usually fringed in black, and just beyond the most transparent blues of Salvador Dali there begins a realm of darkness that we who live today know intimately as the common background of even our most trivial acts. If the Black Paintings have often been hailed as the beginnings of modern art, it is not only because of such technical innovations and slogans as "discontinuous

brushwork," "artistic freedom," "working at the limits of experience," or "integrity of the artist's personal vision." It is because in these pictures the dark matrix of modern life is first laid bare. We recognize in them the circumstances of our own life: inscrutable fragments of knowledge and experience containing both urgent signals and obscure menaces set against an endless gulf of darkness.

It is easier for us today to recognize the connections between Goya and our own epoch than it is to place Goya in the context of his own times. Living and working as he did in the provincial remoteness of Madrid, cutting himself off from his own time and place by withdrawing first to the Quinta del Sordo and later to Bordeaux, Goya may have been forced to rely entirely on the erratic impulses of his genius. Still, a look at the work of other wayward artists working at the same time may serve to place Goya more intelligibly into the context of his astonishingly rich epoch of upheaval and revolution. At the same time, matching Goya's work against the work of his contemporaries may bring the purely personal note of his art into greater relief.

Closest to Goya's fantasies are the paintings by the intellectual, urbane, and very mysterious cosmopolite who was born Heinrich Füssli in Zurich and died Henry Fuseli in London after spending much of his youth in the sophisticated circles of patrons, artists, dilettantes, and critics at Rome. His gripping *Nightmare* [89] or the disturbingly erotic *Debutante* places Fuseli much closer to Goya than was the religious fanatic and poetically inspired William Blake, whose style always aspires to the clarity and rigorous linearity of Michelangelo and other masters of the Renaissance.* Fuseli, too, summons up monsters from the depth of the unconscious. He, too, scents evil and a devious horror lurking beneath conventional appearances; he, too, knows of the dark places of human conscience and human consciousness.

Yet, though it may often reach the intensity and the esthetic quality of Goya's paintings, Fuseli's art would seem to tend in quite a different direction. Wayward and in many ways intensely modern though his paintings and drawings are, they are nevertheless the result of a clear intelligence which calculates beforehand the effects that are to be attained and then marshals all the elements of color and composition to achieve the goal he has set himself. Though they arouse our curiosity and evoke a

*Robert Rosenblum, *Transformations in Late Eighteenth Century Art* (Princeton, N.J., 1970) is by far the best source for the return to an abstract linearism toward the end of the 18th century. For Fuseli, see Gert Schiff, *Fuseli* (Zurich and Munich, 1973), the most complete monograph on the artist.

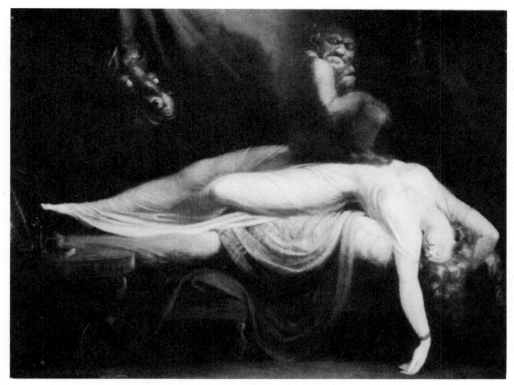

89. Henry Fuseli, *The Nightmare*. Detroit Institute of Arts. Gift of Mr. and Mrs. Bert L. Smokler and Mrs. Lawrence A. Fleischman.

peculiarly morbid sense of sympathy, his ladies, swooning under the incubus of arcane and sinister passions, cast their spell by means of elaborate and fastidious strategy. Fuseli goes *beyond* the statutes and the ideals of the academy. He doesn't go against them. There is much in his handwriting, in his composition, and in his masterful sense of line that gives us pleasure in spite of the fear-inspiring themes. Sublime terror is often spiced with loveliness.

Fuseli's compositions, his brushwork, and his luministic effects retain strong bonds with the Renaissance tradition. Correggio comes to mind with curious insistence whenever one looks at his works. His sense of terror and fear is always adaptable to the drawing room. It is horripilating within the bounds of socially acceptable conventions. His *Nightmare* could easily grace an elegant salon without stopping or clouding polite conversation. Transfer any one of Goya's Black Paintings into a parlor and polite social intercourse is disrupted on the spot. Even when Fuseli's images leave behind the traditional demands for clarity and rational scale, the effect, though haunting, is not comparable with that caused by similar

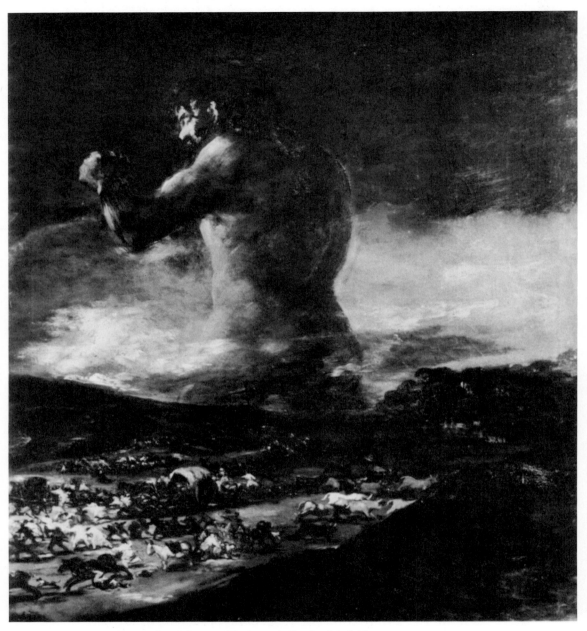

90. Goya, *The Colossus* (*El gigante*). Prado, Madrid.

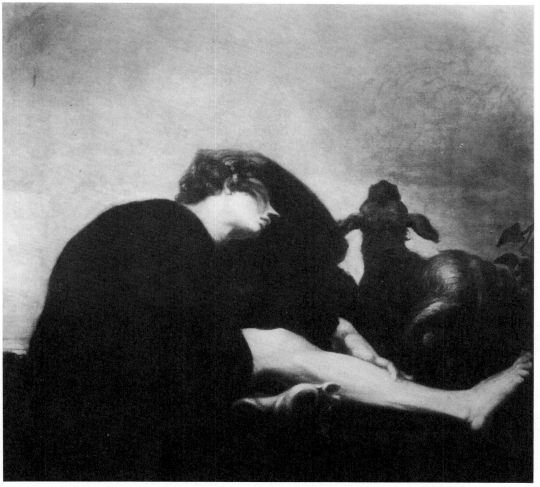

91. Henry Fuseli, *Dawn* (*Einsamkeit im Morgenzwielicht*). Kunsthaus, Zurich.

images of Goya's. Often compared, Goya's *Colossus* [*90*] and Fuseli's *Dawn* [*91*] share a common effect: that of a figure seen against an undifferentiated, unarticulated background so that the body, being incommensurable with a familiar setting or familiar objects, will take on a looming, magnified quality. But the gentle *mise-en-page* of Fuseli's picture, its diffuse lighting, its graceful drawing give his painting a lyrical touch. For all the ambiguity of setting, mood, and subject, we remain unafraid. There is a theatrical effect in the painting that betrays the presence of a very clever stage director who has posed his figures. Everything bespeaks artfulness, and artfulness presupposes an audience, presupposes an act

that is meant to be transitive so that the painting becomes common ground shared by the artist and his public. The painting is a proposition on which painter and audience can agree, despite all sorts of elusive ambiguities. Goya's *Colossus* is thoroughly intransitive. It is so puzzling that one feels fairly sure that even the artist, except perhaps on a subconscious level, does not fully understand the meaning of the image he proposes to us.

The theatrical sense is basic to our understanding of Fuseli. And though this theatrical sense is often put at the service of the horrifying, as it is, for instance, in Fuseli's favorite dramatist, Shakespeare, the horror is always resolved in an Aristotelian manner. It evokes understandable, noble impulses in us. It purifies us and teaches us to be better. It is horror attenuated by the presence of a reasoning, sympathetic artist who calculates his effects and expects us to understand and appreciate his inventive stratagems. We can analyze Fuseli's compositions in the approved, academic manner. But with Goya's fantasies, we enter a different world altogether. Goya himself seems to be helpless in the face of his visions, for he cannot convey them to us intelligibly or by means of conventional compositional schemes.

Fuseli always has a decorative side to him that is totally lacking in Goya. Even in the case of the tapestries, we saw how difficult it was to reconcile Goya's cartoons with the exigencies of the decorative function these tapestries were supposed to fulfill. Fuseli's art can point the way to lesser artists and can even serve as inspiration for minor decorative ensembles. An interesting set of Shakespearean dishes [92], for instance, is clearly in tune with Fuseli's interpretations of Shakespearean themes. Despite the spectral nature of the episode, no guest would lose his appetite while sitting at a table decked with such dishes. By contrast, Goya is immutable. It would be impossible to dilute his style in order to arrive at a composition suitable for the decoration of tableware.

It is a little easier to find literary parallels to Goya's fantasy than it is to find counterparts in painting. For decades, ever since the publication of the first Gothic novels in England, a taste for monsters had pervaded literary taste. Prominent in these horror stories was the theme of artificially engendered monsters whose careers were insidiously evil and perverse, who, at the end of the tale, destroyed their creators. Frankenstein's monster is only the most famous of these apparitions. There is also the legend of the golem, which enjoyed renewed popularity during the last decades of the 18th century and during the entire Romantic era of the 19th. All these legends have in common the notion that man usurps the power of creator only under penalty of death or madness and that he who calls forth new life does so at the risk of self-destruction. The idea of the

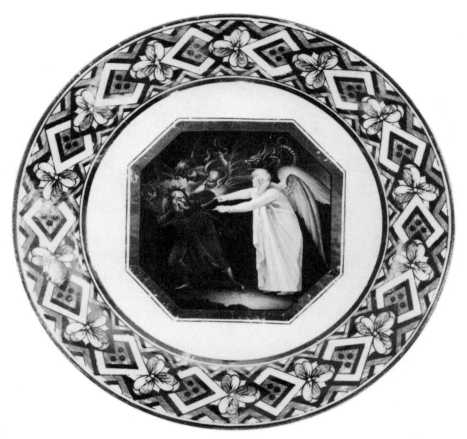

92. Chamberlain's, Worcester, England, Scene from *King Richard III*, from The Shakespeare Service. Porcelain dessert plate. Los Angeles County Museum of Art. Gift of Walter T. Wells, Jr.

artist's living under a curse that is inextricably linked with his talent is already foreshadowed here.

These tales of monster creations do not arise in a vacuum. They are, instead, supported by a great body of serious scientific speculation concerned with the study of teratology.* Teratology is based on the assumption that life can be created by man through a series of scientifically controlled experiments but that the results of these experiments will be, at least at the beginning, monstrous and perverse parodies of the forms brought forth by nature. It was through the creation of an ever larger

* Jean Rostand, "The Development of Biology," in Guy S. Métraux and François Crouzet (eds.), *The Nineteenth Century World: Readings in the History of Mankind* (New York, 1963), p. 177.

93. Pier Leone Ghezzi, *The Evening Meal*. M. H. De Young Memorial Museum, San Francisco. Lent by the Baron and Baroness von Ridelstein.

series of unnaturally bred monsters that many scientists hoped to unveil the very mysteries of the origins of life. These experiments were widely known, especially in the more "progressive" circles of society whose members looked toward a new dawn of human knowledge. In Goethe's *Faust*, the long episodes dealing with Faust's experiments with a homunculus are a clear reflection of this preoccupation, and it is possible that some of these thoughts may have influenced Goya, too. Creation as a dangerous pursuit in which the creator must ready himself to come face to face with the monstrous is surely an integral part of the Black Paintings.

If one wishes to look for 18th-century prototypes for the Black Paintings, it might be fruitful to investigate further a relatively unknown category that for want of a better name can only be classified as "grotesqueries." These must have been painted in considerable quantity by fairly fashionable artists, especially in Italy. The few examples that have sur-

vived, such as Pier Leone Ghezzi's *Evening Meal* [93], prove that they were wayward byproducts and not the artists' major preoccupation. Loosely painted on unprepared, coarse canvas, they are, it would seem, the sort of thing an artist might toss off while cleaning his palette: neither material nor time was wasted on these images.

The similarity between Ghezzi's *Evening Meal* and Goya's *Two Old People Eating Soup (Dos viejos comiendo sopa)* [94] is striking. In both cases, an activity that is usually thought of as sociable and pleasant has been turned into something repulsive; in both cases, we have exclusive focus on an irrelevant action without anything being said about the surroundings of the figures or their narrative context; and there is clear evidence of syphilitic decomposition in the faces of the protagonists. And yet, even though we may be tempted to think that there may be some distant connection between Goya and Italian painters of grotesqueries such as Ghezzi, there remains a profound divergence of attitude, purpose, and end result between the two. Ghezzi is out to entertain us and knows that his public is sophisticated enough to allow itself to be entertained by being shocked first and amused later. Under no circumstances could we ever take this picture seriously or believe that the subject has an earnest meaning. Ghezzi asks us to admire his outrageous wit, and even though

94. Goya, *Two Old People Eating Soup (Dos viejos comiendo sopa)*. Prado, Madrid.

we today may think that the joke is in rather poor taste, we can understand how the less puritanical, less sentimental public of Ghezzi's day may have found his grotesqueries extremely funny.

Goya, though he, too, avoids vouching for the reality of his figures, convinces us that the *Two Old People Eating Soup* have a concrete reality (that is, are not just calculated incongruities), that their action and their appearance mean more than what meets the eye, and that whatever humor may exist in the senile grins of the two faces is grim and fearsome rather than amusing. If we think of Ghezzi's painting in terms of drama, then the action is one in which the artist, like a playwright, manipulates his actors in such a way as to amuse his audience. All four elements—playwright, actor, play, and audience—are accounted for. Goya's painting seems to be a drama played out entirely between the artist and the figures that haunt and possess his imagination. He is not in control of them. He does not manipulate them. He paints them either under the imperious dictation of a visionary reality or in order to lessen their terror by giving them concrete shape. In either case, both the play and the audience are quite irrelevant to him. Here as in the *El sueño de la razón* plate of the *Caprichos*,* one is reminded of Goethe's prologue to *Faust*: "*Ihr naht euch wieder, schwankende Gestalten . . .*" ("Once again you approach, hesitant figures . . ."): The fantastic personages that the artist projects are not summoned up by the artist, commanded, interpreted, and given form by him. Instead, they impose themselves on *him*, and though he is frightened, he is nevertheless compelled by his most intimate nature to do their bidding. His art is at their service. With that we reach the only positive victory of the Black Paintings: Whatever happens, whatever terrors the hollow, indifferent world may hold, the artist, unlike the common man, recognizes in himself the power of perception and of creation based on his perceptions.

There is a primitive sort of magic in all of these paintings that is integral with their strength. The urgency with which Goya paints the horrors of his imagination is the urgency with which a primitive medicine man carves hideous images to confront the onslaught of demons: By showing the demons how horrible they are, it may be possible to frighten the demons themselves. The intricate dragons we find on Chinese mirrors had this protective charm. The fiercer the dragon represented on the mirror, the better one's chances of frightening the invisible dragons that surround us. There may, after all, be a cathartic element in the Black Paintings that

*This famous plate showing Goya asleep at his work table beset by a swarm of nocturnal monsters was originally meant to be the frontispiece of the *Caprichos*.

could explain how it was possible for a man who had seen such terror and such emptiness to rid himself of this annihilating experience and go on to paint the serene, even heroic, paintings of his last years.

The primitive, talismanic quality that may attach to the Black Paintings is purely conjectural and proposed with many reservations. What is undeniable, however, is that the word "primitive," which was to become more and more important in the development of modern art, can be applied to these pictures with far more justice than to any other paintings executed in the history of Western art since the beginnings of the Renaissance.

The urge to look back toward the origins of man and of man's civilization is one of the prime components of that late phase of 18th-century Enlightenment which we generally refer to under the all-too-liberal label of Romanticism. The great novels dealing with the enviable lives of noble savages had already been written, and in the visual arts, the return to the "*tabula rasa*," as Rosenblum calls it, had already been made, primarily by John Flaxman. But the return to the pristine sources of human life posited by the Romanticists led to a "pure" style of great tranquility. The heroic, morally sound aspects of a lost Golden Age were stressed, just as the essential goodness of the child (another kind of primitive) was upheld as axiomatic. Goya short-circuits Romanticism, while sharing certain aspects of it. By going back to the origins of mankind, he finds cannibalism rather than nobility, darkness instead of light. The primitive side of man's nature is fraught with monsters. And even the child, so touchingly worshiped by his age, is often represented by Goya in morally equivocal light—for example, *Manuel Osorio de Zuñiga* [112].* Nor should Goya's monsters be confused with William Blake's heroic demons. Blake, when he descends to the subconscious, "dreams of things impossible." Goya's visions aren't only possible; they are highly plausible.

It is in these respects that Goya, even during the isolated years of the Black Paintings, participates in certain major trends of his age. He recognizes new, frightening forces at work both in the past and in the future, and he finds a painter's way toward the expression of these discoveries and realizations. The general desire to look back to the beginnings of history and the beginnings of man may have been dictated at least partially by the realization of all those who witnessed the titanic changes of the years 1780-1820 that man's new, unfamiliar condition made a sober, unprejudiced study of man, of his environment, his origins,

*For a discussion of this portrait see page 230.

his purposes, and his possible meaning an imperative task. There is in all of this a yearning toward the primitive, an unshrinking desire to look at everything afresh no matter what the consequences. *"Au fond du gouffre pour trouver le nouveau"* ("To the bottom of the abyss to find something new"), *"La nostalgie de la boue"* ("A yearning for the primeval mud")— these, later on, became slogans indicating an intense urge to examine and give expression not only to what is noble, spiritual, and morally acceptable but also to that which is uncouth, obscure, cruel, and vicious. Goya takes up the task that troubled so many artists after him and that turned the public against those who were unwilling to produce the false illusions of beauty and truth that the market demanded. To do this, Goya evolved a new style, a new technique, a new vision, which cannot be measured any longer in accordance with esthetic programs or academic standards but which can be judged only in relation to the high goal that the artist sets himself. No criterion conceived prior to the work of art can any longer be considered valid. Each new painting, each new style is not only a manifestation of the creative impulse but also carries a new critical system within it. Here, too, Goya and Fuseli diverge despite their mutual glorification of the fantastic aspect of art.

The brushwork and the colors of the Black Paintings, even though they in some ways presuppose late Baroque virtuosity, are nevertheless clumsy, ponderous, and rough when compared to Goya's earlier or later paintings. They are, if one wants to measure them against the criteria of Goya's own day, ugly and "primitive." There is in them a lack of finish that has nothing to do with the sketchiness of late Baroque painting or even with the broad brushwork of the French Romanticists such as Delacroix. It is as if the artist himself were aware of his insufficiency and tried to convey his new recognition of human inadequacy by means of the stammering quality of his unsure brushwork. The skills of the painter are no longer made evident for the edification of a respectful public. Instead, the painter is willing to appear in all his human weakness. He leaves the rough, sometimes hesitant traces of his brush standing even when such coarse passages diminish the legibility of the forms that they are supposed to describe. Goya takes for granted that each artist, if he wanted to, could be a skillful artificer. But he feels free to leave craftsmanlike finish behind whenever his intuition, or his theme, demands it of him.

Perhaps it is Goya's conscious or unconscious participation in the Spanish tradition of art that allows him to turn his back on the tradition of elegant handiwork. David, even though he, too, was a champion of the artist's freedom, and even though he, too, despised empty craftsmanship, never allowed his brush to escape from his firmly controlled grasp.

Goya shares with his contemporaries the need to rediscover the origins of man's civilization. Like the *Primitifs* who first clustered in David's studio, like the Nazarenes and the later Pre-Raphaelites, he is obsessed by the idea of discovering the origins of his art. But whereas his contemporaries are impelled by the belief that the origins of man's civilization are basically good and innocent, Goya comes to far more problematic conclusions. It is symptomatic that many artists at the end of the 18th century chose to illustrate the old legend of how the art of painting was born.* But though these artists idolized the primitive, they represented the primitive characters of their narratives with enormous sophistication of both technique and intellect. It is Goya who gives us the first glimpse of the truly "primitive" artist in the modern sense of the word. In the Black Paintings, all the struggles of creation, all the halting mysteries of engenderment become evident. The groping unpreparedness of the artist who confronts his own mysterious vocation is made the very theme of his art. His forms are awkward, and his calligraphy becomes bold and clumsy. Instead of presenting us with a finished, elegant painting, as his contemporaries always do, he shows us works that have no finish at all but bear all the traces of a difficult, painful birth and a struggle toward a still more uncertain new form of life. The difficulties of creation, the labor, the bafflements that face the creator are left on the canvas for us to see. We are made to assist, literally as well as figuratively, at the "origins of painting."

*Robert Rosenblum, "The Origin of Painting: A Problem in the Iconography of Romantic Classicism," *Art Bulletin*, Vol. 29 (December 1957), pp. 279–90.

10

Occasional Paintings

The main body of Goya's work is composed of portraits and of large cycles such as the tapestry cartoons, *The Second of May* and *The Third of May*, the Black Paintings, and, at the end of his life, a small series of paintings on proletarian themes. These cycles of paintings are accompanied by equally ambitious series of prints: the *Caprichos*, the *Disasters*, the *Disparates*, the *Tauromaquia*, and the *Bulls of Bordeaux*. The essential substance of Goya's art and of his life can be found in these works.

There also exist, however, many paintings that can only be described as "occasional." Some of these are among the dullest work the artist ever executed. Others are among his most astonishing creations. From both categories there is much to be learned.

The chief works in the former group are a number of allegories that are traceable to public commissions. Though they are fairly uninteresting in themselves, they constitute clear proof of Goya's inability to keep alive the time-honored genre of allegory. Goya has an uncanny gift for convincing us of the visions of his fantasy. Without hesitation, he can go far beyond the realities of normal experience and introduce us into a convulsive universe of terror. But when it comes to revealing the world of ideals that his contemporaries and his predecessors believed existed behind the material concretions of the tangible world, Goya fails as few other great artists have ever failed before or after.

Paintings such as *Allegory of the Third of May*, *Allegory on History*, *Allegory on Philosophy*, and the series of allegories dedicated to Commerce, Science, Industry, and Agriculture either can be considered signs of Goya's scornful indifference to commissioned themes that did not touch him personally or—if one wants to put a positive construction on Goya's

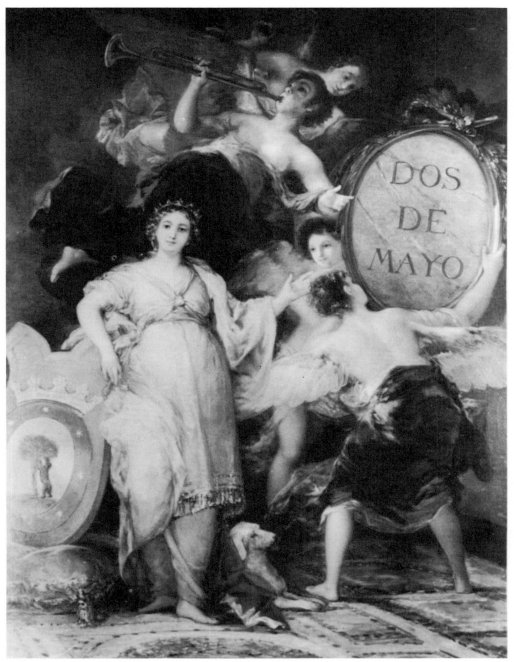

95. Goya, *Allegory of the Second of May* (*Allegoria del 2 de Mayo*). Ayuntamiento, Madrid.

execution of these paintings—they can be thought of as deliberate, ironical parodies of a kind of art that had grown hollow and meaningless.*

Although all of these paintings contain passages of great bravura painting, one picture suffices to illustrate Goya's attitude toward allegory. It also gives ample proof of the general bankruptcy of this genre. The so-called *Allegory of the Town of Madrid* or *Allegory of the Second of May* [95] is the most bafflingly sardonic counterweight to Goya's painting of *The Uprising at Puerta del Sol on the Second of May* [49]. The picture was originally commissioned to glorify King Joseph Bonaparte, and the framed shield to which the figure impersonating the City of Madrid points held the bust-length portrait of King Joseph. With the fall of Napoleon and the French retreat from Madrid, the portrait of King Joseph was painted out and the word *"Constitución"* was substituted. The constitution referred to was the liberal one drawn up by the Cortes in session at Cadiz. With the return of King Ferdinand VII to the throne, the Cadiz constitution was repudiated, and a tidal wave of reaction and repression swept Spain. The painting was again modified, and a portrait of King Ferdinand appeared in the oval frame, covering the word *"Constitución."* Finally, in 1872, the violently antagonistic ideas and ideals that had alternated on the face of the painting were neutralized by means of the present inscription, which recalls a moment of Spanish patriotic ardor to which all factions—royalist, republican, and revolutionary—could subscribe.

The history of the painting demonstrates how empty the whole concept of allegory had become by Goya's time. A given set of symbols—that is, a female figure wearing a crown of city walls, a trumpeting figure fluttering aloft, and a bit of ostentatious drapery—could be used for the allegoricization of the most contradictory political themes. No wonder the figure that is to embody the City of Madrid looks like an inexperienced soubrette and points awkwardly at the oval frame in the upper right corner of the picture. The belief in the actuality of symbols and allegorical figurations has vanished just as, in San Antonio de la Florida, the belief in the existence of angels had disappeared. What remains of allegory is a handful of dead attributes that can be used interchangeably to illustrate almost any theme.

It is also not irrelevant to note that Goya, who throughout his life was a great lover and connoisseur of the subtleties of the female toilette, should suddenly turn so utterly clumsy when it comes to the draperies of these allegorical figures. It doesn't take an expert of *haute couture* to notice that

*Nordström, *op. cit.*, p. 95; and George Levitine, "Some Emblematic Sources of Goya," *Journal of the Warburg and Courtauld Institute*, Vol. 22 (1959), pp. 106–31.

he throws his stuffs over his allegorical figures without any regard to the cut or the fall of the materials. There is nothing regal in the draping of these cloths just as there is nothing authoritative in the stance of the figures. It almost seems as if the cloths that are thrown over his allegorical females are meant to be used over and over again on various occasions instead of being cut and fitted for a specific figure in a specific composition. Given the great attention Goya usually pays to matters of dress, it is quite likely that the careless draperies of his allegories are an intentional, parodistic aside, glossed over by the virtuoso description of surfaces. In this way, the drapery really becomes expressive of Goya's attitude toward the entire genre of allegory.

More important than these tongue-in-cheek allegories are the more personal paintings (some of which may have been commissioned) that have a moralizing undertone. To call these pictures allegories only confuses the issue. Their realism is too sharp and pungent, the emotional participation of the artist too evident for these paintings to bear comparison with the more conventional works discussed above. The first of these "occasional" pictures (ca. 1795) grow out of the same mood that engendered the *Caprichos*. In a letter written shortly after his recovery from the first attack of his violent illness, Goya tells of being busy on a series of paintings that are not commissioned but are the product of his personal meditations, ideas, and moods. The paintings referred to in this passage have often been identified with a small series that Goya presented to the Academia de San Fernando. Most famous among these are *The Madhouse* (*Casa de locos*) [96] and *The Burial of the Sardine* (*El entierro de la sardina*) [97]. Historically, they illustrate the widening gap between artist and public—a crisis that was felt in artistic circles throughout Europe. The artist, if he is to follow his own inspiration instead of painting on commission, is suddenly no longer sure of his public. There is no telling whether his product will please collectors or whether the public will reject his output. Since there is, properly speaking, no place for these paintings, a neutral kind of no man's land has to be found to receive them. The museum, in the modern sense of the word, is born. For where, indeed, would one hang *The Madhouse* if not in a museum? It is fit neither for the church nor for the home, and no public or governmental building could be a suitable place to display it.

In *The Madhouse*, as in many of the contemporary *Caprichos*, there is a vague echo of Piranesi's *Carceri*, only what was sonorous and grandiose in Piranesi has become drab and commonplace. The vaults and shadowy recesses of *The Madhouse* have only a superficial resemblance to the horripilating arches and underground chambers of the *Carceri*. Nor is

96. Goya, *The Madhouse* (*Casa de locos*). Academia de San Fernando, Madrid.

there much to be said for a possible relationship between Goya's picture and the prints and paintings of Bedlam and other madhouses that were so fashionable in the 18th century. The most famous of these is, of course, the concluding scene of Hogarth's *The Rake's Progress*, in which the unlucky hero is shown among the wretches in Bedlam. It is possible that Goya knew a print after Hogarth's painting because in both scenes there appears the figure of a megalomaniac with a crown on his head and a scepter in his hand. But the treatment of the theme is entirely different. Hogarth moralizes and, despite his powerful realism, ennobles. The nude in the right foreground is evidently taken from an antique sculptural prototype. Just as the lady in the middle of the painting visits Bedlam in order to be entertained by the wild antics of its inmates, so Hogarth visits Bedlam in order to draw from it a salutary moral lesson.

Goya does not permit such moral and esthetic distancing. His composition is deliberately confused and difficult to analyze. There is no moralizing intention, and probably no social comment was intended. Though the reform of public madhouses was of some concern to the avant-garde of late 18th-century thinkers and politicians, such considerations can hardly be attributed to this small painting. It is the urgently felt

97. Goya, *The Burial of the Sardine* (*El entierro de la sardina*). Academia de San →
Fernando, Madrid.

200

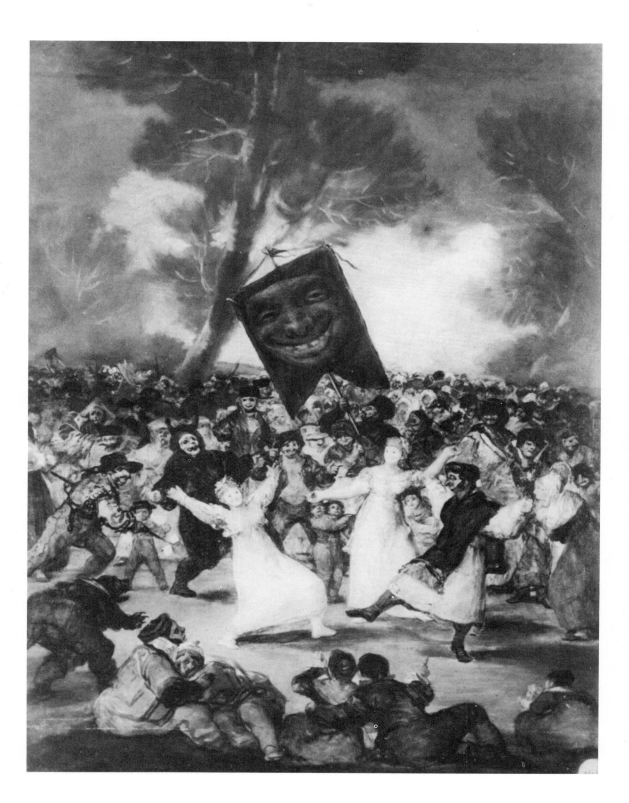

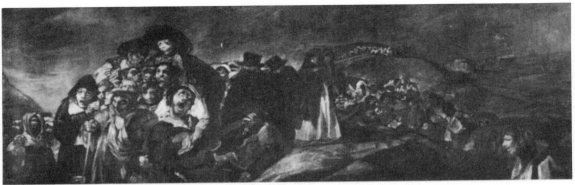

98. Goya, *The Pilgrimage to San Isidro* (*La romería de San Isidro*). Prado, Madrid.

expressive tension of the scene that seems to have motivated the artist. The fact for its own sake is the heart of the matter.

The Burial of the Sardine [*97*] deals with the far more cheerful subject of a popular feast. It is also one of the most astonishing virtuoso performances from Goya's brush. Rarely did Goya again reach such decisiveness of touch. Every brushstroke is a calligraphic marvel at the same time that it describes with consummate precision the expression of a face, the mood or emotional charge of a stance or a gesture. We have arrived here at the perfect balancing point between the early tapestry cartoons and the later Black Paintings. All the riotous gaiety of the former appeals to the eye from the surface of the painting. But in the darkening of the colors, in the masklike ambiguity of the faces (some of which *are* masked, while others, though unmasked, have all the impassive rigidity of masks), and especially in the overwrought gestures and expressions, one begins to feel the obscurely disturbing undertone of mass hysteria underlying the fiesta. Beneath the shrill songs and staccato dance rhythms there lurks the baleful *basso ostinato* that will ultimately erupt with full force in the howling mob of pilgrims of *The Pilgrimage to San Isidro* [*98*] and lead on to Ensor's crowd scenes.

A peculiarly blithe note is sound by a miniature cycle of paintings inspired by the misdeeds of a bandit named Margato and his humiliating comeuppance at the hands of a courageous mendicant monk. The story is divided into separate episodes much as if they were frames of a film or images in a row of cartoon strips. The bandit robs a farmer, threatens the monk, the monk struggles with the bandit, the monk succeeds in getting the gun away from him [*99*], shoots him in the buttocks, and binds him before delivering him up to the police. The compositions are all fresh and spontaneous. One can't help wondering whether Goya, like Géricault in his Fualdès series, intended to try his hand at popular illustrations, at

202

reconciling what was in that day spoken of as "fine art" with folk images. In any case, the forthrightness, humor, and masterful blend of journalistic reportage and refined inventiveness of composition are unique in Goya's work. Small in scale and unpretentious, they nevertheless constitute an important milestone in the development of modern art.

Closer in spirit and execution to the Black Paintings but probably painted before 1812 are the two monumental canvases known, for lack of a better title, as *The Young Ones* and *The Old Ones*. These are among the most startling paintings in the far too little-known museum at Lille.

The Young Ones [100] is a peculiar mixture of the delectable and the frightening. The central figure has a ripe exuberance to it, an ostentatious self-confidence that cannot fail to make its appeal. A radiantly healthy

99. Goya, *Fra Pedro Wrests the Gun from Margato* (*Lucha entre Margato y Fray Pedro de Zaldivia*). Art Institute of Chicago. Mr. and Mrs. Martin A. Ryerson Collection.

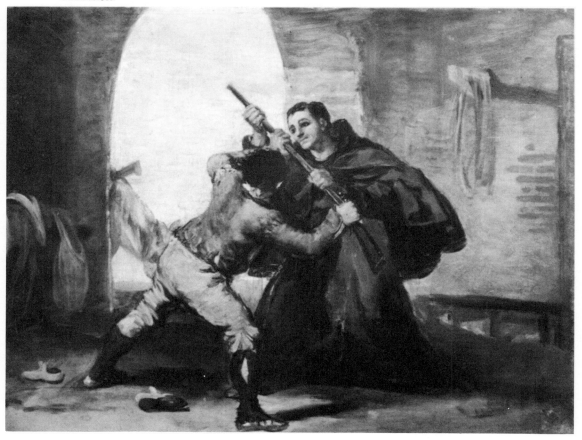

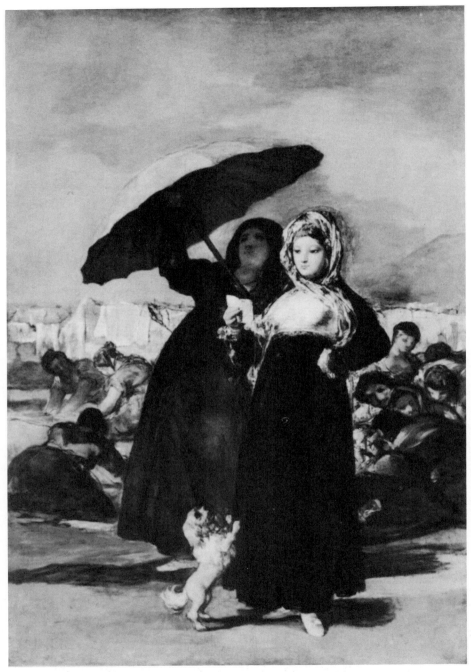

100. Goya, *The Young Ones* (*Les Jeunes*). Musée des Beaux-Arts, Lille.

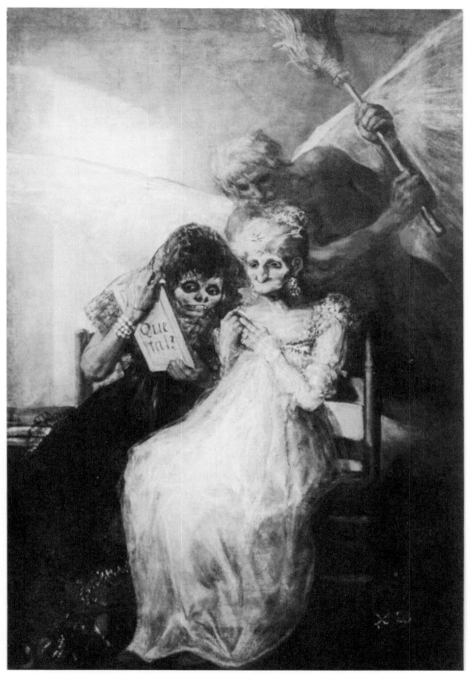

101. Goya, *The Old Ones* (*Les Vieilles*). Musée des Beaux-Arts, Lille.

woman, smug with a full sense of her appetizing body, casts a smiling glance at the sheet of paper in her hand. From her somewhat triumphant stance and look, we can safely deduce that she is reading a love letter and preens herself on her conquest. She is dressed in a rich black gown with white stuffs around her bosom and a white kerchief wrapped tightly around her plump face. Behind her, a maid, dressed in brownish black but without the brilliantly silky white accents of the central figure, opens a large black parasol. The color has been laid on a little more thinly than in the figure of the mistress; and especially in the passages of the maid's face and hands, the canvas ground has grown through the superimposed pigments so that a more transparent effect is produced. Still farther in the background, painted in a broad palette-knife technique, and with a minimum of descriptive definition, is a group of kneeling washerwomen on the banks of the river that seems to flow just outside a town composed of a series of white buildings.

It is interesting to compare this scene with Goya's earlier and superficially very similar The Parasol [2]. Compared to other pastoral decorations of the 18th century, The Parasol seemed quite original and expressive of ambiguous intentions. Compared to The Young Ones, it seems tame and irrevocably linked with a pastoral tradition that goes far beyond the Rococo all the way back to Venetian painting of the first decade of the 16th century. The more one glances from one painting to the other, the more incredible it seems that the same hand should have painted both. All the academicism of a geometrically constructed composition, which was so marked in The Parasol, has been abandoned here; all the youthful pleasure in extravagant coloration has been superseded by a subtle reduction to white, black, ocher pink, and an unpleasantly unwholesome mauve in the shorn poodle. The penetrating sunlight is replaced by an atmospherically dispersed, dusky light that stands in puzzling contrast to the ostensibly light-hearted subject.

The answer to the contradiction probably lies in the companion piece, or, rather, in the artist's desire to have us look at both paintings in sequence rather than as independent creations. For in The Old Ones [101] we encounter mistress and servant again—this time in a frightfully decayed state. Syphilis has corrupted the face of the maid into a hideously deformed snout, while the mistress, haggard and toothless, looks on with rheumy eyes as page after page of a scandal journal is turned for her amusement. Behind the two women, a winged old man wields a broom aloft, ready to sweep this human offal away. Visually, we have been prepared for his apparition by the sinister black umbrella (so different from the pink sunshade one could reasonably expect) in The Young Ones.

The painting of both these pictures, but especially of *The Old Ones*, is of an unparalleled vigor and brio. Boldly, the vermillion of the old woman's inflamed eyes is slashed against the glistening white of her eyeballs, and all of Goya's virtuosity is poured over the glittering silver robe, which gives the whole painting a phosphorescent illumination. The beauty of Goya's technical facility is as sardonic as the beauty of the hideous old woman's costume. Never have technical grace and coloristic enchantment been used so poignantly to describe the vanity and corruption of existence.

It would be far too simple to interpret these paintings as moralizing images in the traditional Christian sense. Death is not necessarily the wages of sin. Death and the horror of implacable decomposition are the fate of all things, independent of moral judgment. Many critics have seen a certain social criticism broached by Goya's juxtaposition of the idle young courtesan and the valiantly working washerwomen in the background. This interpretation is probably correct, and may link this painting with Daumier's celebrated paintings of washerwomen who are such close relatives of Goya's laundresses. But this social comment is not the only or even the most emphatic note sounded by the painting. For Goya, though he foreshadows the ultimate end of the young courtesan and though he expects us to see the two pictures in conjunction, nevertheless praises and admires the plump beauty, the proud youthfulness of the courtesan. For all the wrathfulness with which Goya disfigures the two women in *The Old Ones*, there remains an unresolved element of tragedy. Our repugnance for the ultimate end of physical beauty doesn't make the loveliness of youth any the less desirable.

The purpose for which these two monumental canvases were destined is still unknown. Were they meant to be publicly exhibited? Their size and technical splendor make such a possibility quite plausible. Yet where and how could such didactic pictures be put to use? As with the Black Paintings, we encounter here the problem of the homelessness of painting in the 19th century. Whenever art becomes polemical and detaches itself from decorative purposes, it is excluded from inserting itself directly into the stream and current of public life, as church painting, allegory, and history painting had done previously. In order to bring such paintings and a wide public together, the museum becomes the natural home for art during the 19th century. But the museum, by its isolation from quotidian cares and activities, subverts the very purpose it sets out to serve. We can be sure that Goya did not intend these pictures to be hung in the hushed, detached rooms of a public museum. Yet it is obvious from their didactic purpose that he meant them to have a social function. Just what he wanted to teach remains a mystery, however. Only if it should prove possible in

the future to discover the context in which the paintings were to be hung will it be possible to unravel the puzzle. As things stand now, we can only call attention to them as masterpieces of Goya's brush.

Although the Black Paintings, as a cycle, represent Goya's most ambitious achievement, if one were to designate a single painting as his absolute masterpiece, the choice would have to fall on *Session of the Royal Company of the Philippines* [102], rather than on any single one of the Black Paintings. For sheer imaginative power, for the perfect assimilation of technique and expressive purpose, this immense canvas—Goya's largest—is without equal; and only the fact that it is exhibited in a remote provincial museum has kept it from being more widely known, studied, and esteemed. Since there are no facts of a documentary nature to help us in our consideration of the picture, the best that can be done is to set down the riddles with which the painting challenges us.

To begin with, there is the question of the painting's origins. No painter, least of all the businesslike Goya, undertakes to paint a group portrait of such colossal dimensions without having been commissioned to do so. Yet no record of the commission, no mention of a contract have come down to us. It seems strange that what must have been Goya's most lucrative painting should have been executed without a word being revealed about the circumstances of its creation.

More enigmatic still is the typology of the painting. Is it a group portrait, a genre picture, or a history painting? The normal categories of painting seem to break down here. If we call it a group portrait, we do so only for lack of a more accurate terminology.

Ostensibly, of course, the painting represents much the same situation that found its most perfect expression in Rembrandt's *Syndics of the Clothmakers' Guild.* Both the Rembrandt and the Goya represent the council meeting of a mercantile organization. The only difference as far as subject is concerned lies in the fact that Rembrandt was commissioned to paint the portraits of the presiding officials only, whereas Goya includes two massive groups of nonranking members. At first glance, then, the painting would seem to be a group portrait, a category with which we have already dealt in relation to *The Family of Charles IV.*

Rembrandt's painting conforms to the exigencies and traditions of group portraiture even though it goes beyond the realistic sobriety of most Dutch group portraits by catching up the various individuals in a dramatic interplay of actions and reactions. Compositionally and coloristically, the *Syndics* exemplifies all the principles of group portraiture: sociability and the reasonable respect for individuality within a larger social context.

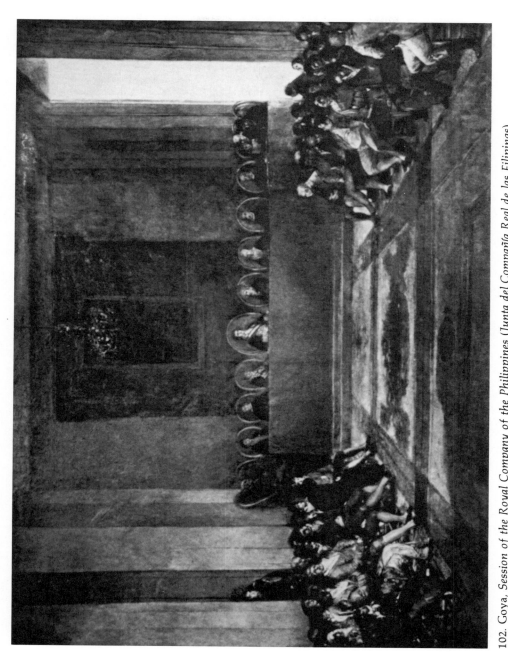

102. Goya, *Session of the Royal Company of the Philippines (Junta del Compañía Real de las Filipinas)*. Musée Goya, Castres.

Despite the diversity of expression, gesture, and psychological reaction, the dominant note remains one of harmony and of integration within the group. Equally important for our considerations, the dignity of each figure is preserved together with its distinctly expressed social status, its tenor of life, and individual features. Even if we look at the faces in Rembrandt's painting only cursorily, we will carry away with us a fairly clear impression of outward appearances and inward personality.

If the presence of these elements constitutes a group portrait, then Goya's *Company of the Philippines* cannot possibly be a group portrait. The physiognomy of the sitters has been so blurred that we have hardly any impression of what they look like even after having studied the painting in great detail. Those figures whose official rank is most elevated are almost unrecognizable. And if we are left in the dark about the characters of the portrait sitters, we are left even more perplexed by the action. Rembrandt, too, avoided references to explicit anecdotal action. We do not know exactly who has raised the question or what the issue is—but we *do* know that a question has just been proposed by someone in the conference room because the eldest of the syndics is seen rising from his chair, his head turned toward his interlocutor, his features alert as if he were collecting his ideas for a proper reply. The action is therefore oblique and subtle but still quite logically related to the circumstances. The action in Goya's *Session* is unfathomable. The presiding functionaries are totally passive. Only King Ferdinand, in the central, thronelike chair, thrusts his left forearm onto a table as if he were leaning closer to someone in front of him. The flanking groups of members (or are they merely spectators?) do not focus on any particular object. Quite the contrary. Everyone seems to be fidgety and restless with intolerable boredom, and every face stares off vacuously in a different direction. Instead of concerted action, instead of eternalization of individual features, instead of an interpretation of the social needs of mankind, we have here a total suspension of plausible activity, blank faces that bespeak mass anonymity, and a distinct sense of the irrelevance and meaninglessness of all human relationships.

If, under the weight of these considerations, we are forced to discard the notion that the *Session of the Royal Company of the Philippines* was commissioned as a group portrait and turn to other possibilities, we are similarly baffled. For surely this exceptionally large canvas cannot possibly be thought of a a genre picture. It lacks all the humor, all the picturesqueness of genre painting just as it lacks the pomp and splendor of court painting. Is it history painting, then? Does the *Session* aim at illustrating a particular moment in the existence of the corporation? The idea is hardly

plausible, because nothing is happening. The various members of the Company have come together for no visible or understandable reason. They aren't listening to a presentation of new statutes, they are not receiving an eminent visitor, they are not voting, discussing, or pondering new courses of action. In this respect, the *Session* seems to exist at the diametrically opposite pole from David's unfinished *Oath in the Tennis Court*, which combines history painting with group portraiture. David's painting was meant to extol the power of individual action when individual action is yoked to a common purpose arising out of a conscious realization of the historic moment. In an instant of enthusiastic intuition, all the men who pledge themselves to the tennis-court oath seem to recognize that history calls on them to join in an action that will mark forever a turning point in the affairs of mankind. The kind of illumination and sanctification that once was the prerogative of God's miraculous intervention is here secularized. Just as God once called on St. Paul to follow the insights of *his* divinely inspired conscience, so David's heroes become aware of the categorical demands manifest history makes on them. For David, the individuality of each of these figures, carefully studied and elaborated in countless studies and sketches, was of utmost importance, just as the explicit nature of their joint action, which ennobled these individuals, was of equally profound concern.

If we have used the word "space" in conjunction with the *Session of the Philippines* it is only for lack of a better term to describe the inchoate, stagnant atmosphere in which the figural groups are dispersed. Goya is not alone during the first third of the 19th century in questioning the nature of space. But he is the only one with the courage to redefine space in terms of the void. Other artists, though they too destroy the logical construction of perspectival space, come to very different conclusions. In the hands of Caspar David Friedrich, for instance, space is a mystic presence which lies beyond the scope of man's sensuous or spiritual comprehension. In such pictures as *Monk by the Seaside*, space is unbounded. It does not stretch forward into infinity (as it does in Tiepolo's masterful use of perspective) so that the spectator is given a clear direction, a straightforward path toward the empyrean light which draws all things upward (morally as well as physically). Instead, it flows in all directions at once, leaving the infinitesimal figure of the monk without coordinates, without a lighted trail that penetrates space.

It is equally significant that space in the late Baroque is always synonymous with light. The glory of the heavens radiates throughout every corner of the firmament. With the advent of Romanticism, space is synonymous with darkness.

The surprising turn taken by Goya in the *Session* is his transposition of these modern speculations on the nature of the universe from a lonely, mystic encounter between the individual imagination and the hostile, impassive infinity of space, to a social situation in which a large number of individuals are enclosed within relatively narrow confines. The dread majesty of Caspar David Friedrich's immensity of space encroaches on the everyday affairs of men as they go about their business in a meeting room. Infinity invades the domestic scene like a dark flood. For the dominant force of the *Session* is the dreary, meaningless emptiness of the room itself which no gathering of men can dispel. It is a space that does not tolerate the coordinates of up and down, forward or backward. We, as spectators, are granted no firm footing in the picture and therefore are unable to measure distances or take our bearings. We cannot tell whether we are floating like wraiths above the scene or lying on the floor looking up. Even the carpet, an element that was always used by earlier painters to introduce a comprehensible, continuous bridge between front and back of a composition, does not help us to orient ourselves in space. It is spectrally insubstantial, and its patterning, rather than evoking a sense of structure, simply dissolves into a series of shifting, drifting shapes. Perspective, with its ordering, harmonizing presence, has been exiled from this picture. There are no center and no periphery. There is only the bleak void that drains off at the bottom.

Caspar David Friedrich and the Romantics, though they sensed the anarchy of modern space, took flight in an emotional, mystic abnegation of individuality so that the immensity of unknowable space, despite its darkness, could still be encompassed in a hymnal manner that retained positive values and was best expressed in such poems as Leopardi's "*L'infinito*" and Victor Hugo's "*J'étais seul près des flots.*" In typical Romantic fashion, the individual submerged himself in infinity. Having lost faith in the knowable, he had only the alternative to praise the mystery of what lay beyond his capacity to understand. There was an element of adventure in this Romantic attitude, and there was also the proud and exciting faith in the absurd. In the last analysis, the Romantics remained bound to the traditions of Christianity. Rather than shaking their faith, contradictions and absurdities actually stimulated it. The enigmatic character of the world and of the universe were turned into proof of God's presence even though that presence was no longer as available as it had been in the preceding centuries.

Goya's vision of the incommunicable nature of the cosmos forbids such hopes. All warmth has fled, and even when men gather together with some declared purpose, there is no common ground possible. Inevitably

they are claimed by the yawning, endless, unilluminated vastness that sucks us back into unbreachable loneliness and insignificance. The men who people this large canvas are much like the blind, erring colonists of Joseph Conrad's *Heart of Darkness*, condemned to cross-purposes in an impenetrable jungle that makes mock of their existence and undoes all their pretensions at morals, human bonds, and self-knowledge. Here is a clear foretaste of Poe's paralyzing intuitions of nothingness and of Baudelaire's spleen and ennui. The demon of acedia steals all the luster from this world's sunlight, jeers at our comings and goings, and mocks all our pretensions.

Although the secret of this painting remains indecipherable, there are some elements that may some day help in resolving Goya's conundrum. The reference to Leonardo's *Last Supper* may be such an element. For certainly no painter working after 1493 could possibly paint thirteen men sitting behind a table without being aware of Leonardo's example. But if Goya did intend us to compare his painting with Leonardo's *Last Supper*, he must have intended us to come up with negative conclusions. Everything in the Leonardo is articulate, rhythmic, harmonic, resolved, and integrated; each figure is immersed in a rhythm that travels through the entire extent of the composition, and yet each figure stands out with supreme individuality. In Goya, however, not a single relationship of hostility or antagonism is visible. Total indifference and irrelevance reign in the interstices between the figures. The curious effect created by the gilt frame of each of the chairs, which turns each bust-length figure seated around the far table into a medallion portrait, is probably quite intentional and adds to the sinister sense of alienation.

The other reminiscence of an earlier painting that haunts the *Session of the Royal Company of the Phillipines* is far less precise but nevertheless persistent enough to merit mention. The lighting effects, as well as the bare hall in which the meeting is being held, seem to be a carry-over from Velázquez's *Las Meninas* [29]. Bleak and of a scale that dwarfs the figures, the room is of the utmost importance in setting the tone of the entire picture. The fearful distortions of perspective, amplified by having the room so large and hollow, give the role played by the space an even more dominant accent. The manner in which some of the presiding figures stare out of the picture as if they were aware of us also seems to have some connection with *Las Meninas*, and this impression is reinforced by the figures seen at the left, detached from the main body of the *Session* and yet a part of it—much as was the case with the figure of Velázquez's position in *Las Meninas*. Goya teasingly gives us all sorts of hints but forces on us the recognition that all lines of flight end in ambiguities. The

false foreshortenings, the unrecognizable faces, the pointless yet menacing stares out of the picture, and above all the suspension of any understandable action, give one the peculiarly Kafkaesque feeling of being on trial without knowing why. The effect is hard to gauge from the reduced reproduction, but standing in front of the immense canvas with its vacant center, one can't help but feel oneself humiliated, isolated, and insidiously exposed on all sides.

Goya is the first to illustrate in his paintings the dubious nature of action when action is no longer determined by a fixed, transcendental moral code. In a world that had lost its former stability based on revealed religion, he and his contemporaries had only reason and instinct left. Both proved to be unreliable instruments for navigation in a new era bedeviled by enigmas, vague menaces, and the very concrete horrors of the Napoleonic Wars.

That Goya's art after 1812 strikes a severe blow against the age-old concept of art as a form of instructive communication is proved not only by the Black Paintings but even more by the series of graphic plates known as the *Disparates*. The Black Paintings, being decorations for the artist's own home, need, after all, not have meant anything to anybody but the artist himself—though even such a degree of hermeticism is without parallel in the history of art. The *Disparates*, however, are graphics, the form of art most closely associated with the printed word, in a technique that loses all justification if it is not to be broadcast in a large edition. One can only conclude that Goya intended to broadcast the idea of an inscrutable, alien, and enigmatic universe to a very wide public—to make, in other words, the language of non-sense attain wide currency.

In these plates, the disruption of normal coordinates, on which we all depend to comprehend the world we move in, is at its most extreme. This disruption is all the more emphatic as it is often mixed with highly convincing realism.

Take, for instance, the most famous of all the *Disparates*—"The Dead Branch" [103]. The tree as well as the huddled wretches sitting in the crook between trunk and branch are described with downright affection for surface appearances, but these realistic observations are transferred to a limbo in which all reality loses its footing. How grateful one would be for a cloud in back of the figures. Then one could safely interpret the space that surrounds tree and figures as sky and gain a certain hold on things. But there is no indication that the background is sky. It is a vast, amorphous nothingness. It has no character and no substance. Nor can one call the grayness of its texture a pervasive twilight. The light, too,

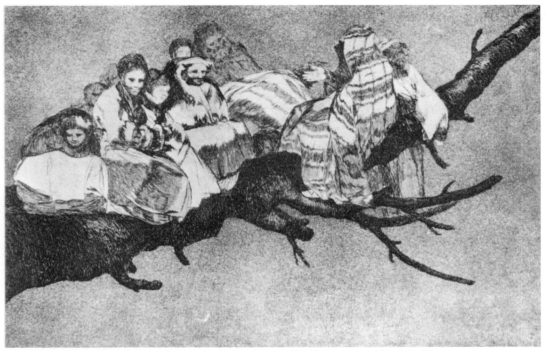

103. Goya, The Dead Branch: Ridiculous Folly (*Disparato ridiculo*). *Disparates* No. 3. Metropolitan Museum of Art, New York. Harris Brisbane Dick Fund, 1924.

does not come, as light should, from a given source, differentiating volumes from voids as it travels through the air. There is only an inchoate gloom that robs everything of definition. The fact that people should be huddled in a tree is less strange and far more acceptable than the timeless, placeless ambience. Again, Goya turns to fragmentation rather than composition. The "frame" has been chosen in such a way as to exclude important data, and we come away feeling deprived and baffled.*

Slightly more fabulistic is the image of Plate 13, "A Way of Flying" ("*Modo de volar*") [105]. Men wearing birdlike headdresses and sporting huge wings are seen in flight. There is no horizon line, no way of telling up from down, and, most important of all, there is no indication of Goya's

*It is revealing to compare Goya's "The Dead Branch" with a similar painting representing figures caught in a tree in a spectral, hallucinatory landscape. This painting, *The Evil Mothers* [104] by the Italo-Swiss painter Giovanni Segantini (1858–99), is often considered a precursor to Surrealistic visions of the 20th century. Segantini, however, by giving us the whole tree in its landscape, reduces the pitch of his terror. Though the landscape is certainly strange in its barren vastness, it still gives us support under our feet and a helpful sense of knowing what is near and what is far. Goya terrifies us not only by presenting menacing subjects but by projecting a sense of permanent helplessness.

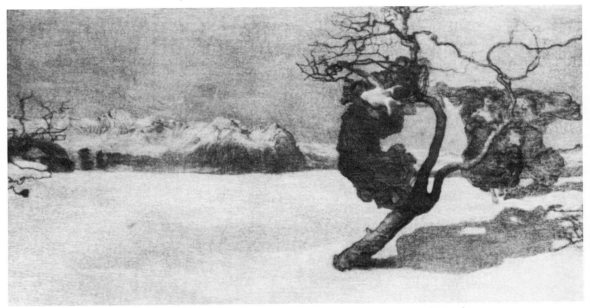

104. Giovanni Segantini, *The Evil Mothers* (*Die bösen Mütter*). Kunsthaus, Zurich.

105. Goya, A Way of Flying (*Modo de volar*). *Disparates* No. 13. Metropolitan Museum of Art, New York. Harris Brisbane Dick Fund, 1924.

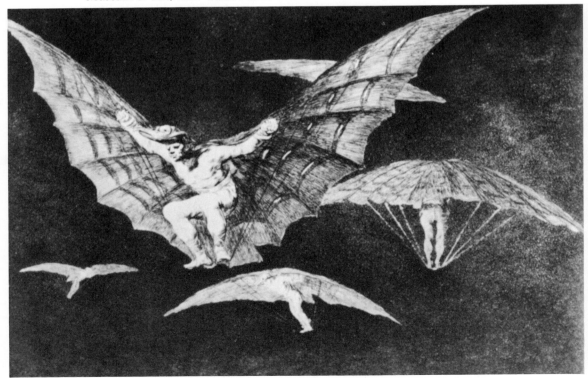

(and, by implication, our own) point of vantage. This divorce from any kind of ground is a constant in the *Disparates*, for even those plates that do not levitate in pure air are devoid of any indication of locale or ground plane.

Yet for all their distortion of normal experience, there is nothing artificial about these visions. To call them dream images short-circuits the issue. For even in dreams we experience gravity and register sensory experience. Some part of our being resonates to the menace and the loneliness of the *Disparates*. Clinical psychology might at some future date help in the interpretation of this haunting series of pictures. But their real meaning, one is willing to believe, will forever lie beyond the grasp of even the most refined scientific examination. Psychiatry, after all, tries to resolve distraught and incongruous situations. The *Disparates*, however, are the quintessence of that part of our life that forever defies understanding.

In the *Disparates* and in *The Session of the Royal Company of the Philippines*, as well as in the Black Paintings, incommunicability becomes a viable subject for art.

11

Portraits

Since portraiture developed very early in Goya's *oeuvre*, we must glance back to the beginnings of his career in order to seize one of the most essential elements in his character and his art.

For an artist who is chronically in love with the miraculous diversity of human character, portraiture is the most natural and the necessary mode of expression. It is not only a matter of painting a vast corpus of portraits. It is far more a matter of seeing the world and sensing all the forces involved in the sheer act of living in terms of individual character. Goya's idols, Rembrandt and Velázquez, share this passion and express themselves in terms of portraiture even when they are dealing with mythological or historical themes. Rembrandt's *Samson and Delila*, his *Conspiracy of Claudius Civilis*, or any of his other dramatic subjects taken from history, mythology, or Scripture are conceived of in terms of their protagonists' personality. Looking at his figures, we are immediately given their full biographies. The actions in which they are involved gain depth and inner necessity precisely because the outcome of their actions is fatefully inscribed in their personal history, which, in turn, is made manifest by their outward appearance. This is just as true of Velázquez. Rubens and Bernini also produced movingly penetrating portraits in which psychological finesse and emotional sympathy are frequently as profound as those found in the portraits of Rembrandt or Velázquez. But when these artists work on compositions of more narrative scope, their portraitist's insight is largely suppressed in favor of a powerfully disciplined urge to present the universal significance of the narrative rather than the minutiae of personality that made the dramatic encounter inevitable. The penchant toward perceiving and rendering valid essences not bound to time, place, or accidents of personality can even be seen in Rubens's or Bernini's portraits. These portraits (with very few notable exceptions) respect the

right of the individual to present himself in a composed and socially acceptable manner. That is not to say that either Rubens's sitters or Rubens himself favored false posturing. The sitters of Rubens and Bernini, as well as the artists themselves, considered social position to be an integral aspect of the human personality. The social type of the individual is, to them, an important function of an individual's character. For Rembrandt and Velázquez, individuality is something independent of social position.

Goya, then, is temperamentally a portraitist. Even his earliest works, the tapestries, distinguish themselves, as we have seen, by an unsettling emphasis on individualization instead of following in the accepted tradition of decorative generalizations. The young girl in *The Parasol* [2], though she has comparatively little character, is far more insistently characterized than the shepherdesses or sweethearts of other 18th-century tapestries who are generally quite interchangeable. But for all this temperamental inclination toward the unique and the highly differentiated, and in the face of Goya's declared admiration for Rembrandt and Velázquez, Goya's portraits are profoundly colored by his own conceptions of art and the artist's obligations. Velázquez's sobriety of approach and Rembrandt's lyricism still leave us feeling that for all the multiple and profound insights that have been granted us by the artist's inimitable intuitions, there remains a secret, a certain aura of sanctity in the case of each portrait. And it is this light of an unnameable grace that gives the ultimate, crowning meaning to their having lived and to their having been painted. A suprapersonal force, an element that goes far beyond the sum of facts and insights we have gathered concerning these sitters is what really makes them worthy of being looked at by future generations. Perhaps it is not too much to say that there is something essentially reverent and religious in Renaissance-Baroque portraiture. The individual, within this tradition of portraiture, is considered an extension of divine will, and it is part of the artist's duty to make out and fix for eternity the God-given element in human existence. The primary urge toward portraiture is the wish to immortalize what is capable of immortalization. Goya's portraits are the creation of quite a different motivation, and the celebration of an indestructible human soul plays a very exiguous role. Goya's portraits are the first modern portraits.

Like the tapestries, Goya's first essays in portraiture grow out of an established 18th-century tradition. Their color is lively, and their technical brio is of high virtuosity. Pinks, transparent grays, mauves, apple greens, and citron yellows predominate, and the lighting is generally quite diffuse and without strong shadows. The social rank of Goya's sitters is conceived of as an essential clue to their characters; indeed, in some cases, the social

position of the sitter is the only clue we have to the true nature of his temperament. Distinctions are made, as was natural in the 18th century, between the intimate portrait and the ceremonial portrait. From the first, the distinction between the portraits that interested Goya personally and those that did not is immediately apparent. Unlike earlier portraitists, Goya does not bring the same polish of craftmanship, compositional originality, or personal warmth to all his portraits. Frequently, all these aspects of painting are neglected, and shabby shortcuts or shoddiness of brushwork (which must not be confused with Goya's brilliant ability to abbreviate the rendition of visual experience) make it difficult to find a common denominator of quality in these works. His integrity as an artist is capricious and often depends on the intensity of interest that his sitter was able to command.

In his portrait of his brother-in-law, Francisco Bayeu [106], Goya's alertness and overt responsiveness are quite clear. The figure is depicted with great economy of means, and the austerity of the face is emphasized

106. Goya, *Francisco Bayeu*. Prado, Madrid.

by the rigidly erect posture of Bayeu and the cold, stringently limited palette, which is restricted to a narrow range of grays that vary in density and transparency rather than in tonality. The pursed, unexpansive physiognomy of Bayeu is probably accentuated by Goya. The bitter litigations and quarrels that marked their early relationship during the days of Goya's first commissions in Saragossa must have been due in part to the total polarity of their characters—Goya, volatile, sensuous, muscular, morally not overscrupulous, and Bayeu, whose puritanical rectitude seems to have been accompanied by arrogance and sententiousness when it came to the affairs of others. But for all its liveliness of psychological exposition and ostentatiously brilliant brushwork, this portrait and others like it would hardly have been sufficient to have earned Goya the reputation for great portraiture he was to enjoy during his lifetime—a reputation that remains undiminished in our day.

We must turn instead to those portraits that, for one reason or another, forced Goya to reevaluate the obligations and exigencies of portraiture to find the germs of his future greatness in this genre. That Goya felt a certain constraint in fulfilling the demands attendant on being a portraitist of high fashion can be sensed in even his most casual pictures. The figures he painted rarely present themselves with the ease and self-sufficiency that are, without exception, attributes of all 17th- and 18th-century portraiture. Whether we look at the most searching and intimate portraits of Rembrandt or the most fatuous confections of minor 18th-century court artists, the dominance of the individual over his environment is striking and complete. Goya's portraits are the only ones (unless late 18th-century North American portraits are included in the discussion) that stand in conflict with the standards of his own tradition. Instead of inserting themselves with equanimity into the space in which they move, his figures appear to be rigid and almost paralyzed with self-consciousness. They don't "present" themselves in the gracious manner in which sitters are introduced to us throughout the history of Western portraiture since the early 15th century. An awareness of isolation begins to manifest itself in these works, which is essential to understanding the slow strangulation of the entire genre of portraiture in the 19th and 20th centuries.

The *Marquesa de Pontejos* [107] is an exemplary portrait of Goya's early career, and it is useful to put it in context by comparing it with works of the two dominant schools of the day, the French and the British. Boucher's *Madame de Bergeret* [108] and Gainsborough's *The Honourable Mrs. Graham* [109] can, in all fairness, be taken as the established standards in the field of 18th-century full-length portraiture. More ambitious than the bust portrait and more lyrically expressive than the state

107. Goya, *Marquesa de Pontejos.*
National Gallery of Art,
Washington, D.C. Andrew Mellon
Collection, 1937.

108. François Boucher, *Madame de
Bergeret.* National Gallery of Art,
Washington, D.C. Samuel H. Kress
Collection, 1946.

portrait, which is usually posed in an interior, the combination of
landscape and portrait affords the painter a much wider latitude in
revealing his sitter's character by bringing it into sensitive and expressive
conjuncture with the grandest and most pliable of all possible settings:
nature. Boucher profited from this juxtaposition of park landscape and
portrait figure by bringing all the conventional traditions of Baroque
portraiture to their ultimate refinement. The figure of Madame de Bergeret
dominates the canvas. A lithe and vivacious momentum is brought into
her pose by the slight extension of her arms and the diagonal axis of the
bodice, which suggest that Madame de Bergeret has suddenly appeared
before us out of the *bosquets* behind her. Her head turns slightly in an
alert and pleasing fashion as if she heard steps behind her, and a certain
expectancy tautens her graceful body. By adjusting the compositional axes
of trees and figure, Boucher has brought the two major elements of his

222

picture into close harmony. One has the impression that the park is Madame de Bergeret's realm, that she is at home in this welcoming fragment of nature. There is a continuity between figure and landscape that clearly demonstrates the artist's powerful vision of the essential oneness between man and his environment. The landscape becomes a direct extension of the figure and helps to bring her nearer to us at the same time that it gives her a strong visual and spiritual support and enhances both her grace and her dignity. It is interesting to note in this

109. Thomas Gainsborough, *The Honourable Mrs. Graham*. National Gallery of Art, Washington, D.C. Widener Collection, 1942.

respect the subtly used floral motifs, which appear most evidently on the right side of the painting where natural roses growing from large urns mingle with *costumier* roses on Madame de Bergeret's gown. There is no essential difference between these two kinds of flowers.

Gainsborough is perhaps a trifle closer to modern sensibilities than Boucher. Mrs. Graham, instead of being utterly caught up within the landscape, stands to one side contemplating it. This meditation on the loveliness of nature evokes a languid smile on her lips. The goodness of nature has awakened associations that ennoble her mind and stir sentiments of tranquility and gentleness. Again, nature and man are seen as a single emanation of delight and charm. Though there is in neither picture any statement of a religious nature, the essential beauty of each figure results from a commonly held and deeply meaningful faith in the worthiness of man and his ultimate perfectibility. In admiring Madame de Bergeret and Mrs. Graham, we are ourselves ennobled, for we recognize in their images symbols of the sanctity of the creatures wrought in the image of God, who also gave them dominion over the earth and all that is in it. We, in our turn, are ennobled by recognizing and admiring the charm of the sitters and the artists' skill. Their charm is communicable and transitive.

The Marquesa de Pontejos belongs to another world, and the painter who is responsible for her portrait also conceives of the bond that binds him to his sitter in a manner that would have been perplexing to either Boucher or Gainsborough. The most obvious divergence lies in the totally different evaluation of the combination of figure and setting. In overall effect, this painting resembles the method used by carnival photographers who hang up a shoddily painted scenery flat in which a hole has been cut for the face of the client. The resulting photograph owes its humor to the incongruity between the familiar reality of the face and the flat implausibility of its surroundings. Goya focuses on the head of the marquesa to the detriment of the rest of the painting, and the final irony resides in the fact that the head is so strangely vapid and bereft of character that the insistent regard that the artist has cast on it, sacrificing all other elements of his painting, is not rewarded. Everything (with the possible exception of the aggressive little pug dog) is blurred, without density or volume. Even the costume and the figure of the marquesa, though they are painted with exquisite attention to the transparency of the voiles and the shimmer of silk ribbons, are totally out of tune with the face. With somewhat arrogant wit, Goya has diminished the waist to an extraordinarily brittle thinness, and this distortion is not hidden (as a similarly flattering waist in Madame de Bergeret is hidden) by the artifice of his composition. On

the contrary, its anatomical implausibility is emphasized. The whole rendering of the body is probably modeled after current fashion plates. Among all the varieties of figure drawing, only fashion plates can easily justify their distortions by means of their function, for they are designed to show off particularities of modishness, and their whole purpose is to indicate that the style of dress that they advocate can be worn by anyone. They are therefore the exact opposite of portraiture and justifiably suppress individuality of face and body in order to focus attention on the particularities of their costumes. Goya's adoption of the fashion plate is not only an oblique and rather deprecatory comment on the character of the marquesa, it also has implications that will become more meaningful later on. This is one of the first instances in modern art of the use of "commercial" arts. Respect for the "fine arts" is showing its first and very tentative sign of shriveling.

The landscape in the painting is quite unconvincing, and we must beware of judging its brushwork passages by current standards. Our eyes, trained by our admiration for Impressionism and Abstract Expressionism, tend to be overly generous in automatically ascribing a positive value to "broad" brushwork. It is true that Goya's brushwork is loose in this instance, but it is also shoddy and thin. For a craftsman of Goya's sophistication, this kind of brushing on of pigment is not a matter of bravura spontaneity but is instead a gesture of contempt. It isn't even good underpainting. Anyone who has looked at Goya's sketches or unfinished paintings will see immediately that there is a tremendous difference between his speedily set down brush sketches when he tries to catch the spontaneous movement of the fleeting instant and the kind of slapdash shortcut that aims at stimulating mere brilliancy of surface.

The landscape in Goya's portrait, even in this sorry vestigial state, has no logical significance. The figure doesn't stand within the landscape, part of the splendor of a lovely park, as happens in the Boucher; nor does the marquesa's face or stance suggest her awareness of the charm of her surroundings, in the manner of Gainsborough. There is no compositional transition between figure and landscape and no spiritual relationship between the marquesa and her environment. There is no reason why we have been introduced to the marquesa in this particular location. It is all makeshift, haphazard, and done without conviction. The same, of course, can be said of the relationship between the dress and the figure. For whereas it doesn't occur to us, in the Gainsborough and Boucher portraits, to think of the two ladies as dressed in any other way, the finery sported by the marquesa sits rather uneasily on her. It seems usurped rather than rightfully hers. The trouble is that it was painted for its own sake and not

as an organic part of the figure. In the Boucher and the Gainsborough, the dynamics of the clothes are harmoniously adjusted to the dynamics of the figure. They are expressive clues to the nimbleness of Madame de Bergeret and the suave tranquility of Mrs. Graham. The costuming is derived from their mood and from their character. In Goya's work, it serves no such purpose and therefore it betrays the marquesa rather than aiding her. Instead of flattering his sitter by displaying all her expansive wardrobe for us, Goya offers her up to us with a certain mockery.

Not all of Goya's portraits of this period are as ambiguous in their verdict on human vanity or other shortcomings. The fastidious *Marquesa de Solana* [110] is made of quite different stuff. As a portrait it is decidedly superior to the portrait of the Marquesa de Pontejos. Though it is often dangerous to conjecture about an artist's probable reaction to his sitter, it seems fairly safe to suggest that the Marquesa de Solana, with her spirited, expressively irregular physiognomy, must have intrigued Goya's imagination far more than the doll-like placidity of the Marquesa de Pontejos. The brushwork is more incisive and more substantial. Superficial virtuoso passages disappear in favor of a richer laying on of pigment. The flickering, decorative brushstrokes give way to a much more measured, longer melodic line. Each touch of the brush is emphatically integrated with the rhythm of the figure. There is a far greater sense of the body beneath the costume, and Goya manages to convey the muscular energy that is responsible for so eloquent a stance. Instead of the bland diffusions of grayed tones, Goya sets up an irregular counterpoint of coloristically emphatic areas: the silvery slippers, the bold pink bow, the white of the long gloves outlined against the compact black of the gown. In all, this is one of the most vivid portraits of Goya's first maturity, and it would be tempting to see in it a return to the humanistic traditions of 18th-century portraiture. However, the essential break with past conventions that was established in the portrait of the Marquesa de Pontejos remains unhealed in this later work. In fact, the disparity between figure and environment that was already so surprising in the Pontejos portrait has been pushed even further. The landscape in the earlier portrait is still respectful of earlier conventions. To the hurried observer, the schematized and insubstantial landscape of the background might even look somewhat like a landscape in the background of a Gainsborough. But in the case of the Marquesa de Solana, this last vestigial bond with the manner of seeing implicit in the works of Goya's predecessors and contemporaries has been dissolved. A sharp diagonal separates the background into an upper and a lower zone without indicating either a measurable depth or a recognizable interior or exterior setting. Velázquez frequently kept the background of

110. Goya, *Marquesa de Solana*. Louvre, Paris.

his full-length portraits quite neutral; still, in all cases, by his uncannily precise rendering of all the atmospheric nuances, Velázquez provided a rationally as well as a sensuously logical setting for his figures. Even his most economical portraits retain a distinct balance with their surroundings, and their placement in the picture frame gives his compositions a distinctly structural scaffolding that sustains them and binds them to their natural habitat. In Goya's work, this structure begins to disintegrate, so that the figures are seen as if deprived of their natural and expressive surroundings. They are isolated and put up for study much the way biological specimens are prepared for study as unconnected facts.

Most charming of all Goya's portraits is the ambitious group portrait representing *The Family of the Duke of Osuna* [111]. In no other portrait before 1800 is Goya's palette as fresh or his will to see only the most pleasant aspects of his sitters so completely manifest. The children are pretty, innocent, and affectionate; their elders appear to be affable and tender. The brio and airiness of execution rival that of Gainsborough, whose portraits were already accepted in Spain as models of aristocratic ease and intimacy.

And yet it would be impossible to mistake this portrait for anything but a Spanish painting. Even in the most austere of English or French portraits, the stark and downright shabby background of the Osuna portrait would be unthinkable. We are given no hint of the palatial or idyllic surroundings of the figures. Instead of being expansive in the manner of all portraits of the late 18th century from Reynolds to Angelica Kauffmann to Vigée-Lebrun, this portrait is constricted. Loneliness and uncertainty rather than sociability and aplomb mark Goya's portraits from the beginning.

There are other disturbing features in the Osuna portrait that are not noticeable at first glance. Most striking is the odd disproportion between the dimensions of the duchess's head and the incompatibly spindly size of her arms and torso. If one tries to read the figure by itself from head to toe, it falls completely apart. The feet are an impossible distance away from the thighs. The upper body is seen in full face, the thighs and legs must be presumed to be in profile, yet there is no transition between these two angles of vision, an effect that gives to the pose a stiff and awkward cast. Slightly wooden, "held" poses are noticeable in the other figures, too, most uncomfortably in the duke, who stands at an uneasy slant to the rest of the group. The slightly staring, unblinking quality of the faces

111. Goya, *The Family of the Duke of Osuna*. Prado, Madrid. →

goes with the tightness of their poses. One is reminded far more of early 19th-century daguerreotypes (which required of the sitters absolute and protracted motionlessness) than of the fluent and gracious portraits of Goya's contemporaries.

The great masterpiece of Goya's portraiture before the advent of what might be called his tragic style (which coincides with the first virulent attack of his recurrent disease in the year 1793) is also one of his most popular works. The portrait of *Manuel Osorio de Zuñiga* [112] is a picture that is as ravishing in color as it is wicked in characterization. Its great popularity is most certainly due to the former rather than the latter aspect. Looked at cursorily, little Don Manuel seems the most exquisite in a long line of Baroque and Rococo children's portraits. He is dressed in a loosely tailored suit of persimmon-colored cloth tied at the waist by a charmingly pseudomilitary sash of silvery gauze. The interplay of solemn dress and childishness is humorous and even touching. In this respect, Goya again follows in the footsteps of his great preceptor Velázquez. The pompous finery of Velázquez's portrait of *Infante Philip Prosper* [113] contrasts with the frailness of the doomed little prince to produce a hauntingly poignant effect. Velázquez, a discreet and sober artist, usually holds his own sentiments in reserve and allows only oblique, unobtrusive hints to tell us of his own feelings. The stock drapery backgrounds brought to a decorative perfection by Van Dyck are used throughout the 17th and 18th centuries to add pomp or indicate the lofty social position of the sitter. But Velázquez, in those few works in which he used draperies and architectural settings, discovered in these elements a surreptitious vehicle for stating his own intuitions. The soft red velvets, the hushed atmosphere, the tender light falling through an invisible door—all these are additions not dictated simply by a desire for ostentation. One need only look at Velázquez's other portraits to see how different his treatment of such elements can be, how distant and aloof his draperies are when he means to indicate only an outward expression of wealth and power. Here, in the portrait of Philip Prosper, his purpose is quite different, and in each gradation of color there is eloquent testimony to Velázquez's instinctive desire to enshrine the innocent, fragile boy in a protective interior where all is warm, soft, and benevolent. At the same time, the confluence of the major axial lines (the curve of the drapery in the upper right which debouches directly into the curve of the golden sash) knits child and interior together in such a way that the setting becomes a direct extension of the child's own warmth and tenderness.

112. Goya, *Manuel Osorio de Zuñiga*. Metropolitan Museum of Art, New York. →
Jules S. Bache Collection, 1949.

In Goya's portrait what at first seemed so enchanting and innocent about Don Manuel Osorio now seems a little unsettling and equivocal. There is a strange discrepancy between the luxury of the child's dress and the cold emptiness of the room in which he stands. The brilliant color of the dress is a deliberate obstacle in the way of our perception of Goya's intentions, but once it is surmounted, and we look away from the flattering delights of the costume, the discrepancy between setting and costume becomes emphatic. The light in the picture is cold and illuminates no pleasing setting. The bleak space, once we subtract the figure from it, might very well be that of a prison cell. Moreover, the space is deliberately rendered in an ambiguous manner so that we cannot tell whether we are inside a room or outside. If we look at the only architectural indication, the vertical line to the right of the painting, we can read the angle as either coming toward us or receding from us. Two equally valid, but mutually exclusive, readings of the angle are given us. Space, which in the Velázquez portrait of Philip Prosper was a sheltering, secure background, is made disturbingly equivocal by Goya.

The contrast between these two artists becomes even more astonishing when one considers their treatment of the animals in the two pictures. In Velázquez, a humorous, touching play between the fragility of the boy and the diminutive size of the dog gives the relationship between the two something companionable and tender. There is a warm intimacy between them, and they gaze out at us with the same trusting innocence. Just the opposite is true of Goya's portrait, in which animals and boy are deliberately dissociated. Manuel Osorio, with a completely detached air, parades a pet magpie in front of three avid cats crouching in the darkness. The bird is exposed to imminent danger and the cats are being tormented because they will be punished if they give in to their killer instincts. And the devious little boy responsible for this miniature scene of malicious teasing stands aside from the imminent drama—a little too ostentatiously impassive to be truly unaware of the wicked game he pretends to ignore. More than a hundred years before Freud, Goya penetrates the innocence of children's appearance to portray the latent ambiguities and curiosity about death and pain that dwell in every child. Few painters, if any, after Goya have ever dared to draw so devastatingly acid a picture of boyhood in which the loveliness of the surface makes the underlying waywardness take on sinister shading.

There are other, earlier 18th-century paintings of children maltreating animals. In *Lord Grey and Lady Mary West as Children* [114], for

113: Diego Rodríguez de Silva y Velázquez, *Infante Philip Prosper.* →
Kunsthistorisches Museum, Vienna.

example, Hogarth shows two small children, one of whom holds a puppy upside down by the hind legs. But the incident is simply based on the observation that little children are clumsy in their treatment of dogs. The action has a bemused, tender flavor. Goya's Don Manuel Osorio, in contrast, looks devilishly knowing.

Goya remained true to his vocation as portraitist even during those years that saw the creation of his far more ambitious and historically more important paintings. Despite the dethronement of the individual that we witness in *The Third of May*, despite the realization of the human tragedy

114. William Hogarth, *Lord Grey and Lady Mary West as Children*. Washington University, St. Louis, Mo.

of incommunicability that stares at us from the Black Paintings, Goya never forswore his innate curiosity about his fellow man. Only the nature of his portraiture, not the quantity or quality, changed during the more than thirty years that were left to him after the first attack of his illness in 1793. The brilliant witticisms, the sly sarcasms and frothy, jubilant palette were left behind. He still painted portraits on commission, but now he chose his commissioners instead of hiring out his talent to the first comer. In his early portraits there was often much love. But it was a flighty, spirited love that was never quite free from a waspish amusement with the object of his love. He liked to lay bare the secrets of others; there was an impudent indiscretion in which he took pride. The gallery of Goya's early portraits was a little like Leporello's famous catalogue. It was a witty listing of conquests, and each conquest was due to the artist's having discovered the weakest side of his sitter's character. In his later portraits, the emphasis and the attitude shifted. The mockery went out of Goya's voice, and what once was exposed in his pictures as foolish error now assumed the guise of human frailty commanding understanding rather than laughter.

A comprehensive study of European portraiture from 1780 to 1828 is still lacking in the literature of art history. But it is unquestionably at this time that the changing position of man in his world and in his own esteem was made most graphically clear by changing attitudes in the field of portraiture. Some of the greatest portraits in the whole repertory were painted at this time, so that one has the impression that portraiture was about to enter into a period of great expansion. In actuality, however, portraits by David, Goya, and Ingres, and by German, Italian, and American artists, represented the swansong of the genre.

Portraiture persisted throughout the later 19th century and persists in our own time only as a rarity, a freak in the work of major masters. Probably the invention of photography must be taken into account here, since it furnished a cheap, quick product that satisfied the need for the recording of individual physiognomy. But photography itself was not the cause of the gradual decline of portraiture. It was, instead, the changing value of the individual that began to undermine the validity of portraiture. Only the fatuous continue to think of their appearance as important enough to make a claim on an artist's time. For most of us, a cheap, quick photograph renders sufficient justice to our exterior. The change can best be observed in the work of the two founders of modern art: David and Goya. Both were born portraitists and therefore were profoundly involved in the changing scheme of values centering on the representation of individual sitters.

David's advantages and Goya's handicaps during the early stages of their careers as portraitists are quite obvious. David is the brilliantly skilled craftsman whose authority over composition is suave and fluent. His *Antoine-Laurent Lavoisier and His Wife* [115], compared to a similar conjugal portrait by Goya, *The Family of the Duke of Osuna* [111], quite clearly reveals Goya's provincial awkwardness. To say that the Goya is "different" from the David is only to confuse the issue. The David is not just different. It is better. David's pictorial sense, his ability to place the figures in relation to each other, to space, to furnishings, and to the overall format of the picture are unrivaled. He tells us about the sitters without once getting lost in anecdote or trivial detail. His feeling for pictorial hierarchies is such that he can paint even the slightest detail of laboratory instruments with the utmost fidelity without ever allowing our eye to deviate from the major concerns of the portrait.

In Goya's portrait of the Osuna family we may be touched by a certain naive charm, and there is also a delicacy of color that deserves praise, but there remains one supremely important issue: Goya does not know how to recommend the individuals to our attention by pictorial means in such a way as to make us grasp their human or social importance. Essentially, the sitters remain a matter of indifference to Goya, and, as a result, his composition is indifferent, too. He has failed to bring new life to a tired, schematic tradition of grouping his sitters. The faces are as blank as the gestures are meaningless, and only the virtuoso passages of costume painting keep our flagging interest focused on the picture. It is indicative of the whole picture and of Goya's attitude toward portraiture at this time that we frequently remember details of costuming in his paintings but are prone to forget or confuse the facial features of his sitters.

Many critics have pointed to the influence of English portraiture, Gainsborough's in particular, on Goya's portraits from the end of the 18th century. Probably, Goya, whose circle of friends was definitely anglophile in its cultural and political sympathies, knew a great deal about English portraiture. But the elements of this knowledge that he assimilated into his own work are precisely the weakest side of English portraiture: its relative blandness, its accentuation of the fashionable, its disregard for individual character, its rather summary sketchiness, which frequently degenerates into conventional abbreviation instead of being part of the artist's style or interpretation. Goya misunderstands or fails to sympathize with Gainsborough's search for new sensibilities. The proto-Romantic losing of oneself in poetic meditations that often substitutes for character interpretation in Gainsborough is lost to Goya's masculine and empirical temperament. If Goya's late Rococo ladies look vacuous and a little

115. Jacques-Louis David, *Antoine-Laurent Lavoisier and His Wife*.
Metropolitan Museum of Art, New York. Purchase, Mr. and Mrs. Charles
Wrightsman Gift, 1977.

simpering, it is not because their thoughts and sensibilities have flown to distant places of romantic contemplation but simply because he does not perceive sufficient character in the sitters' faces to interest him. Gainsborough's vision and David's, too, predetermine the style of their portraits. Even if they have no interest in their sitters, even when they are grinding out potboilers, they are sustained by a definite and useful preconception concerning the dignity of the individual—any individual—which lends interest and human warmth and singularity to their portraits. For Goya, "humanity" as an abstract concept no longer has its old validity. The belief in the sanctity and dignity of mankind as a whole has lost currency and is replaced by isolated encounters with sympathetic or antipathetic individuals. Goya's predecessors and contemporaries could discern the grandeur of mankind even in a relatively meaningless individual. Goya and his spiritual heirs of the 19th and 20th centuries see the grandeur of the individual only against the tragic background of man's irrelevance.

If we glance at a sequence of Goya's female portraits—the *Marquesa de Pontejos* [107], the *Marquesa de Solana* [110], the *Condesa de Chinchón* [116], and the *Marquesa de Santa Cruz* [117]—the variability of Goya's quality as a painter in relation to his personal sympathies becomes quite evident. Whenever Goya is left indifferent by a sitter, he paints an indifferent portrait, which is generally redeemed only by its sarcastically exquisite treatment of costume or by superficial and sly mockery. The witty but ugly face of the very self-assured and knowing Marquesa de Solana contrasts not only in psychological penetration but also in sheer painterly quality with the flat, impassive face of the Marquesa de Pontejos. The pretentious emptiness of the fashionably garbed Marquesa de Santa Cruz interests us only for its incongruity: an insignificant figure and face lost in immensely grand classicizing trappings. The shy torment of the Condesa de Chinchón, on the other hand, is conveyed to us in truly painterly fashion by the compositional relationship between the figure and the overwhelming darkness around her, by the transparent delicacy of the coloristic scale, by the turn of her head and the sensitively observed gesture of her delicately modeled hands. Equally important—and very rare in Goya's work—is the organic unity that he achieves here between dress and figure. In the *Marquesa de Santa Cruz* we instinctively feel a disparity between the woman and her manner of dress. Even the far more sober and qualitatively superior *Marquesa de Solana* makes us wonder how a woman with such a face could possibly have put that huge pink bow in her hair. Over and over again one has the feeling that Goya's official

116. Goya, *Condesa de Chinchón*. Duque de Sueca Collection, Madrid. →

117. Goya, *Marquesa de Santa Cruz*. Valdés Collection, Bilbao.

portrait sitters resemble those flat cutout dolls that little girls like to play with by pasting different costumes on them. No matter how outlandish (measured by our own standards of fashion) the immense crinolines of Boucher's ladies, no matter how insubstantial Gainsborough's gowns, no matter how exaggerated his hats, we are never tempted to think of Boucher's or Gainsborough's sitters dressed in any other way. With Goya, it is often quite otherwise: Either we remember the face or we remember the costume. In that respect, the Condesa de Chinchón is a notable exception. Her gown is inseparable from the figure and from the mood of the painting. It is a true extension of the sitter's personality.

Pose, too, is an important and elusive element that has never been sufficiently discussed. In Rigaud's portrait of *Louis XIV* [*33*], the king is unquestionably *"en pose"*—but it is the pose of a king, and therefore pose and individual are perfectly congruent. Goya's *Marquesa de Santa Cruz* also poses—and so does David's *Mme. Recamier*. But we now have to distinguish between pose and pose. David poses his subject in a socially acceptable and understandable manner that lends her the dignity of a Roman *matrona*. The pose is meaningful to him, to his sitter, and to his public. Goya, when he poses his official sitters, has an obviously sarcastic attitude. His *Marquesa de Santa Cruz* is no Calliope. She is an awkward and transparent impersonation of Calliope by an actress who doesn't feel in the least comfortable in her role. At his best, Goya does away with the

240

pose altogether. In his *Condesa de Chinchón*, for instance, we face the sitter directly, without any intermediary travesty of "posing as something." But the moment the prop of a pose is avoided, the individual becomes an elusive and isolated figure. She cannot assert herself against the dark space around her. She glances shyly off to one side as if unsure of herself. Her gesture becomes hesitant. How, this portrait seems to ask, does one present one human being to another without the mitigating crutch of social convention—without, that is, assuming a pose? For every portrait is a presentation—and a presentation to unknown men and women of future generations. If, as Goya implies, we scarcely know who we are, if we no longer know why we were put on earth and where we will go after we leave our terrestrial existence, it becomes a difficult business, indeed, to find the necessary aplomb for having our portrait painted. The individual is no longer a brother of all men present, past, and future, all of them willed into existence by an all-knowing, all-forgiving God. He is an erratic and enigmatic particle. The only possible reason for painting a portrait derives from the elusive bond of friendship and sympathy. And sympathy and friendship will be the foundations of all of Goya's later portraits. The authority, the assertiveness of 18th-century portraits (an assertiveness that is still strong in David's portraits), vanishes from Goya's work, and there remains the indefinable but nevertheless powerful mystery of that immediate warmth that we instinctively feel for those men and women to whom we are drawn. In the 20th century, that circle of men and women for whom artists feel sympathy becomes more and more restricted, until finally only the artist's immediate family is represented in the work of our best artists.

The peculiar, sometimes negligent, sometimes purposeful, distortion and manipulation of space in Goya's early portraits have already been considered. The lack of cohesion between the space occupied by the figure and the space of an ambiguous, unconvincing park landscape is especially noticeable in the *Marquesa de Pontejos*. As long as Goya is still making his way, he retains these (to him) meaningless appurtenances of late Baroque portraiture. Only gradually, as he becomes more secure as the leading, unrivaled portraitist of Spanish society, does he start to dispense with the decorative surroundings of figures. Instead of parks or luxurious interiors, he begins to leave the background of his portraits neutral and empty. Velázquez's monumental court portraits must have pointed the way, and Rembrandt's late portraits, which focus on the sitter to the exclusion of everything else, may also have confirmed Goya on his new path. But if Velázquez and Rembrandt did away with what they considered extraneous matter in their mature portraits, they nevertheless located their

241

sitters in a tangible atmosphere established primarily through their mastery over luminous effects. Even without prosaically describing the furniture or the architectural environment of their sitters, both Rembrandt and Velázquez do convince us that their sitters exist in a space that is analogous to the space in which we live and move. A harmonic proportioning that links the figure to the frame, plus the compositional force of light traveling through atmosphere and revealing the features of the sitters in a convincing manner, give each portrait by Velázquez or Rembrandt a clearly established relationship to the space in which they exist. We never once question how Velázquez's full-length figures manage to hold themselves up on a floor that simply isn't there, nor do we ever wonder whether a bust-length portrait by Rembrandt represents the sitter as standing up or sitting down. So firmly are these compositions anchored in a logically understandable space that both Rembrandt and Velázquez can take space for granted without bothering to construct it for us.

Goya's portraits make an issue of the spatial environment of his portrait sitters, and it is for this reason that his portraits often have a hauntingly equivocal, uncertain air about them that distinguishes them from all other contemporary portraits. Again a comparison with David can be fruitful. For David, also, was fully conscious of the changed circumstances in which he as a painter of portraits had to operate.

David's *Mme. Recamier*, though not exactly contemporary, occupies much the same place in David's work that the *Marquesa de Santa Cruz* [*117*] occupies in the *oeuvre* of Goya. Both artists distinctly react against the decorative abundance of late Baroque painting and restrict their means with a fine sense of pictorial economy. In both cases, the sitter is an enlightened and fashionable lady belonging to an aristocracy that prides itself on being liberal and avant-garde. Both ladies affect a rigorously classicizing fashion in dress and furniture. But only David's painting, although not as highly finished as are most of his portraits, conveys a distinct sensation of space that is absolutely adequate for the deployment of the figure without suggesting that the space overwhelms the figure. By a tactfully measured distance that is established between us and Mme. Recamier's reclining figure, David lays the foundations of a comprehensible spatial environment, which, though it is far from the architecturally closed perspectives of the Renaissance-Baroque tradition, still conveys to us the feeling that Mme. Recamier is located in a surrounding that is geared to her stature, personality, and social rank. However undefined the space, it never makes us uneasy by suggesting that it is limitless or amorphous.

Goya, however, deliberately moves the classical couch on which the

Marquesa de Santa Cruz receives us very close to the picture plane so that there is no intermediary distance between us and her. The head and foot of the bed are cropped by the frame, and there is no indication of how the feet of the couch relate to the floor. A bolster that supports the marquesa's right elbow cuts diagonally into the picture but doesn't establish a perspectival line into depth because it completely contradicts the depth-ward extension of the headboard. In fact, the bolster doesn't seem to have any firm relationship to the mattress on which it rests, and there are no other compositional coordinates (such as the candelabra in David's painting) from which we can take our directions. The total effect of the Goya is as unsettling as the effect of the David is reassuring. Figure, couch, and surrounding space are disproportionate to each other and give the figure an aspect of being utterly at sea, like floating jetsam. The classic pose and dress seem to be a kind of whistling in the dark: When you're confused about your identity, the quickest and easiest remedy is to assume a mask and pretend that you have become the character whose outward appearances you have assumed. Marx was probably right when he observed that the socially as well as spiritually insecure bourgeoisie could not play their part in history without having recourse to the outward trappings and costumes of periods gone by.

The different psychological effects in the two portraits derive from the different relationships between figure and surroundings. In David, the figure is undoubtedly dominant. Mme. Recamier appears relaxed, com-pletely "composed," fully capable of receiving visitors or of facing the artist, who may be imagined as busy at his easel. She is in full command of the situation. Goya's marquesa is swamped in space. Even her couch is far too big for her, and there is something distinctly unconvincing and forced about her pose. Pose turns into posturing.

The heroic fiber of human life is no longer self-evident, and whenever Goya is called upon to portray sitters whose position in the world demands the heroic tone, the discrepancy between conventional ideal and palpable actuality is so sharp as to touch the same demonic, monstrous chords that are struck by the Black Paintings. Especially the portraits of the reinstated King Ferdinand open up a psychological abyss of brutal stupidity, of corruption, and of cruelty born of self-fear that is in every way comparable to the unwholesome terrors of the Black Paintings. In the portrait of King Ferdinand [118], we are told about ignoble vileness by an artist who no longer believes in even the hypothetical virtue of the human soul. It would be wrong to call this portrait a caricature for the reasons that have been discussed in connection with the portrait of Charles IV. Suspicion, vanity,

cruelty, greed, and stupidity are what we read in the repulsive face and in its artificial pose. But these vices are only the symptoms of a far more devastating malaise. A core of emptiness, a sickening knowledge that human existence is bereft of transcendental power, a mere sum of animal instincts and pointless actions and reactions emanate from this portrait. And if it is possible for one man—and that man a king!—to be born without a soul, without a purpose, without an immortal spark, then how can anyone be sure of the validity of his purpose, of his identity—in short, of the necessity of having been born? An animal among animals, man cannot even have the instinctive tranquility of other animals because, unlike other animals, he is dimly aware of a destiny and avenges himself on his fellow man for being condemned to the torment of self-doubt. It is strange to notice how, in the portrait of King Ferdinand, the nausea of self-hatred radiates from the central figure and even infects the heraldic lion at the king's feet. The noble beast, symbolic of pride and power, looks surprisingly like a gorged rat. In two very similar portraits Goya included royal robes and royal insignia. But the uncertainty with which the robes are worn and the scepter is held attests to the awareness in Ferdinand (and in Goya!) that these insignia are usurped and that they are no longer considered to be concrete manifestations of "the grace of God."

Invisible, ideal forces acting through individuals and giving those individuals their heightened, hallowed significance disappear from the portraits of the elect very rapidly during the 19th century. David is close to Goya in this respect. Only slightly false archaicizing of figure and costume lends his *Napoleon with the Insignia of Empire* a spurious, superficial impression of being truly regal. But the unnatural tension of the pictorial construction, of the emperor's stance, and of the artist's overanxiousness gives the show away. One need only glance back at Rigaud's *Louis XIV* [33] to see how casually both king and painter took the divine right of kings for granted. Ingres, unlike the republican-hearted David, was able to reveal suprareal powers in the guise of the human figure. His *Napoleon in Majesty* solves the problem by ruthlessly sacrificing the mortal reality of his portrait sitter. Ingres turns Napoleon into a thundering idol of ivory and jeweled fabrics whose scale is deliberately left ambiguous by withholding from our eye any object or form of daily human experience through which we could gauge the dimensions of the towering idol. But Ingres's painting is the last regal portrait there is—if it can be considered a portrait at all. Afterward, in England as well as on the

118. Goya, *Ferdinand VII*. Museu de Arte, Santander. →

continent, the ruler as representative of higher powers in his quality of king no longer survives in art. He is either human-all-too-human (Prince Albert, Empress Eugénie) or else an abstract, bloodless, lifeless hieroglyph of political power.

It would be misleading, however, to represent all of Goya's portraits during the first three decades of the 19th century as being so demonic and malevolent. The official portrait represents only the extreme of Goya's desperation over the condition of man. Actually, Goya's portraiture during this time is not all devoted to exposing the viciousness of which mankind is capable. There are portraits of friends (and Goya is increasingly adamant about painting only those he loves) that are full of warmth and affection. The magnificent portraits of the Suredas [*119, 120*] testify to Goya's sensitive interest in the reticences and delicacies of faces that are beautifully rendered and highly individualized. It is precisely in these works that he

119. Goya, *Don Bartolomé Sureda*. National Gallery of Art. Gift of Mr. and Mrs. P. H. B. Frelinghuysen 1941.

120. Goya, *Doña Teresa Sureda*. National Gallery of Art. Gift of Mr. and Mrs. P. H. B. Frelinghuysen 1941.

draws closest to Rembrandt and also gives one a clear premonition of such masterpieces of Romantic portraiture as Delacroix's *Baron Schwiter*. For in these intimate portraits, which already have a certain unpretentious bourgeois quality, Goya achieves the highest goals of portraiture: He combines a sober, scrupulously factual transcription of individual features with an intuitive exposition of all the contradictions, vulnerabilities, and secret sentiments that hide behind a face. He manages, in short, to give us all the character that his sitters willingly relinquish to our gaze at the same time that he makes us ponder over the secrets that are so carefully concealed.

Still, even in portraits that are warmed by sympathy and friendship, there remains a distinctly pathetic note that is missing from contemporary or earlier portraiture. Goya's later portraits always have a slightly haunted, fugitive air. There is often something strained and awkward in the poses. The two pendant portraits of the Suredas are typical of this trend. Señor Sureda leans a little limply on one elbow and seems rather unfocused. He is neither striking a pose to welcome us nor is he off his guard, rapt in some poetic contemplation. His wife is far more alert. She holds herself erect and stares rather defiantly at us, but it is a defiance born of uncertainty. French society portraits by David, Ingres, or their imitators are quite different in that we consistently feel ourselves welcomed by the sitters. Ingres's portrait of *Madame Devauçay [121]*, contemporary with *Doña Teresa Sureda*, is exemplary in this respect. Introduced to the sitter in what really amounts to a social presentation ceremony, we are greeted with a smile (more or less aloof, depending on temperament and status), and we are set completely at ease by being accorded a conventional reception. Dona Sureda, however, seems obliged to make a distinct effort. Perhaps the costume, which requires a rather stiff corset, is partially responsible for this impression, but an awkwardness remains that cannot be explained away on these grounds. Almost all of Goya's sitters seem to be oppressed by the pretentiousness of having their portrait painted. Goya implies that one has to be either very fatuous or very sure of the enduring significance of one's life to sit with equanimity to a portrait painter.

There is one category, however, in which Goya's talent as a portraitist maintains itself without the problematic, equivocal nature of most of his portraits, and that is the portrait of instinctively passionate young women. To the end of his life, Goya remained a robust, candid admirer and lover of women despite his recognition of the tough element in female psychology. It is in his portraits of beautiful, ripe, or ripening women that Goya achieved what is given to only a small handful of portraitists: He created a typology that became indissolubly linked with a specific breed

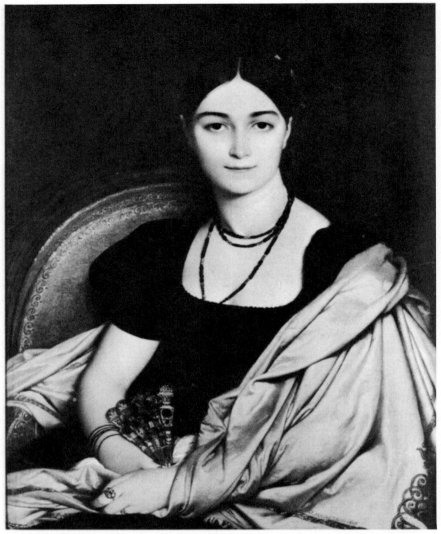

121. Jean-Dominique Ingres, *Madame Devauçay*. Musée Condé, Chantilly.

of mankind. In such paintings as *Isabel de Porcel* [*122*] and *Señora Sabasa Garcia* [*123*], he created images that all the world thinks of when the words "Spanish lady" are spoken, just as surely as the words "English gentleman" invoke the shade of Van Dyck. Both these paintings present themselves without any of the unresolved tensions of most of Goya's

122. Goya, *Isabel de Porcel*. National Gallery, London. →

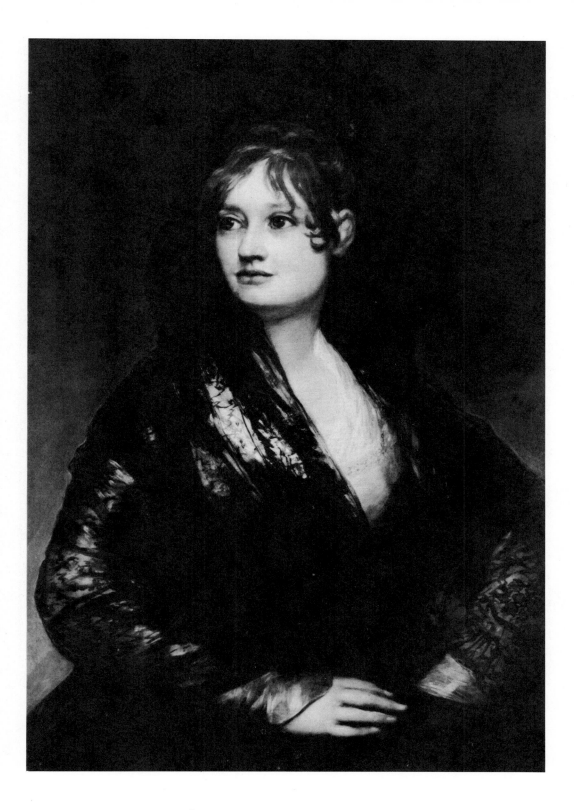

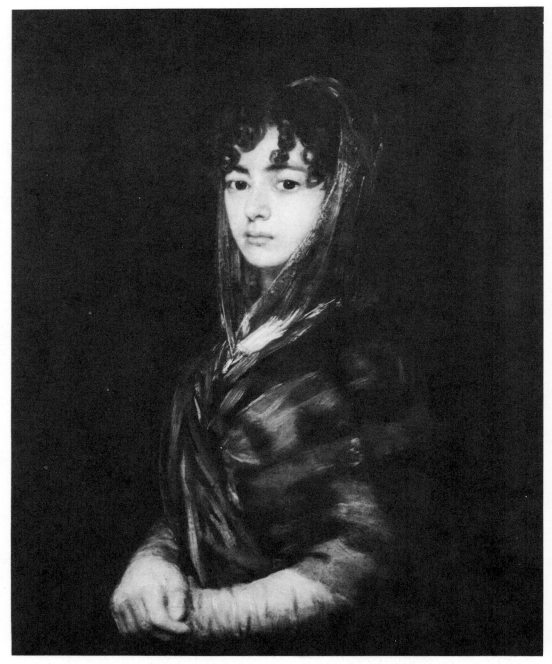

123. Goya, *Señora Sabasa Garcia*. National Gallery of Art, Washington, D.C. Andrew Mellon Collection, 1937.

other portraits. Neither one has that slightly apprehensive overproportion of disquieting, empty, isolating space. Confronted by these sensual, proud, self-assured women, all the enigmatic, disturbing quality of Goya's other contemporary portraits seems to evaporate. Of all Goya's paintings, these magnificent portraits alone attain to that complete assurance and wholeness that is the attribute of the masters of the Renaissance-Baroque tradition. Unlike Goya's other pictures, these portraits can be hung in a gallery next to paintings by Rembrandt, Titian, Rubens, or Velázquez without demanding a drastic reorientation on the part of the spectator.

After Goya's self-exile in Bordeaux, portraits continued to be of major concern to him. Official portraits, naturally, play no part in his production now. The sitters are exclusively Goya's friends, and he is at liberty to become increasingly freer in his extremely pictorial interpretations of physiognomy. His palette remains somber and very restricted in its hues. But what is lost in variety of color is made up for by the subtle luminosity of Goya's blacks, grays, and browns, which take on a depth and luster rivaled only by Hals, Velázquez, and, later, Manet. Within this restrained range of color, a small glint of carmine can frequently reach a smoldering quality of such intensity that the impression we carry away from Goya's later portraits is one of a very strong colorism.

The portrait of *Don Ramón Satué* [124] is perhaps the finest example of the late portrait style. If we compare it to a similar early portrait such as that of the *Don Pedro, Duque de Osuna* [125], we can observe the continuity as well as the fresh originality of Goya's late style.

Both figures are posed at three-quarter length against a neutral, dark background. But the proportion between figure and pictorial format is quite different. The duke of Osuna has that quality one can observe so frequently in Goya's portraits before 1820: His gesture and stance are lost in the dominant, undefined space around him. There is something unresolved, hesitant, and weak in the cutting off of the body by the lower frame. Don Ramón Satué is dominant within the format of the canvas. His stance and smile, both casual and indicative of a certain familiarity that is presupposed between the sitter and us, are directly expressive and have none of the uncertainty noticeable in the duke of Osuna. Generally, the later Goya portrait sitters are not afraid to meet our eyes, and there is something transitive in their expression that comes through to us directly. In the earlier portraits, Goya posed the sitters so that they either avoid our eyes or meet our glance with impassive, blank stares.

A new economy of means makes itself felt in Goya's last portraits. Not only is the color more restrained, but the artist, instead of making his intervention felt, withdraws behind his subject and allows more freedom

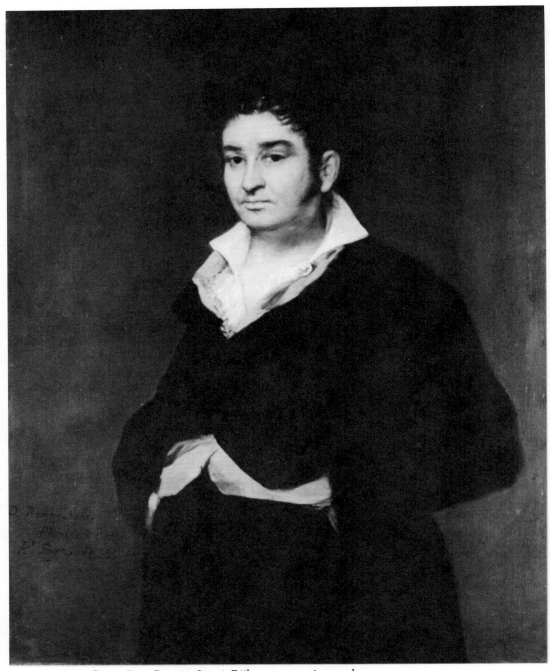

124. Goya, *Don Ramón Satué*. Rijksmuseum, Amsterdam.

125. Goya, *Don Pedro, Duque de Osuna*. The Frick Collection, New York.

to his sitter. Goya, the reckless analyst, tells us very little about the character of his sitters and nothing at all about his own judgment of them. In his portrait of Ramón Satué, for example, the sitter's tender but slightly ironic smile, his relaxed, friendly, but not altogether welcoming stance are

really all we have to go on. But by a peculiar paradox, though we know less about the sitters of Goya's last portraits, we respect and love them more profoundly. The residue of what must always remain unsaid even between the best of friends gives the late portraits, and above all the portrait of Ramón Satué, a quality of mutual confidence and respect among artist, sitter, and spectator that makes our encounters with these pictures and with these men and women unforgettable.

A last point must be mentioned concerning Goya's new conception of virtuoso technique. This question is extremely elusive without a direct visual confrontation of the canvases because the artist's handwriting, his technical methods of pigment application are involved. In the earlier portraits, Goya's methods are fairly true to the standards of 18th-century criteria. The long, melodic brushstrokes aim at an abbreviated description of the form, and the arabesque decorative quality that is so much part of late Baroque composition transfers itself to the delicately textured and varied densities of the pigment paste. A loaded brush is usually used and is touched to the canvas very fastidiously at the beginning of the stroke. Gradually, weight is applied to broaden the stroke in the middle, making the pigment more pastose. At the end, the splayed hairs of the brush, depleted of pigment, create a streaked effect that allows the lower stratum of color to shine through, giving the painting a scintillating, light effect. With great deftness, Goya conforms to these 18th-century technical virtuosities even though he will frequently tend toward a more bold, slashing stroke in which the pigment is not entirely transformed into the silky, highly articulated material that the 18th century holds so dear.

In his last portraits—such as *Don Ramón Satué*, and even more remarkably in the *José Pio de Molina* [126]—the pigment is boldly declared as what it is: a paste of oil and ground mineral pigment. The balance between the raw materials at the artist's disposal and the material that he is trying to render (skin, textile, etc.) is tipped in favor of the pigment. In the portrait of Molina, the effect is particularly startling and gives the bust a fierce, material, physical presence as if it had been sculpturally modeled out of the impasto. Certainly Rembrandt's influence must be considered here. Perhaps Goya while in France saw more varied examples of Rembrandt's work than had been accessible to him in Spain. Perhaps a parallelism between Goya and Rembrandt in their old age produced similar effects without any direct connections being necessary. Both artists, during the last years of their careers, arrived at a detachment from conventional standards of feeling and seeing that made it possible for them to cut through outward appearances and seize on what was most important and alive in their consideration of their friends: sympathy,

devotion, a somewhat oblique irony, and a touching awareness of the fragility of human existence. There is also a distinguished reserve in the way in which both Rembrandt's and Goya's characters present themselves to the world. The self-conscious pose has been dropped, and a certain negligence of stance takes its place. Both *Don Ramón Satué* and *José Pio de Molina* share this characteristic, which allows them to take their place next to such paintings as Rembrandt's portrait of Burgomaster Six.

126. Goya, *José Pio de Molina*. Sammlung Oskar Reinhardt, Winterthur.

An inherent danger lurks in every comparison between Goya and Rembrandt, and one must be careful not to attribute Rembrandt's variety and richness of personality to the far more somber Goya. Goya's portraits—even the last, warm, friendly portraits—lack the depth of Rembrandt's portraiture. The world's conception of the individual has changed in Goya's time. The immortal glow, the blessing from on high that is poured over each of Rembrandt's figures, is absent in Goya. Even in such late ecclesiastical pictures as the *Last Communion of San José de Calasanz*, the beam of light that strikes through the darkness of the picture to illuminate the dying saint is somehow mechanical, a contrived theatrical "spot" set up in the teasers, and not the pervasive, suprareal glow that cradles the mellow souls of Rembrandt's sitters.

12

Proletarian Paintings

The growing oppression of the Bourbon restoration increased Goya's difficulties. Even though he was cleared by the tribunal of the Inquisition, his sympathies were fairly well known, and almost all his acquaintances were liberals who either had become embroiled directly with royal and ecclesiastical repression or were considered suspect by the authorities. Goya tried to regulate his affairs to suit changing conditions. He made a large bequest to his son to avoid the possibility of governmental confiscation, and finally when the stifling air of reaction became intolerable to him, he requested a passport for France under the pretext of going to Plombières for the thermal waters. After 1824, though he was to return to Spain for a short period to settle some financial matters, Goya lived the life of an exile in France.

This exile, however, need not be considered altogether in a pathetic light. Friends who visited him in Bordeaux were surprised to find how robust and cheerful the deaf old man still was, and from all we know of his rather irregular household with Doña Leocadia Weiss, he remained an irrepressibly tempestuous and stubborn man to the very end.

By ruse and cunning stratagem Goya was able to keep the benefits of his possessions in Spain while living free of all political responsibility in France. In fact, it is wrong to speak of Goya as an "exile." It would be more correct to class him as an "expatriate." But whereas David's talent subsided in exile because he needed the nourishment and sustenance of direct political engagement, Goya was completely self-sufficient. David collapsed when his talent could no longer be placed at the service of sociopolitical events. Goya thrived on detached independence. David was not able to find within himself an artist's vision of the inner meaning of human existence. Even though living in the artificial isolation of all expatriates, Goya achieved a vision of mankind that embraced political

257

and social overtones that are, in their way, as strong in their appeal as were those in David's earlier political paintings.

In his extremely important work on Goya, Francis Klingender saw a democratic or downright socialist factor as the primary motif of Goya's *oeuvre*.* Certainly, Goya's deep intuition about the new social condition of man after the French Revolution is among the most astonishing strengths of his late work. But it would be a mistake, I think, to connect Goya with any given system of political thought or doctrine. Goya's political thoughts were less directly involved with the course of public events than was David's republicanism. David's great strength lay in his ardent desire to teach, in his passionate will to place art and the artist in an efficient, practical position within a rationally established governmental system. The painter must be in equal parts artist and responsible member of the body politic. Goya's position was far more equivocal. He, too, often wished to teach. But he taught a subject that he had apprehended either intuitively or by means of bitter personal experience, whereas David, when he wanted to teach, presented his material in an emphatically intellectual, systematic way, finding proper metaphors, clarifying issues with great care, and projecting his thoughts with an impressively intelligent method that did not in the least preclude deeply felt convictions. Goya teaches by arousing our sympathy and our curiosity. David teaches by reasonable persuasion.

David the regicide, David the sincere republican was an enlightened, militant member of the middle classes. His education, his urbane sense of civilization, his social obligations were representative of what was finest in the new self-awareness of the victorious middle classes. We have not a single work by David that would indicate an interest in the proletariat. Delacroix, too, disregarded the new proletarian classes and the problems they posed in a changing world. Courbet, however, broke with both Classicism and Romanticism by focusing attention on just this new source of inspiration. In Manet's work, the problem was given a subtle turn. In the conflict between the industrial aristocracy, the middle classes, and the proletariat, where was the artist to take his place? He could no longer be a simple, neutral artisan. Therefore he was not of the working classes. But he also could not participate in the profit-and-loss world of the middle and upper bourgeoisie. The ironic contradictions between artist and society became the very theme of Manet's art.

Goya, for all his years spent at Madrid, where he frequented the highest circles of court society, remained proudly true to his humble origins. In his letters to Zapater, we catch the clear tone of the provincial who was

*Francis D. Klingender, *Goya in the Democratic Tradition* (London, 1948).

rapidly becoming citified and who was proud of having escaped from the narrowness of his rural origins. But at the same time, he viewed civilization of the city—and when one says city, one must remember that Madrid was no Paris!—with the slightly detached eye of a man who, coming from outside, could see the grotesqueries, futilities, and pretensions of urban life. Goya effectively transcended his social environment, as well as his upbringing, far more successfully than did David. In a manner of speaking, Goya did not *become* an exile in 1824 when he requested leave of the king. He had already been an exile in Saragossa when he chafed and rebelled against the provincial traditionalism and mediocrity of his sponsors there. He was an exile in Madrid where his talent opened the way to the highest honors but where his lack of etiquette and his background as a commoner gave his position a freakish touch. True, he was accepted by the small circle of progressive spirits who were trying to bring Spain out of its anachronistic, feudal torpor. But he took good care never to get too deeply implicated in their politically perilous activities, and it is doubtful whether he ever achieved their degree of sophistication.

This attitude of Goya's contributed, naturally, to his gradual isolation, which was no doubt worsened by his deafness. But it also made it possible for him to deal with themes that went beyond all class distinctions. On the one hand, he was capable of producing the intensely private visions of the Black Paintings and of the *Disparates*, which were inspired almost totally by introspective, supra- or subrational experiences. On the other hand, it also lay within Goya's range to look beyond himself, without any preconceived political or social notions, in order to discover the socially determinant men of the future: the worker and the artisan.

Goya's exploitation of this new theme was not merely a matter of motif but of attitude. Not only his paintings of ironsmiths and water-carriers but also his prints of bullfights and bullfighters must be considered in this category. Men doing a job and doing it well, the dignity of workers caught in the performance of tasks that require mastery—these were the true themes of much of Goya's best later work.

In the *Tauromaquia* and in the *Bulls of Bordeaux*, Goya links the theme of work and workers with a spectacle in which man and beast come together in an agonistic ritual. Both man and beast have a recognizable degree of nobility in the face of death, and both are desperately alone even though thousands of spectators crowd the bleachers.

The earlier of the two series, the *Tauromaquia*, traces the history of the art of bullfighting and illustrates several particularly well-known moments of this noblest of all Spanish sports. Advertised for sale in 1816, it is one of the few series of Goya's prints that was published in his own lifetime.

There has been much speculation as to why Goya turned to this subject. Jovellanos and other enlightened friends of Goya violently attacked what they considered a barbarous sport, but there is no reason why Goya should have agreed with Jovellanos in all things. Goya's boast, made late in life, that he had once been a torero, need not be based on actual fact. But his interest in bullfighting is documented by several portraits of toreros dating from his early years in Madrid as well as by several small scenes of the Plaza de Toros in Madrid painted during the 1770s. It is indicative of Goya's attitude that almost all the scenes of the *Tauromaquia* are shown from the point of view of a participant in the arena and not from the bleachers.

For sheer ingenuity of forceful composition, the *Tauromaquia* has no rivals. Unlike the *Disparates*, this series focuses on a "here and now" with breathtaking precision. Goya's economy of means is amazing. Nowhere do we find a stroke of the burin in excess of strict necessity. And yet, unlike the cases of the *Caprichos* and the *Disparates*, one is never left in doubt about where these actions take place. The summary treatment of ambience in the *Caprichos* and in the *Disparates* has an unsettling effect. We are left floating in an outer limbo. The equally concise treatment of surroundings in the *Tauromaquia* gives the opposite impression: It evokes a sense of space that is brought to a sharp, single point of attention. So compact and intense is that one point that all else becomes peripheral and irrelevant. The insistence on juxtaposition rather than on composition, so strong in the *Caprichos* and *Disasters*, is held in abeyance here. These plates are the most composed images of Goya's *oeuvre*. For here he deals with a theme that is not senseless, dispersed, and fragmentary, but that is, in the highest degree, meaningful and subject to human understanding. The encounters of the *Caprichos* and *Disasters* are either enigmatic or brutal to the point of madness. They are raw facts from which the mind reels in horror. The encounters of the *Tauromaquia* represent high artifice. Every move is planned and carefully executed.

In *Homo Ludens*, Huizinga investigates all of human civilization under the aspect of play.* Many of his findings are beautifully proved by the conventions of the Spanish bullfight. The prerequisites for play are twofold: There must be a limited field, and there must be artificial regulations agreed upon by convention. Whereas everyday life is amorphous and haphazard, play adheres to strict rules that cannot be broken. These rules apply only to the limited field in which the game is to be played out. Spectators as well as the actual participants can belong to the world of play. Only the spoilsport is excluded: Whoever watches a tennis

*Johan Huizinga, *Homo Ludens: A Study of the Play Element in Culture* (Boston, 1950).

game and obstinately points out that the rules of the game are nonsense and have no meaning is the true outsider.

The *Tauromaquia* is the most meaningful example of the "civilization game" that Huizinga discusses so persuasively. The field is severely limited and becomes a miniature universe, which is manageable to the human mind and perception. Nothing outside the arena counts once the signal is given for the beginning of the bullfight. Two equal but opposed forces act against each other in accordance with a strict set of regulations. The regulations give the bull absolute freedom of action. A force of nature cannot be constrained to follow man-made rules. The torero and his team, on the other hand, since they are deprived of the brute force that is inherent in their antagonist, have only graceful agility and intelligence on their side, and these two forces are subject to conventions elaborated during the long development of the bullfight. Unlike the Greek *agon*, the struggle is not between equals of the same species but between two equally strong but fundamentally contradictory forces. Both man and beast have an equal claim to our respect. Unlike a normal game, there is no "winning," because the end is total: One of the protagonists will die. And death, though it may come today for the bull, will eventually come for the man as well. If the torero wins, he has not vanquished a weaker opponent. What he has vanquished is the weakness within himself. What the crowd acclaims in both bull and torero is their courage.

Naturally, this cursory interpretation of the bullfight is only the most generalized description of what actually goes into a spectacle that can only be described by the word "sublime" when taken in the sense that the Romanticists gave the word: awe inspiring, beyond the standards of normal experience. Goya, who understands the bullfight from the inside, seems to have anticipated Huizinga's theories. The arena, in his images, becomes a part of the game. It is the limit within which rules and conventions assume meaning. Beyond the arena lies another world in which no rules, no man-made conventions can apply. And each moment of the game, if it is honorably played, is its own climax, because the players stake all they have at every turn. Visually, Goya gives expression to the whole range of sensations of a bullfight by making every line take on a direct meaning in relation to the action. In Plate 20 [*127*], for instance, the dense shading of the upper left corner and the repeated vertical rhythm of the background barrier are in immediate rapport with the figure of the torero vaulting over the horns of the bull. In Plate 21 [*128*], Goya represents the violation of established game conventions. The bull has broken through the barriers of the arena and disrupted the delicate equilibrium established by the conventions. Within the arena, where just

127. Goya, Lightness and Skill of Juanito Apiñari in the Bullring of Madrid (*Ligereza y a trevimiento de Juanito Apiñari en la de Madrid*). *Tauromaquia* No. 20. Metropolitan Museum of Art, New York. Rogers Fund, 1921.

a moment ago all had been order and intensely focused attention, chaotic panic has broken out. A yawning void is counterpointed by a confused mass of figures rushing headlong in all directions. Outlined against a vast void, the bull proudly dominates the scene. With a minimum of light-shade contrasts, Goya here created one of the most tensely charged images in the repertory of graphic art.

Degas, more than any other artist of a later period, is the true heir of Goya's *Tauromaquia*. Like Goya, he loves to give us the purely conventional limits of a staked-out field (usually the stage) on which figures move according to regulations that are highly artificial. The stage becomes a microcosm that, for a fleeting moment, gives us the illusion that there is an ordered harmony abroad. But such a harmony is purchased at a high price, and, as in Goya, beyond the staked-out field there lies the darkness of an amorphous, uncoordinated universe that is utterly unaware of our human desire for clearly ascertainable order. The brighter the sun in Goya's *Tauromaquia*, and the brighter the footlights of Degas's ballet and circus pictures, the more fiercely do we become aware of the darkness that lies beyond.

128. Goya, Accident in the Bullring at Madrid (*Desgracias acaecidas en El Tendido de la Plaza de Madrid y muerte del alcalde de Torrejón*). *Tauromaquia* No. 21.

The torero in these plates rises to a position that few other figures achieve in Goya's *oeuvre*: He becomes a recognizable hero. He does what he must do with the utmost devotion to regulations that he has accepted as valid even though this validity is based not on a higher authority but on a contract between men. He is the artisan of courage, just as the artist, too, by following his bent and doing what he can do best, finds the only fulfillment there is in modern life: the consolation of work freely accepted and perfectly done. In this way, the great bullfighting scenes are germane to the only heroic figures in Goya's maturest work: the workers.

The proletarian world hardly impinges on art before Goya's time. The labors of monks on medieval cathedrals, the heroic allegories of various crafts in the Studiolo of Cosimo de' Medici, workers carousing in taverns or as incidental parts of townscapes in Baroque Dutch art, and two or three major canvases by Velázquez are really all we have before the 18th century. The Rococo abhors work *qua* work and admits it in art only disguised as rosy putti playing at being workers. Chardin introduces a slightly newer note with his maidservants going about their humble tasks.

But his pictures are primarily hymns to domestic virtues, and the figures that appear in them do not impose themselves on our imagination as workers. Of all of Goya's predecessors only Velázquez takes work and workers seriously. But in all of his compositions, the theme of work is thoroughly intertwined with religious or mythological allegory. An ulterior, often elusive, and always ambiguous meaning is imposed on the bare realities of workers and their world.

We must turn to England, and more specifically to provincial England, to find the spiritual predecessors of Goya's proletarian pictures. Whether Goya was aware of the quiet revolution in the pictures in this genre by Joseph Wright of Derby cannot be ascertained, but it is certainly possible he was. Goya's curiosity seems to have been omnivorous. It may well be that Wright's pictures challenged him to do justice to a theme that was growing more and important in his own imagination as well as in the European social and political scene.

A certain virtuoso quality makes itself felt in the *Iron Forge* [129], a picture painted by Wright as early as 1772. The startling forcefulness of the artificial light set in dramatic relief to the glowering darkness of the interior can be traced back via Gottfried von Schalken to the Dutch Caravaggisti of the early 17th century. The new element consists of the visually and psychologically effective tension between the figures and the compositionally equivalent forms of the mighty machinery. The meticulous attention to detail that Wright lavishes on the stance and costume of the figures is equally intense in the implacable form and surface of the gigantic trip-hammer. Machinery and the very architecture of the iron mill are perfectly interwoven with the figural themes, so that one cannot be understood without the other. The relationships between the triangle of the smith's powerful figure and the triangle formed by the lever in front of him and the trip-hammer in back, as well as by the triangle of rafters above the smith's head, are only the most obvious feature of the integration of a new, important class of men with the environment dictated and generated by their active, productive lives. A new self-awareness, a new dignity, is awakening in the picture by Wright and lends a suspenseful solemnity to the entire scene. Wright and many contemporary Englishmen had a full presentiment of the future implications of the beginning Industrial Revolution. One need only look at the aspirations of Wright's good friend Josiah Wedgwood to realize how optimistic and humane was the artists' involvement with industry. In Wedgwood's Etruria as well as in Wright's studio, the modern worker attained dignity for the first time.

Goya's *Forge* [130] represents a synthesis between the modern spirit first interpreted pictorially by Wright and the Spanish tradition of unpre-

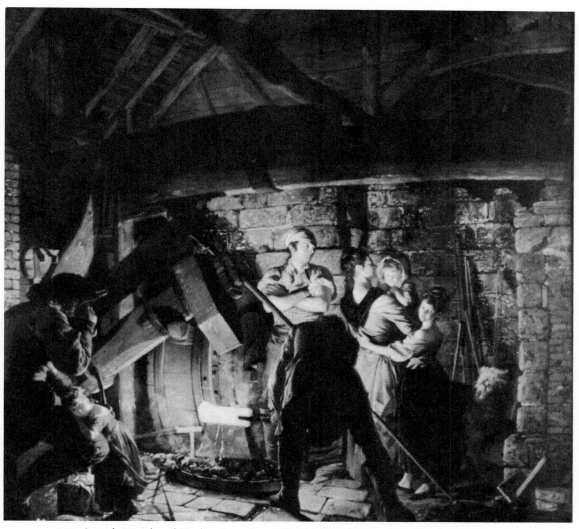

129. Joseph Wright of Derby, *Iron Forge*. Lord Mountbatten, Broadlands, Romsey, Hampshire.

judiced realism as represented at its highest perfection by Velázquez in *The Forge of Vulcan* and *Las Hilanderas*.

The size of a painting is all too often left unmentioned, and in our day, dominated by reproductions that would have us believe that an altar by Raphael is the same size as Vermeer's *Lacemaker*, we have grown increasingly insensitive to the actual dimensions of pictures. In the case of Goya's *Forge*, size is not only visually important but also revelatory of Goya's

265

purpose. Wright's pictures of modest format are destined for the private collection of a growing class of amateur collectors. Their small size also allows a meticulous technique, which was much admired by just the kind of collector to whom Wright appealed. The spectacularly even surfaces, the fastidious modeling must be "read" at close range to be fully appreciated. Craftsmanship was an important criterion in the critical equipment of the upper-middle-class collector in England, just as it had been in Holland a century before. Unlike the aristocracy, which was brought up on the "Grand Style" championed by Joshua Reynolds, the middle class counted honest work as a high virtue even in the execution of paintings. It was a visible guarantee of the artist's seriousness.

Monumental in scope and intention, Goya's painting is of a size usually reserved for altarpieces. Sheer size and a deliberately chosen frog's-eye perspective (which is also standard in religious paintings but very uncommon in genre pictures) preclude the minutely accurate observations of detail inherent in Wright's style. The painting cannot be intimately scrutinized in a cozy drawing room but belongs in a larger, public context. We cannot tell just where Goya expected this painting to be displayed, but we may be sure that he intended it to fulfill the kind of purpose that Courbet later was to envision for his pictures: an eloquent testimonial to the modern human condition addressed not to the collector but to the artist's contemporaries in general.

Goya's smiths are not of the handsome, stalwart cast that makes Wright's picture so appealing. Nor does Goya try to engage our sentiment by surrounding the central figures with subordinate groups in which we can find, as in Wright's masterpiece, reflections of varying attitudes toward the meaning of labor. The light is even instead of being dramatically contrapuntal, and the fascinating tools and surroundings of the workers, impressively exotic to the layman, are deliberately underplayed. Tongs, hammers, the anvil, and the barest indication of a furnace are the only descriptions we find, and even these are entirely subordinated to the three workmen. Wright makes much of his blacksmith's dress; his striped blouse is immaculate, an oblique reference to the pride taken by the man in personal cleanliness and to the householding virtues of his young wife. Goya's workers are dressed in garments that remain unspecified large areas of loosely brushed-on color. Grays predominate, and there are some intimations of fraying and tearing at the seams and hems, but pictorially, the costumes are secondary to the figures and their gestures. The persuasiveness of Wright's realism is achieved by his scrupulous attention to details in the setting and costumes. Neither the physiognomy, nor the personality, nor the action of the blacksmith conveys a meaningful or

130. Goya, *The Forge*. The Frick Collection, New York.

lasting impression. When we turn away from the painting, we tend to remember the smith's blouse and the lighting of the scene better than his face. Wright's hero is a composite of all the virtues Wright saw or wished to see in workers. He is an inspiring exemplar of his class. But even though we can persuade ourselves that such proud, appealing workers existed in the forges of England, we also are led to understand that he represents either an ideal or at least the most *virtus*-charged paragon of workingmen. Goya's workers have none of the hopeful, self-confident, optimistic nobility of Wright's blacksmith. These workers are definitely not ideal representatives of their profession or their class. They are specific individuals with their singular biographies expressed clearly in their faces and in the stance of their bodies. Their work is not only a source of satisfaction and dignity, it is also the force that ages them before their time, that bows them down and keeps them in a state of spiritual bluntness. There is all the world of difference between the muscularity of an athlete with his evenly developed physique and the strength of the worker whose body is shaped by the routine of work that makes demands on only a few muscles which become overdeveloped in relation to the rest of his body. Wright, despite his truly modern attitude, has nevertheless had recourse to the kind of selectivity that we first find fully formulated in the legend of Apelles choosing the finest features of a variety of maidens in order to create the sum of many perfections in his picture of Aphrodite. Wright has observed and understood the worker and his environment from the outside, accurately, with deep respect, but without giving us the full experience of what it might feel like to be a worker who spends most of his waking hours sweating away in a smoky smithy. In Goya's work, just this essence is conveyed to us with an almost breathtaking immediacy. Whatever we learn from Goya's picture about workers is not derived from objective observation of workers but from the inside out, from the worker's own point of view. The subject is so extremely strong that the question of "who painted this" arises only after we have recovered from the original impact. Wright's incredibly fastidious execution elicits admiration for the artist even before we admire the worker in his picture. Only the specialist, only the connoisseur will examine Goya's *Forge* for technique, for "handwriting," for what the French critics call *facture*. Although it can be done, and although even on this count Goya proves himself a master, a stylistic or technical examination of *The Forge* is very much like a stylistic analysis of the prose used in *The Communist Manifesto*: a professional obsession from which the critic cannot escape.

The successor to Wright's *Iron Forge* is Ford Madox Brown's *Work*. The natural heir to Goya's achievement is Courbet's *Stone Breakers*.

Brown's painting is an elaborate, morally laudable attempt to arouse the social conscience of the times; Courbet's is a succinct statement of unimpeachable fact. Wright and Brown address themselves to their equals. Goya and Courbet address themselves to no one in particular but try primarily to be true to the ascertainable facts—not only the exterior facts of how a worker looks but also the more elusive facts of how a worker feels inside his rags and inside his skin.

Surprisingly, it is in *The Forge* more than in any other painting that Goya approaches the compositional stability of the Renaissance-Baroque tradition. He does so without returning to the traditional perspectival means of Caravaggio, Rembrandt, or Velázquez. Space is treated so negligently that we involuntarily supply it ourselves. At the same time, we supply another element that the artist himself withholds: the knowledge that the moment the artist has chosen is in some way climactic. There is absolutely no narrative factor in the painting. Yet the comradely concentration on the work of hammering a piece of red-hot iron is persuasive, because of the extraordinarily balanced composition in which each action has its counterweight, that we involuntarily experience a sense of communion between the workers that is not altogether different from the communion of religious liturgy. It was in his work as a painter that Goya discovered his own salvation, and it was in work that he found the strongest intimation of the survival of man's dignity.

The Forge is undoubtedly the most complete statement of Goya's late style. It is his only painting that is an integral whole rather than a meaningful fragment torn out of an inscrutable context. But it is accompanied by three less ambitious paintings of a similar theme that have always been admired but rarely discussed: *The Knifegrinder*, *The Watercarrier*, and the *Milkmaid of Bordeaux*.

The Knifegrinder (El afilador) [131] is an extraordinary prophecy of Manet's art. With a minimum of modeling and perspective, simply by the authoritative patterning of strong forms and colors, Goya has managed to give substance and a convincing presence to his journeying laborer. The bold mass of the wheelbarrow-suspended grinder's wheel stretches across the entire breadth of the canvas in a sharply outlined pattern of stark, almost geometric simplicity. In tense contrast to the rigid framework of his equipment, the figure of the knifegrinder seems almost tempestuously alive and mobile. His head is lifted, and he looks straight out at us, but his body still preserves the stance imposed on him by his job. The arched back, the stooping shoulders are rendered with the utmost economy of means against a uniform ground. In its reduction of form, color, and theme, the painting predicts Manet's *Fifer*. But for all its esthetic inven-

131. Goya, *The Knifegrinder* (*El afilador*). Museum of Fine Arts, Budapest.

132. Goya, *The Water-carrier* (*La aguadora*). Museum of Fine Arts, Budapest.

tiveness, it also has some of the directness of an alert, intelligent social sense. It is not as diabolically and deviously detached as the Manet. Again, one is strongly reminded of Courbet, not only because of the theme but also because of the determined palette-knife technique and the almost aggressive denial of traditional principles of compositional or chromatic grace.

The Water-carrier (La aguadora) [132] expresses Goya's loving admiration for what is young and healthy, and even the blacks of the costume have a luster and life that underline the proud cheerfulness of the young woman. The point of view has been chosen with great care, so that we look up at her. This return to a traditional formula is not altogether haphazard. In 1820, Goya signed a sizable altarpiece for the sacristy of Seville Cathedral representing Saints Justa and Rufina [133], the patron saints of the city. The lovely sisters had been vendors of crockery before they were called to their destiny of martyrdom and saintliness. Their attributes are the simple earthenware pots that are still so characteristic of Andalusia today. Murillo often represented them as enchantingly fresh and lovely girls, and Goya follows Murillo in this straightforward interpretation of the two saints. The two girls with their attributes appear in Goya's altarpiece very much the self-confident peasant girls who add charm and liveliness to all Andalusian markets. In stance, costume, and expression they are sisters of The Water-carrier, proud in spirit and humble of birth. The deliberately low point of view that Goya has chosen for his saintly sisters is fairly traditional when dealing with saints or with exalted personages because it automatically imposes an attitude of reverence on the spectator. The transferral of this device in The Water-carrier to a theme of quotidian, humble quality might be one more instance of the secularization of religious forms in the art of this period.

The "populist" flavor of Goya's paintings during his last years is not an entirely new element in his art. Already in his tapestry cartoons, Goya had proved that he was interested in the variety and vigor of life among the lower social classes. In some cases, most obviously in The Injured Mason [8], he was even then capable of a depth of understanding that went well beyond the decorative sentiment of Fragonard's description of life among the indigent and escaped the sermonizing attitudes of Greuze's investigations of the life of poor but virtuous villagers. Goya's intentions, however, underwent a deep change in the forty years that separated the tapestries from the later proletarian pictures. Despite the almost aggressive realism of the tapestry cartoons, which puts them at such a remove from Fragonard or Greuze, they still retain a somewhat patronizing air. Though he describes the common amusement of common people with great gusto

in the cartoons, Goya has not quite liberated his art from his own life. Something of the bravado of the self-made success is apparent in the cartoons. He doesn't find it too difficult to describe the life of workers, vagrants, and villagers for the amusement of the more gently born.

In *The Forge*, *The Water-carrier*, and *The Knifegrinder*, the note of entertainment has vanished altogether. What's more, the artist who takes pride in his virtuosity and wit has vanished also. In the tapestry cartoons, Goya is much more present; we are constantly reminded that we are seeing everything through his eyes. In the late paintings, Goya's presence is far less obvious. The subject of the painting takes over to a remarkable degree, and the artist hides himself, so that our discourse with the figures he has created for us can be much more direct. In the earlier paintings, we are persuaded that these scenes exist because Goya has persuaded us to believe the facts he reports to us. In the later paintings, we believe in the existence of the water-carrier or the blacksmiths because they incontrovertibly exist in their own right.

133. Goya, *Saints Justa and Rufina*. Seville Cathedral.

Epilogue

I n 1802, at the time Goya was entering his most mature, decisive phase after completing *The Family of Charles IV* and the two *Majas*, Friedrich von Schlegel wrote: "Only the man who has his own religion, that is to say the man who has an original view of the infinite, can become an artist."

Schlegel was the most eminent spokesman for the avant garde. His call for a new kind of artist indicated that all the established, traditional ideas concerning human existence and its possible meaning in the universe had to be replaced by highly individualized notions about the ultimate things of man's life on earth. No revealed or traditionally organized religion could satisfy the generation that had come to maturity with the French Revolution and its aftermath. It was the obligation of each man to search for new values. And the artist now assumed the role formerly held by the priesthood: In his work, the concentrated forces of all that intelligence, sensibility, and intuition could reveal about the meaning of life were to be passed on to the multitude. This new function of the artist, coupled with a new freedom and a new loneliness, was to be reflected in a hundred ways during the following decades. Alfred de Vigny's identification of poet and prophet in his *Moïse* with the reiterated line *"Je suis grand mais solitaire"* is an expression of this new direction in art, just as Wilhelm Heinrich Wackenroder's dictum "The enjoyment of a noble work of art is comparable to prayer" indicates the usurpation of the throne of religion by the arts. Within the first third of the 19th century, Goethe, Beethoven, and Goya rose to the challenge and created works in literature, music, and painting that embodied all the new power and tragedy unleashed by the individual's confrontation with the vastness of the universe unaided by the intercession of traditional religious faith.

Goya's response to the immensities of suspended possibilities that lie in the universe, inside as well as outside the individual, manifests itself in

134. Francesco Guardi, *Ascent of a Balloon over the Giudecca* (*Mongolfiera in* → *volo sulla Giudecca*). Gemäldegalerie, Staatliche Museen, Berlin-Dahlem.

135. Goya, *The Balloon* (*La mongolfiera*). Musée des Beaux-Arts, Agen.

each of his works. Still, his monumental works (and one must count his graphic series such as *The Disasters of War* among them), for all their novelty and depth, are overlaid by all sorts of considerations that must of necessity accompany the creation of work meant for a large public. It is therefore in his more intimate paintings that one can overhear Goya most clearly—for example, in such apparently unambitious works as the scenes from madhouses (in the Academia de San Fernando and in the Meadows

276

Museum in Dallas) or in the little scenes of fantasy painted as Goya was recovering from his first attack of illness in 1793. But the pictures painted for his own satisfaction in that year are still relatively immature. The cumulative weight of physical and spiritual isolation wrought by deafness and by wartime experience that transformed Goya didn't find expression until later. It is from the small, private works painted after 1806 that we can find the most condensed expression of Goya's art. Choosing at random, we can look at *The Balloon* [135] and at the still life *Slices of Salmon* [136] to measure fully Goya's prophecy of the changed condition of modern mankind.

When the Montgolfiers discovered a practicable technique for flight by means of balloons filled with heated air, a craze for ballooning swept all of the Western world. The delight at overcoming the trudging heaviness of terrestrial existence reflected the entire range of 18th-century sensibility: Ballooning crowned 18th-century belief in the unlimited powers of rationally developed physical science, and it gave free rein to the 18th-century yearning for disembodied caprice, lightness and airiness.The Montgolfiers enabled real men to have a real experience of infinite lightness, of freedom from the shackles of the force of gravity—an experience that had hitherto been reserved for the gods and heroes of Tiepolo's ceilings.

Perhaps the most moving representation of the balloon mania is Guardi's little view in Berlin, *Ascent of a Balloon over the Giudecca* [134]. Surrounded by the scintillating, vaporous air of the Venetian lagoon, a delicate aircraft rises serenely and is cheered on by the tiny figures of elaborately dressed ladies and gentlemen who have assembled at the Punta della Dogana to witness the event. Everything is evanescent and weightless. The graceful little figures, all seen from the back, all concentrating on the vanishing balloon, are the most tenderly elliptical symbols of an age taking leave of its seemingly endless frivolities. All the nostalgia, all sensitive dualism of refined enjoyment with the premonition that the enchantment of life is all too fleeting speaks from this painting, and the balloon dissolving into pure light and atmosphere is the apotheosis of a light-hearted age that is passing away forever.

Between Guardi's depiction of ballooning as a fashionable pastime and Goya's *Balloon* lies the watershed of the French Revolution and the Napoleonic cataclysm. Far from being a source of momentary delight, Goya's balloon hangs over the landscape like an oppressive threat. On the ground below, crowds of people are rushing about in headlong panic, trying to escape. The sky is as blue as Guardi's, but whereas Guardi's sky is still synonymous with heaven, the home of God, and the place toward which all souls turn for comfort and delight, Goya's sky is a dense, distant

277

physical phenomenon dispassionately perceived and soberly rendered. It is merely the closest part of an unknowable void which crushes human life into insignificance.

Perhaps one can best understand the tragic gulf that lies between Guardi and Goya, between pre-Revolution and post-Revolution, by referring to two similar paintings of our own century which speak our own language more clearly. Roger de la Fresnaye's *Conquest of the Air* is a 20th-century version of Guardi's picture. Aeronautics is a source of confidence and pride. The human intellect that gives us dominion over the skies is celebrated in colors that strike a cheerful note within the general atmosphere of a breezy day in early summer. But another Spaniard swept aside these fine hopes just as Goya swept aside the blissful visions of Guardi. In Picasso's *Guernica*, the sky, emptied of angels, is the region from which terror strikes at night. After Guernica, which is only a forerunner of Rotterdam, London, Dresden, and Hiroshima, Goya's prediction, first expressed in *The Balloon*, becomes a fact of everyday life. Our generation and the generations that we can foresee bear the mark of the ominous threat that Goya discovered hanging in the sky.

If *The Balloon* affords us an intimate glimpse of Goya's "original view of the Infinite," as Schlegel demanded of the modern artist, the still life of *Slices of Salmon* gives us a similar view, only this time the perspective turns from the outward view to the universe that dwells within us.

In the Western tradition, still life always represented the goodness of the things of this world, much as the Biblical sacrifice of first fruit attested to man's gratitude for the fullness of God's earth. Usually still life was at the same time charged with an ulterior symbolic language that not only made of the still life a satisfactory rendition of this, game, and fruit, but also assigned specific meaning to the objects represented. Thus, in Dutch still lifes of the 17th century, oysters generally refer to erotic lust, oranges to Paradise, etc. In the work of the greatest of 18th-century still-life painters, Chardin, this religious and transcendental note is still clearly perceptible. Though 20th-century critics have sometimes praised Chardin as an initiator of *l'art pour l'art* by interpreting his still lifes as virtuoso performances, the solemnity that speaks from every one of his paintings quite clearly takes us beyond pure artifice and into the realm of religious contemplation. A sacramental note hangs over the fruit and flowers of Chardin's paintings and lifts them far above the realm of decoration.

It is tempting to think of Goya's still lifes as simple exercises in rendition. But one need only glance at how Goya represents his still life to realize that he works in the high tradition of Spanish principles: Only those things capable of death can be said to have possessed life. All

appearances command respect because they are doomed to die. In the still lifes by Sanchez Cotán, Zurbarán, and Velázquez, this Spanish note is immediately apparent. There is always a careful *dis*sociation of all objects that allows the maximum of self-assertion to each flower, fruit, earthenware vessel, or cabbage stalk. Instead of binding the elements together into a compositional scheme as all non-Spanish still-life painters invariably do, the Spanish painter insists on what might be termed anticomposition. Concomitant with this sentiment is the construction of space around the still life, which follows a very definite pattern in Spain. Atmospheric shadings are absent, throwing the outline of each form into sharp, relentless focus, which further separates the forms from each other and obstructs any kind of esthetic reading of the picture by undercutting all pleasing originality of arrangement. It also forces examination of each element in turn. We experience these paintings not as paintings—that is, as visual organisms in which all the component elements achieve a total that is greater than the sum of the individual items. We are forced into an awareness of the essential isolation of everything that exists in the world. For whereas our eye automatically and involuntarily groups things for us, so that we see in assimilable, understandable patterns that give us understanding of and mastery over all the things that we see, the Spanish still life disperses this capacity of the eye. We are forced, in a way that natural vision never forces us, to see the estrangement among all living things. A kind of interstellar void falls among the objects of a Spanish still life.

Though he doesn't pluck his slices of salmon apart the way Velázquez and all other Spanish still-life painters isolate their objects, Goya nevertheless insists on the unbridgeable gap that isolates all things and forces them to live out their individual, unrepeatable, inscrutable destiny. He does so by completely obliterating all indications regarding the surroundings of his still life. Chardin, too, sometimes sets his still life against a neutral background. He can be extremely reticent about his setting. But if Chardin underplays the setting, it is because he doesn't have to describe it. Without giving us the kitchen table standing on a floor against a wall, he makes us sense the sheltered, domestic setting by the magic of his atmosphere, by the devoted care with which he traces every appealing surface as it is touched by the subdued light of a hushed dining room. Our imagination, given so much to feed on, immediately supplies the rest. In Goya we can supply nothing because we are told nothing. The white strip that bisects the canvas horizontally immediately beneath the three slices of salmon could possibly be read as a tablecloth—but if we read it as such, we do so only because we find the silence and the emptiness of

136. Goya, *Slices of Salmon* (*Ruedas de salmón*). Sammlung Oskar Reinhardt, Winterthur.

Goya's painting unbearable and force a rational interpretation on it in order to comfort ourselves. We are whistling in the dark. By rendering the textural appearance of the fish with uncanny immediacy and then denying the white area underneath any kind of definition, Goya achieves so sharp a contrast that we cannot relate the reality of the fish to the unreality of the white strip below. By stretching the white from the left frame clear to the right frame Goya also deprives this white area of any spatial existence. It is simply a phosphorescent area that hovers in the general darkness of the painting.

There is more: The relationship between the heap of sliced fish and the frame is casual and, as it were, irrelevant. In Chardin (or in any other still-life painter, for that matter), the amount of space between the still life and the edge of the painting is always carefully calculated to give us just that sense of intimacy that adds all the sense of domestic virtues and of family values to his still life. Conversely, the Flemish or Neapolitan manner of filling the entire area of the picture with still life forms gives these paintings a sense of abundance and opulence that again—but in a

different way—evokes an ulterior and symbolic meaning. It indicates the endlessness of nature and its inexhaustible riches. In Goya's painting, on the other hand, one has the feeling that one could easily enlarge or restrict the space that surrounds the central motif without changing the ultimate meaning of the picture. And the meaning of the painting resides in this very understanding of irrelevance. A life has been destroyed and reduced to passive matter. The masterly way the glistening skin of the fish is painted immediately brings to life the cool rushing water and the lithe movement of the fish within its normal habitat and makes the contrast between its life and its death all the more poignant. The same can be said of the pink flesh, which reflects a last hint of pulsing blood and supple muscle even though it now reveals itself to be nothing but an inert mass of various shades of rose and red. With destruction of life there comes nothingness. The dead fish in the paintings of countless other painters immediately remind us of the pleasures of the table. In Goya's superficially brilliant depiction of the lusciousness of salmon flesh, we taste instead the bitterness of irretrievably pointless death which casts its shadow on all life. If death holds no meaning, can there be significance to life?

The ultimate questions that were asked by Goya in *The Third of May*, in the Black Paintings, and in *The Disasters of War* were always asked within the framework of the artist posing a question within a larger context of war or of feverish madness. In this still life there is no context, and there is no question. A supremely modern fact is stated. The enchantment of living experience (our delight in the heady textures and colors of the fish) is annihilated in view of an impassive knowledge that all must come to nothingness.

The nihilism that pervades the annals of modern history is foreseen and expressed by Goya. If we are still able to feel admiration and gratitude to the artist in view of such a painting as his still life of *Slices of Salmon*, it is due only to the vague hope that mankind, though seemingly doomed in an impenetrable universe, cannot be quite lost as long as there remain spirits such as his: incorruptible and courageous witnesses whose passage on earth lends dignity to their race.

Index

Page references to works of art are listed in italics. Works of art are by Goya unless otherwise indicated.

PHOTO CREDITS

Alinari, Florence, plate 27; Beedle & Cooper, Northampton, 47; Foto O. Böhm, Venice, 11; Photographie Bulloz, Paris, 10; Editorial Photocolor Archives, Inc., New York, 29, 49; Photographie Giraudon, Paris, 121, 135; Manso, Madrid, 20; MAS, Barcelona, 4, 5, 7, 8, 17, 19, 21–26, 28, 31, 80, 84, 85, 87, 88, 94–98, 106, 116–18, 128, 133; Scala, Florence, 2, 12, 81; Vaghi, Parma, 41.